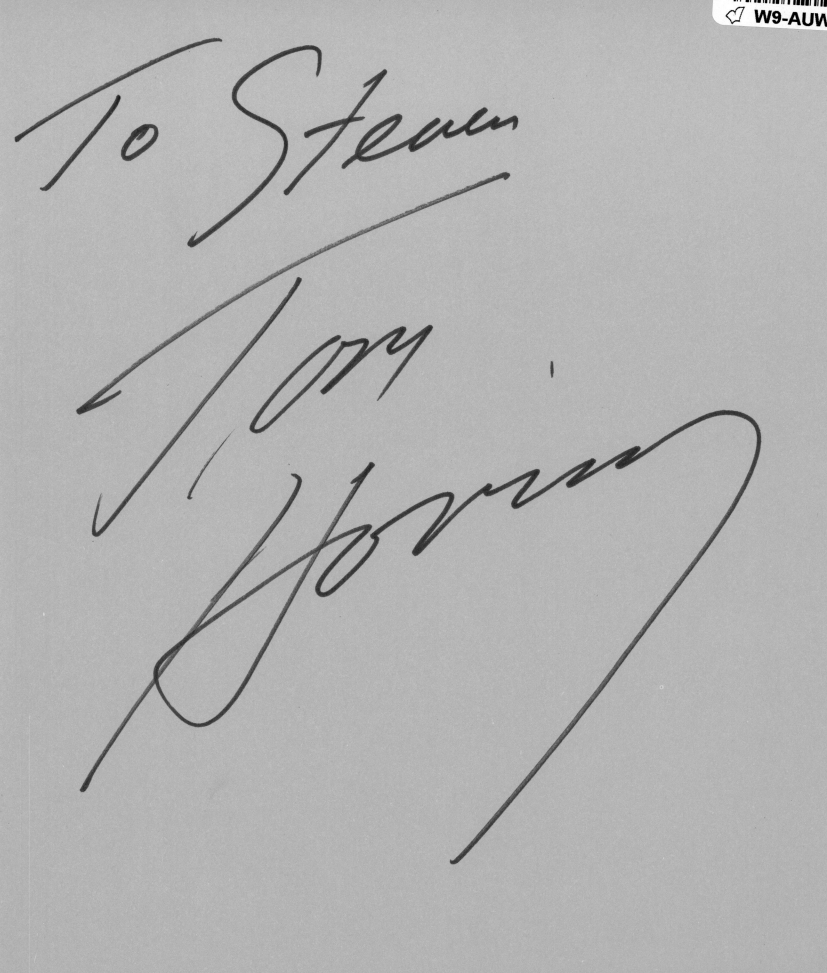

To Steven

Tony
Hovey

# GREAT WORKS

# OF WESTERN

ARTISAN NEW YORK

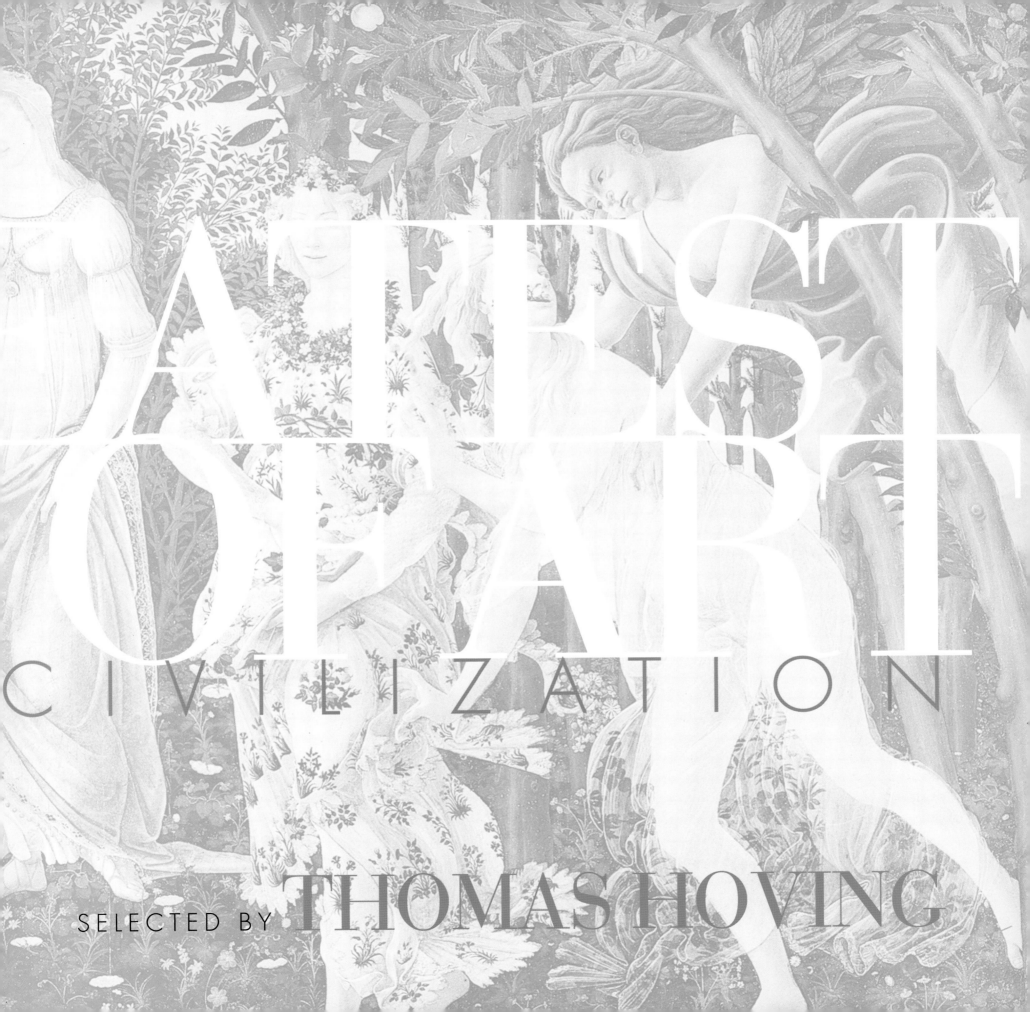

# TASTE OF ART

## CIVILIZATION

### SELECTED BY THOMAS HOVING

EDITOR: Ann ffolliott
DESIGNER: Susi Oberhelman
PRODUCTION DIRECTOR: Hope Koturo

Published in 1997 by Artisan,
a division of Workman Publishing Company, Inc.
708 Broadway, New York, NY 10003

Library of Congress Cataloging-in-Publication Data

Hoving Thomas, 1931-
    Greatest works of art of Western civilization / Thomas Hoving.
    p.    cm.
    Includes index.
    ISBN 1-885183-53-4
    1. Art—United States—Catalogs.  2. Art museums—Catalogs.
I. Title.
N510.H68    1997
708.13—dc21                          97-15289
                                     CIP

PRINTED IN ITALY

10    9    8    7    6    5    4    3    2    1

FIRST PRINTING

ONE EARLY MORNING of an exceptionally beautiful day I got the idea of retracing every step of my life as an art expert—from 1951—and writing down the works of art that had bowled me over visually and emotionally, the ones that after years I could describe down to the tiniest details, as if standing in front of them. These are the ones that changed my life, the ones I believe to be the pinnacles of quality, elegance, and artistic strength, the best mankind has created, the hallmarks of unalloyed genius. I walked in my mind through the great art repositories of America, Europe, Russia, Egypt, and South America and met again all those works that had overwhelmed me at first sight. I didn't care about how many times they'd been published or lauded, or whether they had appeared in my various art history courses, or even if the creator was known or if I knew him or her. All I cared about were my reactions and whether they mirrored the power, the mystery, and the magnetism of the works themselves.

When my journey came to an end I had counted one hundred and eleven works. They are, to me, the very finest that have survived from western civilization or had an intense impact upon the west. Indelible, indomitable, I look upon them almost as friends, works I continually revisit for guidance and in whom, no matter how many times I see them, I find something new and inspirational. I have no doubt that every one who looks at them will discover something profound about them and themselves.

The order in which they appear in this book is a fantasy order, precisely the one I'd prefer to see them again, shock after beautiful shock.

THOMAS HOVING

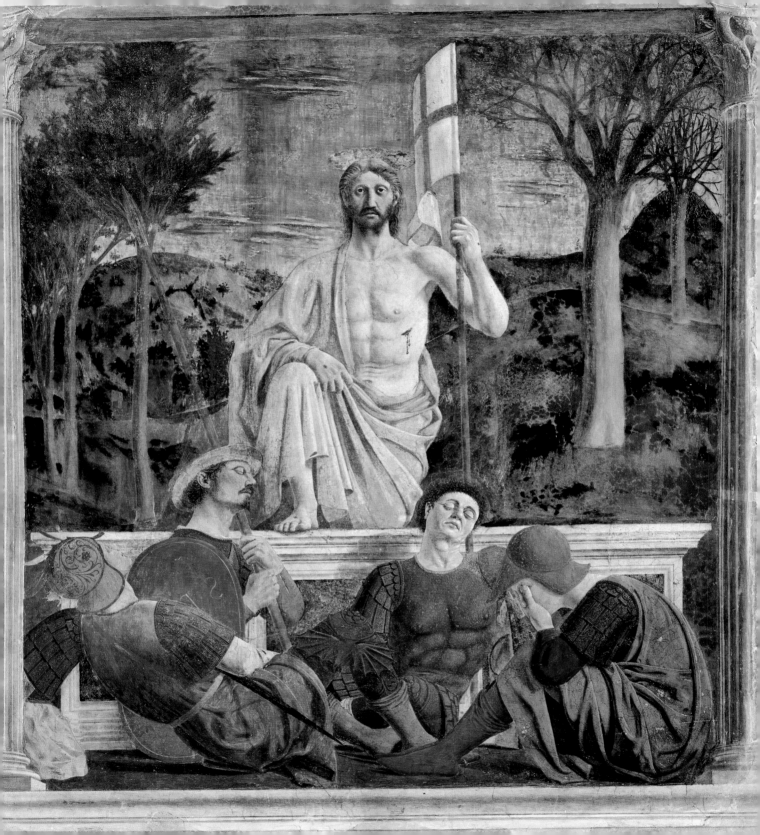

PIERO DELLA FRANCESCA

# RESURRECTION

WHEN I WAS LIVING in Italy as a graduate student, my wife and I fell in love with the flinty works of the Renaissance painter Piero della Francesca and decided to make an autumn pilgrimage throughout the country and look at nothing but his paintings and frescoes. We started in Rome with the all-but-obliterated fresco of the four evangelists in Sta. Maria Maggiore and wended our erratic way up to Florence, Perugia, Urbino, Arezzo, Monterchi, and, finally, Sansepolcro. We arrived there in the late afternoon and checked in at a small hotel—the only one open at that time of the year—and the proprietor, upon hearing that we would like a bath later on, retired to the back courtyard to split wood for the fire to heat up our water. We sped off to the municipal museum to see Piero's *Resurrection*. Alone in the room where it is on display, with no other people in the way, and no other works of art to diminish its grandeur, we stood in awe at the frightening image confronting us of a risen Christ triumphant—no, more than triumphant, a Christ both victorious and enraged. It is a vision of the Christ Avenger who will rid the world of sinners, the Christ of Saint Michael, the killer of monsters and satans, the demiurge of the

Second Coming who looks you square in the face, who locks his blazing eyes with yours and asks, "Are you a sinner or among the blessed?" It had better be the latter. The colloquy is strictly between Christ and the onlooker, for the magnificent four soldiers are completely unaware of the momentous event that is taking place.

Piero's works seem to stand apart from the works of his Renaissance contemporaries as stronger, more subtly imbued with a special feeling for geometry, and not, like the others, too easily seduced by contemporary fads such as the rendering of perspective. He seems to have understood the classical spirit in a particularly sensitive way and details such as the man doffing his shirt to be baptized in the *Baptism* in London's National Gallery are startlingly similar to sculptures such as the Belvedere torso in the Vatican, which Piero could never have seen.

Piero was born in Borgo San Sepolcro and his father, a tradesman, was wealthy enough for Piero to obtain an excellent education. By 1439 he was working in Florence as an associate of Domenico Veneziano who was hard at work on the fresco cycle in Sta. Maria Novella. Florence was a mine of

PIERO DELLA FRANCESCA
(Piero di Benedetto dei Franceschi)
b. ca. 1406-12, Borgo San Sepolcro, Italy
d. Dec. 10, 1492

RESURRECTION
late 1450
Fresco

Current Location: Pinacoteca Comunale,
Sansepolcro

stylistic treasures and Piero presumably was influenced by the works of such as Donatello and Luca della Robbia. No doubt he also pored over humanist and architect Leon Battista Alberti's important theoretical treatise on painting. He soaked up all that Florence could give him and began to distill the lessons into his own style, one of order, discipline, symbolic light, and a touch of fantasy.

He went back to San Sepolcro around 1442 and was given the commission to produce an altarpiece for the Confraternità della Misericordia, a work that shows influences from Donatello and Masaccio, which was completed only around 1462. Piero always worked slowly and painstakingly. He worked for several years after 1448 for the Marchese Leonello d'Este in Ferrara where he

seems to have been influenced by northern art. In 1451 at Rimini, a city on the Adriatic coast, Piero executed a marvelous heraldic fresco of *Sigismondo Malatesta Before St. Sigismund* in the renowned Tempio Malatestiana, a memorial church for the Marchese built from designs of Alberti, which is one of the most important surviving Renaissance structures. This was also the moment Piero made the magnificent, luminous *Baptism* in London, with its stunning classical aura and a wondrous landscape showing the Tuscan hillsides.

His fully mature works are truly powerful. Among them are the frescoes, unfortunately in rather a bad state, in the choir of the church of S. Francesco in Arezzo. These show in a highly dramatic way various anecdotes from the Legend of

the True Cross. Among the flashing images are bits and pieces of silvery armor that illuminate the surroundings like brilliant moons. Piero began the work in 1447 and finished it only by 1466.

The most fruitful patron of his career, Count and later on Duke Federico da Montefeltro of Urbino, established in that hill town a most extraordinarily sophisticated Renaissance court. For him, Piero painted the *Flagellation* in the late 1450s, which is now back in Urbino after having been missing for years following a theft. This poetic and haunting scene gives the impression of being carried out in some Homeric hall, it is so filled with the flavor of ancient times. For the duke and his consort, Battista Sforza, Piero created a diptych portrait, probably a marriage memorial (they were married in 1465) which is today in the Uffizi in Florence. The duke and his bride-to-be are shown to us on the front side in a charming combination of the unvarnished and the ancient Roman, in stark profile, warts and all. The landscapes are sere and probably were influenced by painters from the north. On the back of the panels we see the noble couple in a triumphal procession surrounded by the personifications of the Virtues.

The last two decades of Piero's life were spent at San Sepolcro, where he received commissions for altarpieces that have unfortunately been lost. But surviving is the lyrical *Nativity* in the National Gallery, London. In his late years, Piero wrote treatises on painting and how to attain perfection in proportions and on applied mathematics.

# BED

ROBERT RAUSCHENBERG
b. Oct. 22, 1925, Port Arthur, Texas

BED
1955
Oil and pencil on pillow, quilt, and sheet on wooden supports
6 ft. 3¾ in. x 31½ in. x 8 in.
(191.1 x 80 x 20.3 cm)

Current Location: Museum of Modern Art, New York

I FIRST ENCOUNTERED Robert Rauschenberg's sloppy unmade bed, slathered and splattered with paint and glued down so that when it was hung on the wall it wouldn't fall apart, in the the Leo Castelli Gallery in New York where it was first exhibited. I was bowled over by the shock of it, its impudence, its strength, and the sense of bewildered impotence and rage that it communicated. Part painting, part sculpture, part found object, and part detritus, it seemed very courageous at the time and seems even more so today. It's the kind of thing that widens the boundaries of what is called conventionally the fine arts. I was convinced on my visit also that it was the single sexiest work of art I'd ever seen, plus one of the most appropriately decadent—steamy and redolent with taboos, yet possessing all the proper artistic properties of color, form, shape, and substance. I find now much symbolism inherent in the work. To me, this enrapturedly messy bed is the veritable symbol of the continuing human hangover that is the state of mind of the second half of the twentieth century. I further believe that incongruously embedded in this bizarre and compelling image are the ghosts of Vietnam and other American sad secrets and failed hopes.

Rauschenberg grew up in Texas and during World War II joined the U.S. Navy as a neuro-psychiatric technician. In the service he learned how little difference there was between sanity and insanity and realized that a combination may be more important—certainly for art—than sheer sanity. During the war, he stumbled upon art in San Diego at the museum there in Balboa Park and was, later, overwhelmed by the stunning pictures hanging in the Huntington Library near Pasadena. After the war, he studied at the Kansas City Art Institute under the G.I. Bill of Rights, went to Paris for a spell, and then returned to America and studied with geometric abstract painter Josef Albers at Black Mountain College in North Carolina, where he was also influenced by the avant-garde composer John Cage. He moved to New York and enrolled in the Art Students League there. He worked briefly in the window display department of Bonwit Teller before teaming up with the painter Jasper Johns to form a free-lance window display studio. In the mid-1950s,

Rauschenberg became one of the stars of the Leo Castelli Gallery and was enshrined in the Mount Olympus of pop art, although he was always far more important as a universal artist than a practitioner of a single trendy style.

From the late 1950s he started to work with newspapers and magazine photographs in his paintings and cooked up a technique whereby he could transfer the pieces directly to his canvas. From Andy Warhol he got the silk-screen stencil technique for putting photographic images onto large canvasses and buttressed the pictorial anecdotes with broad strokes of paint. These works were influenced by themes from modern American history and pop culture and possess a power that is never limited to the specific event depicted by the photographic images. In the period from the 1970s until today Rauschenberg has been preoccupied by lithography and other printmaking methods and is more and more incorporating imagery from his own photography.

Rauschenberg is still making art in New York and Florida, and he frequently travels throughout the world on a wide variety of projects.

# ZEUS OR POSEIDON

NO ONE HAS convincingly been able to identify this life-sized bronze in the National Archaeological Museum in Athens with certainty as one of the two Olympians—for each one could have thrown either a thunderbolt or a trident. I don't think the identity matters. It is the sublime depiction of the courage, indomitability, and sheer beauty of mankind that is what this amazing bronze is all about. There are some works of art that defy words, and this is one of them. This brave and all-powerful god in the fullness of his immortal prime of life is, I believe, the most perfect image of classical humanity that has survived. No other example of Greek art of the fifth century B.C. has the same delicate combination of idealism and practicality, the muscular and the intellectual. This god is so universal he could be an image of the Christian God the Father as well—the quintessential creator and avenger of almost every religion—and what mankind would like to be in its wildest dreams.

The sculptor is unknown, but may have been a member of the Parthenon generation.

ARTIST UNKNOWN
Athens, 5th Century B.C.

ZEUS OR POSEIDON
5th century B.C.
Bronze
6 ft. 10 in. (2.08m)

Current Location: National Archaeological
Museum, Athens

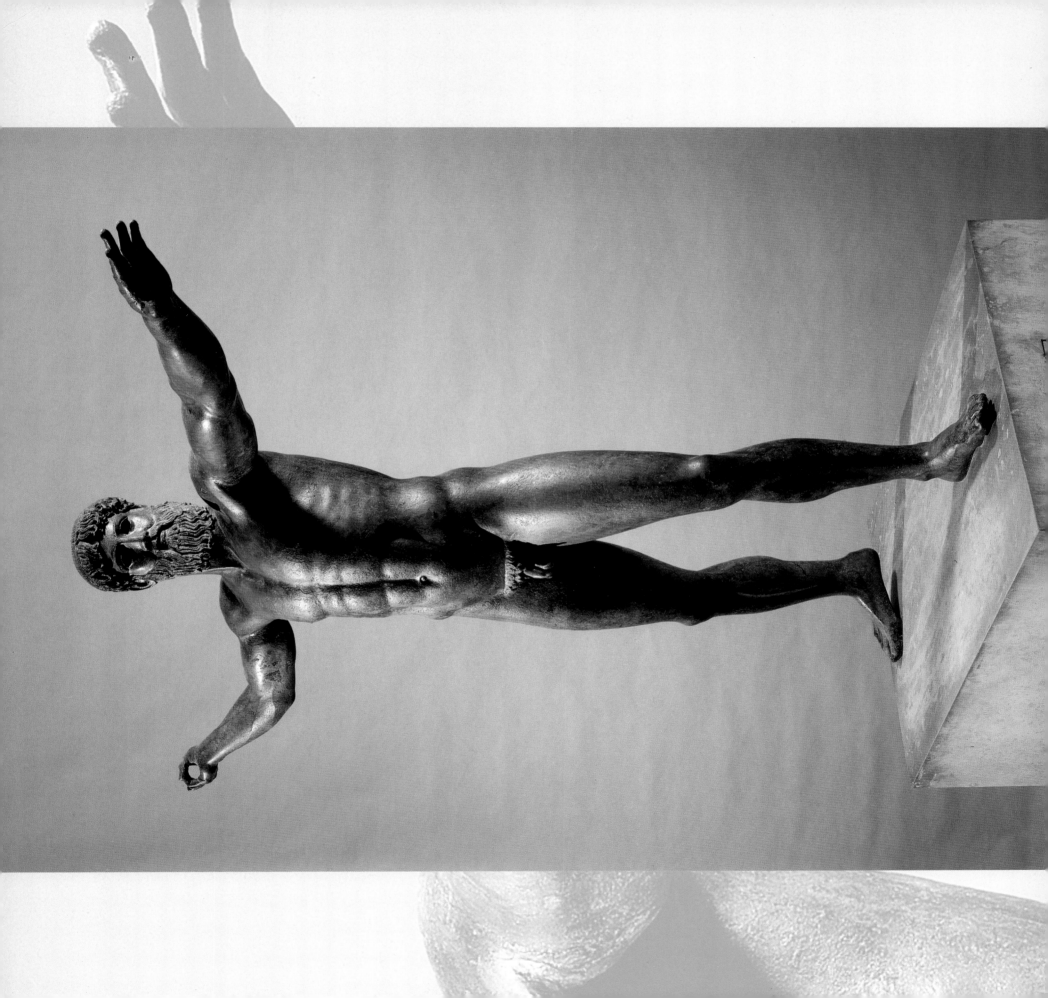

REMBRANDT VAN RIJN
b. July 15, 1606, Leiden, the Netherlands
d. Oct. 4, 1669

THE RETURN OF THE PRODIGAL SON
1668–69
Oil on canvas
104 x 80¾ in. (262 x 206 cm)
Current location: The Hermitage, St. Petersburg

# THE RETURN OF THE PRODIGAL SON

AFTER LOOKING AT Rembrandt's paintings by the score over a period of decades, one comes to the realization that those produced in the last five years of the master's tortured life are by far the most accomplished as art, and certainly the most moving as human dramas. They are rough-hewn, sprawling, and intense, with breathtakingly spiritual colors—rusts and golds, flamelike hues, and darknesses that tear at the heartstrings. They seem to be Rembrandt's attempts to expiate his multiple sins, for he was a sleazy, conniving man who stole from the dowry of one of his wives, among other mean-spirited acts in his life.

The best of these late gems, and perhaps the finest biblical painting in all of Western art, is the huge canvas depicting *The Return of the Prodigal Son*, painted in 1668–69, less than a year before he died. This monumental painting is charged with emotion, but is not overly dramatic as many earlier pieces are. It is dominated by the wretched (and most assuredly mendacious) prodigal, who has just returned in rags, which have been made to look more threadbare by being painted as if golden in hue. His head has been shaved to protect against disease or, more mundanely, lice, and his shoes have shredded into leather strips. He has dropped to his knees and crawled into his father's bosom, and one naked foot is showing (a very impolite thing to show in the seventeenth century), with the toes curled up in anxiety. It's a cold evening—the elderly patriarch is wearing a heavy red shawl—and one senses that the bum is shivering. But is he acting?

The father's embrace is almost tentative, perhaps because he is just at the moment of realizing that this creature really might be the boy whom he has believed to be long dead. The father's face and body seem to heave a profound sigh.

Although there are four onlookers—including two servants, who almost disappear into the murky background, and a lawyer with a fancy velvet cap—only one bystander counts: the elegant young man standing to the right, with the light on his face. He stands inside the scene, but at the same time strangely outside of it, for he is the older son who suffered through his tempers and complaints. He gazes upon the unforeseen event with a mixture of incredulity, hurt, and anger. One senses that Rembrandt has chosen to portray them at a moment seconds before the faithful son asks, "How, Father,

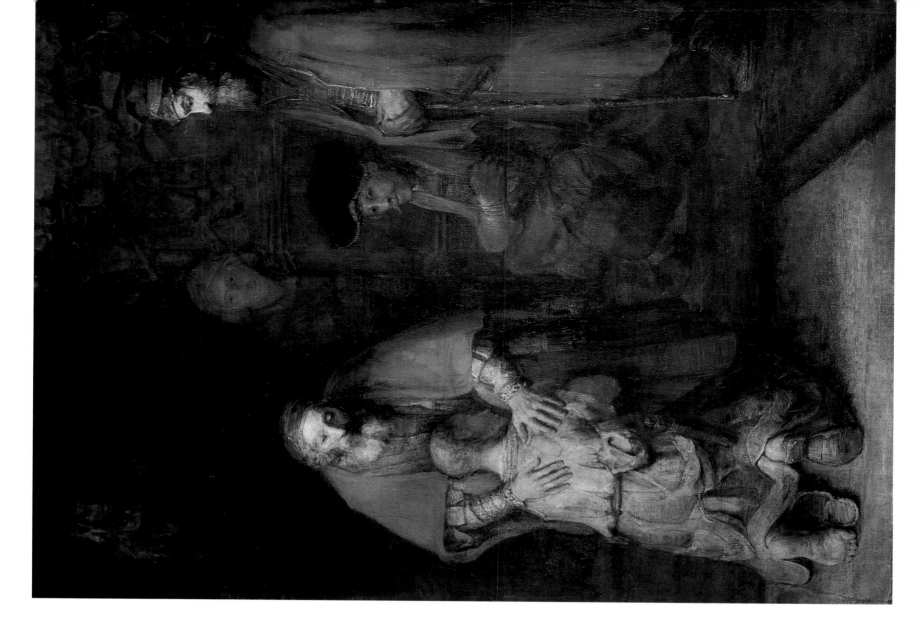

can you bring yourself to celebrate *his* return?" The answer is implied in the father's gesture of forgiveness and tenderness—a feeling that, for the viewer, is greatly enhanced by the knowledge that all of Rembrandt's children had died by the time he painted this work. In the Bible, the father's words are among the most moving in all of Christ's parables, and become illustrious symbols of everything Christ stands for: "Son, thou art ever with me, and all that I have is thine. It was meet that we should make merry, and be glad: for this thy brother was dead, and is alive again; and was lost, and is found." (Luke 15:11–32).

*The Return of the Prodigal Son* is said to have remained unfinished at Rembrandt's death (although there is sharp disagreement on this—to me it looks admirably complete) and is symbolic of the artist's own period of inward reflection.

Rembrandt grew up in the university city of Leiden. His father, Harmen Gerritszoon, was a fairly prosperous miller (and added the appellation "van Rijn" after his mill on the Rhine River). The family of his mother, Neeltje van Zuytbroeck, were bakers, and loftier than the father's side. At the age of fourteen, after seven years of study at Leiden's

Latin School and several months at the university there, Rembrandt decided to become a painter and served as an apprentice to Jacob van Swanenburgh for three years. In 1624, he was recognized as an exceedingly promising artist-to-be and studied for six months in Amsterdam with Pieter Lastman, a fine traditional history painter with an open mind. But Rembrandt was a mediocre student and an enthusiastic artist. Lastmann's influence can be seen in Rembrandt's early work.

His career took him on succeeding flights from high to low and at the twilight of his life, increasingly in debt and gradually looked upon as an anachronism, Rembrandt slowly closed off the rest of the world.

Early on Rembrandt staked out a course for himself to become one of the most renowned younger painters of the nation. His early works are learned, historically accurate, and highly theatrical, too, using almost violent contrasts of light and darkness. By the end of the 1620s, Rembrandt was singled out for praise in the autobiography of Constantijn Huygens, the secretary to the Prince of Orange, and from that obtained several painting commissions from Prince Frederick Henry.

He created a Passion series for the prince, influenced by Peter Paul Rubens, who was the rage of Europe at the time. He intended to bring to his works the greatest and most natural emotion, and they are exceedingly powerful. Yet steadily throughout the decade, for reasons that are not clear, there was a gradual falling out between Rembrandt and the prince.

Rembrandt moved to Amsterdam in 1631 and immediately garnered a host of portraiture commissions, including the spectacular group portrait in the Rijksmuseum, *The Anatomy Lesson of Dr. Tulp* of 1632, a depiction of the top members of the city's guild of surgeons. This painting is remarkable; it breaks from the standard formula and shows the individuals interacting and energetic, rather than having their heads boringly set on the same plane.

In the 1630s Rembrandt completed some of his most moving religious pictures, such as the dynamic *Sacrifice of Isaac* of 1635, now in the Hermitage. In 1634 he married the daughter of the burgomaster of Leeuwarden, Saskia, who brought to the match a hefty dowry and social connections that Rembrandt had never enjoyed previously. In 1641 after three stillborn children, Saskia gave

birth to Titus (who would tragically predecease his father). Saskia passed away in 1642.

The painter was stricken with grief, yet he produced one of his grandest works at this time, the so-called *Night Watch*, which should more accurately be entitled *The Militia Company of Captain Frans Banning Cocq*. This sweeping portrait of the guard turned out to be a watershed in Rembrandt's life. The works afterwards express a greater depth of human emotion than the artist, always intrigued with psychological motives, had ever before attempted. His brushstrokes became broader, his shadows more brooding, the backgrounds darker. He created a series of landscapes notable for being wild, even frightening.

And at the same time Rembrandt was accused of pilfering from Saskia's estate. He had a scandalous affair with Titus's nurse, who sued him and eventually was shipped off to an insane asylum where she died in misery. But with the mounting troubles Rembrandt created some of his best work, especially etchings. Between 1643 and 1648, he invented a cycle of illustrations of Christ's ministry, including—because of its high asking price—*The Hundred Guilder Print*.

In the 1650s the artist, becoming more and more isolated and disappointed by seeing his pupils and followers get commission after commission, fell into bankruptcy. His possessions were sold at auction in 1655–66. He found a young lover named Hendrickje Stoffels, who became his model for a dozen or so studies including the poignant and beautiful *Bathsheba Reading the Letter from David* in the Louvre. Hendrickje gave him a daughter but was officially censured by the church for living in sin with him. In the 1650s he completed the marvelous *Aristotle Contemplating the Bust of Homer*, which is today in the Metropolitan Museum of Art, and the *Prodigal Son*.

In his late years—the decade of the 1660s—Rembrandt increasingly retreated into his lonely studio and, bereft of commissions and always in debt, he painted some of his most gorgeous paintings, primarily soulful and powerful self-portraits. The finest is perhaps that painted in 1669, the year of his death, which shows him wearing an exotic turban. He sees himself with brutal directness as a mortal with hopelessly sagging flesh who still manages to look out at his darkening world with a firm, fearless gaze.

# THE APOCALYPSE TAPESTRIES

NICOLAS BATAILLE
HENNEQUIN DE BRUGES
based on work by Jean de Bandol

APOCALYPSE TAPESTRIES
1375–80
Wool tapestry
Height: 14 ft. (4.27 m)

Current Location: Musée des Tapisseries,
Château d'Angers, France

INTERIORS OF CASTLES and churches during the Middle Ages were swathed in tapestries. The medium flourished, if for no other reason than that cold walls had to be insulated and brightened. Hundreds of tapestries have survived, despite destruction due to religious persecution and vandalism—many were burned for their silver or gold thread!

One set stands out as unsurpassed: the *Apocalypse* tapestries in Angers, woven by Parisian tapestry weaver Nicolas Bataille for Louis I, duke of Anjou (brother of the duke of Berry), from cartoons crafted by the painter Hennequin de Bruges. Hennequin adapted his cartoons from an illuminated manuscript of the Apocalypse painted by Jean de Bandol of Bruges for Charles V. Thus, the seventy-eight monumental tapestries illustrate episodes from the *Apocalypse*, the arcane last book of the New Testament, with its visions of thunderstorms and earthquakes, deluges of fire and blood, the end of the earth and mankind.

Two of the *Apocalypse* tapestries are especially radiant. The first (number thirty-four) illustrates the passage describing the combat between Archangel Michael and his angels fighting the dragons of Satan (Rev. 12:7–12). Five armored angels swarm out of a breathtakingly beautiful azure cloud and plummet to earth like fighter jets to spear two terrifying dragons, one with seven heads. The second masterpiece (number thirty-five) depicts the scene in which an enigmatic woman receives her wings from Saint John (Rev. 12:13–14). In this tapestry, a gorgeous woman standing next to a seven-headed dragon is being given a set of wings by a hovering angel. The colors are straight from paradise, especially the vivid Chinese lacquer red of the background, which is decorated with sinuous blue-and-white foliage and flowers. Few other Western works can match the color, sweep, imagination, dynamism, gaiety, mystery, eroticism, power, and glory of these tapestries. When one visits them for the first time in their modern surroundings—in which the lighting is excellent—one simply cannot believe the scale of the undertaking, the diversity of the depictions, and the overpowering sense of grandeur. The *Apocalypse* is in a real sense the telling of wild, immense dreams, and these breathtaking tapestries are perhaps the only illustrations that have ever been created that truly capture the unruly and cosmic force of the biblical adventure.

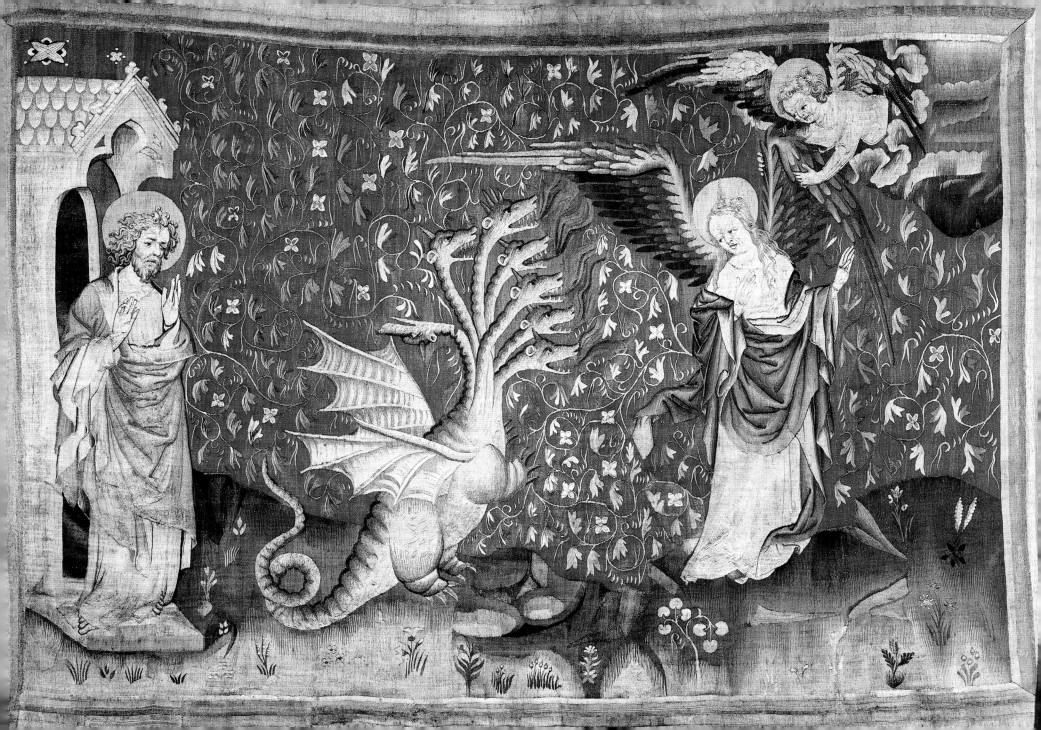

# JAY DEFEO
## THE ROSE

JAY DEFEO
b. 1929
d. 1989

THE ROSE
1958–1966
Oil paint with wood fragments and mica on canvas
128⅞ x 92¼ x 11 in. (327.3 x 234.3 x 27.9 cm)

Current Location: Whitney Museum of American Art,
New York

WHERE AN ARTIST comes from, what inspires him or her to overreaching greatness, is a constant mystery. There has never been any way to explain how visual genius is born or which work of art will, in time, be generally described as summing up an era. There is no explaining why the late painter and photographer Jay DeFeo achieved supreme greatness in one work, perhaps the single most expressive painting of the 1960s, and one of the most expressive statements in the entire last third of the twentieth century.

*The Rose* became, over the eight years it took DeFeo to complete it, an obsession in the practice of construction. The approximately 11-x-5-foot oil painting is covered with so much pigment that it weighs nearly 2,000 pounds. DeFeo used that much material to create a "star" configuration in low relief consisting of sixteen or so raised rays (and several partial ones) and their corresponding channels. These three-dimensional "spokes" burst from the impacted, tight epicenter of the upright and lofty rectangular picture and radiate outward through an undulating terrain of a beige-white field of pigment, mica, and wood chips, layered and sculpted in a haphazard, even chaotic, manner. The palette of colors is spare—white, with small amounts of yellow and gray and touches of near-black—but the effect DeFeo created with it is as vivid as if the full spectrum had been used. When you confront this unique painting-sculpture for the first time there's a feeling of shock and amazement: you ask yourself "What *is* this all about?" Then the picture asserts itself and in a curious way calms you down and excites you. All of a sudden, this star becomes radiant and celebratory and poignant, too.

There is virtually no subject matter in the traditional sense in *The Rose*, but the image ignites an enormous feeling of freedom. DeFeo said all she wanted to achieve was a piece that had a center. She did that, but also created something mysteriously grandiose and deeply moving, a strange and haunting image benevolently exploding, a sort of "angel" in abstraction trumpeting the birth of all matter. This captivating and profound work has also

a distinct religious mood to it and could be interpreted as an illustration for the Book of Genesis.

DeFeo is best known for her work during the late 1950s and early 1960s in San Francisco. She was a member of the circle that included some of the more talented Beat Generation writers and chroniclers. She made fascinating photographs and painted a select few pictures. Her works hang in a host of prestigious American museums, including the Museum of Modern Art, the de Menil Collection in Houston, and the Lannan Foundation in Los Angeles.

After *The Rose* was removed from DeFeo's studio-apartment, it went on loan to the Pasadena Art Museum and then to the San Francisco Institute of Art, where it was more or less buried in storage. It was given finally to the Whitney Museum of American Art in New York City, but was not shown until it became one of the gems of the museum's touring exhibition entitled "Beat Culture and the New America: 1950–1965," which traveled around the United States in 1995 and 1996.

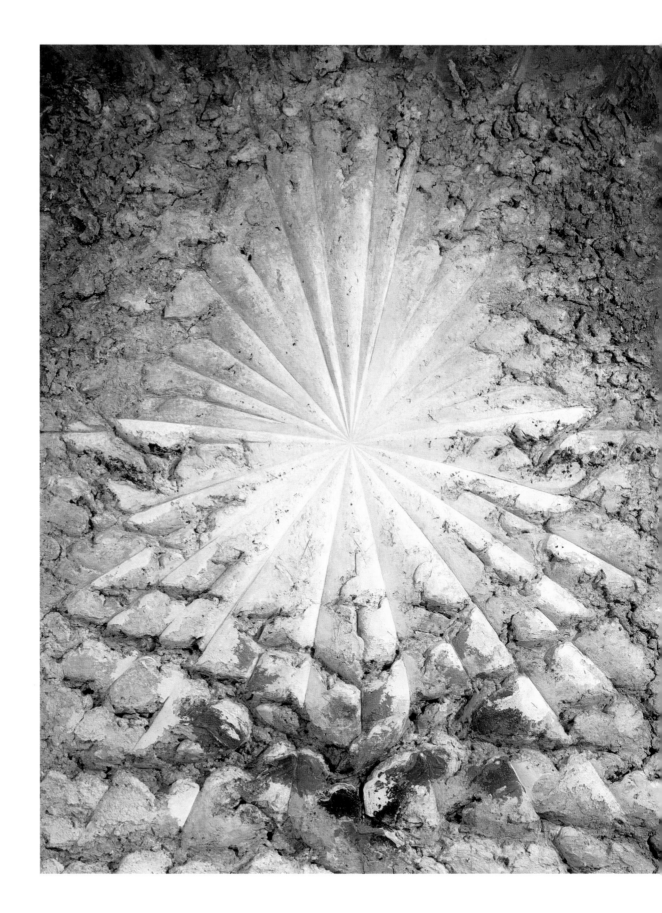

# ANDREA MANTEGNA

## CALVARY

EVERY TIME I FIND a painting by Andrea Mantegna in some museum of the world I am caught up short, impressed by the tense, tightly drawn figures and the intense colors. There are few Mantegnas that are not in the top ranks of art.

For me, his most successful work is the *Calvary*, in which a stunning perfection of execution and profound religious emotion elevate this relatively small panel painting to the highest level of creativity and spirituality. This image of the torturing and killing of Christ—originally part of Mantegna's altarpiece for the church of S. Zeno in Verona—couldn't be further away in style, organization, or artistic intent from the *Procession to Calvary* of Pieter Brueghel the Elder, but both pictures embody the same profound message. Here, the three crosses on Golgotha are depicted in an atmosphere of threatening stillness. There is a hint of God's vengeance to come in this gemlike panel as the participants in the drama act out their roles—suffering, grieving, dumbly observing or ignoring the momentous act of history, and gambling for Christ's clothing. The classical starkness, the unearthly contrasts of light (note the masterful use of light and shade on those who are blessed and those to be damned), the golden hues, and the clarity of the crag looming behind Christ and the city of Jerusalem beyond it are elements that add to the potency of this rich masterpiece.

Mantegna received his training in Padua, and early on it was perceived that he was a prodigy. At the age of ten Mantegna was apprenticed to and adopted by Francesco Squarcione, a Paduan antiquities collector and teacher of painting. In 1448, Mantegna set up his own workshop in Padua. Months after moving out on his own, he was given an astounding commission (now lost) and signed it proudly: "Andrea Mantegna from Padua, aged 17, painted this with his own hand, 1448." He flourished from this tender age until his death with a constant series of commissions, primarily in Mantua, as well as in Padua. Perhaps the apex of his career was the group of works he made during the more than forty years he spent in Mantua as court painter to Ludovico Gonzaga and his family, beginning in 1460. Above all are the imposing and witty frescoes in the so-called *Camera degli Sposi* ("Wedding Chamber") 1472–74 in the Palazzo Ducale. The Gonzaga family proved to be a powerful humanist influence on his life—especially Ludovico's

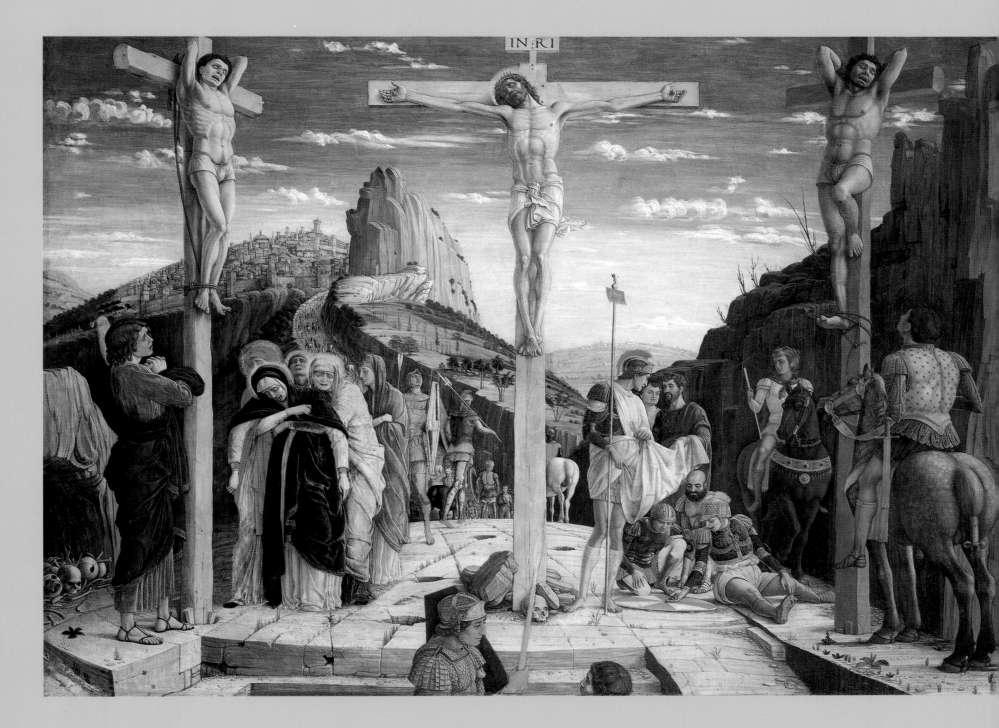

son, Francesco, and his wife, Isabella d'Este.

In many ways Mantua and Padua were better places to absorb the spirit of humanism than the super-charged atmosphere of Florence. From the time Petrarch lived in Padua in the 1360s and 70s, the city had encouraged a fascination with the classical world, and this gave birth to a paradise of enthusiastic collecting and studying of all forms of antiquities. The fervor worked its way deeply into Mantegna's works, some of which even seem to be painted anthologies of the Roman statuary that had been discovered at the time.

# ALPHABET

MASTER E.S.

ALPHABET: E AND G
Engraving on paper

Current Location: Bavarian National Museum,
Munich

WE HAVE NO IDEA who he was, this Master E.S.—the initials with which he signed many of his engravings, and one of the few clues to his identity—but he was one of the originators of line engraving in the mid-fifteenth century. Although Martin Schongauer (ca. 1445–1491) and Albrecht Dürer (1471–1528) are far more famous print-makers, this anonymous artist who may have worked in a monastery in Switzerland was less slick and far more inventive. First seen in the 1440s, his engravings continued through 1467.

Nothing in the entire panoply of print-making, in fact, is like E.S.'s entertaining, bawdy, frivolous, and splendid twenty-three minuscule letters of the Gothic alphabet, which may be one of the most invigoratingly creative works of the fifteenth century. Each letter is a wild combination of interlocked humans, animals, and the most imaginative monsters ever dreamed up. For what purpose? We don't have any idea—they were probably just for fun. They seem to have been devised to stand on their own as images, to be admired, laughed at, blushed over. Their genius resides in the wide variety of the images and their striking originality, simplicity,

uncompromising freshness, and even their crudeness. The best ones are cutting little caricatures as acidulous as the best political cartoons ever made, filled with the artist's tart observations of the foibles of mankind and the animal world.

Each one of these bizarre letters is a delight, but three should be singled out as madly successful: "X" (now in the British Museum) consists of four deliciously ugly musicians who are playing the zither, bagpipe, horn, and bells, while mugging ferociously at the onlooker. In "E" (now in the Print Room of the Bavarian National Museum, Munich [inventory no. 10889]), a proudly well-dressed old geezer who may be a tailor sits cross-legged, amusingly oblivious to the fight taking place above his head between a crow, two dogs, and a cat whose face is animated by a silly expression of outrage. The action in "G" (also in Munich [inv. no. 10900]) starts at the bottom with a monkey playing a horn, then progresses up to a dog gnawing on a bone, then to a second monkey playing quizzically with a dunce's cap, then on to a dragon perched on the arm of a monk who stands on the head of another monk, while a third monk grabs at both the second

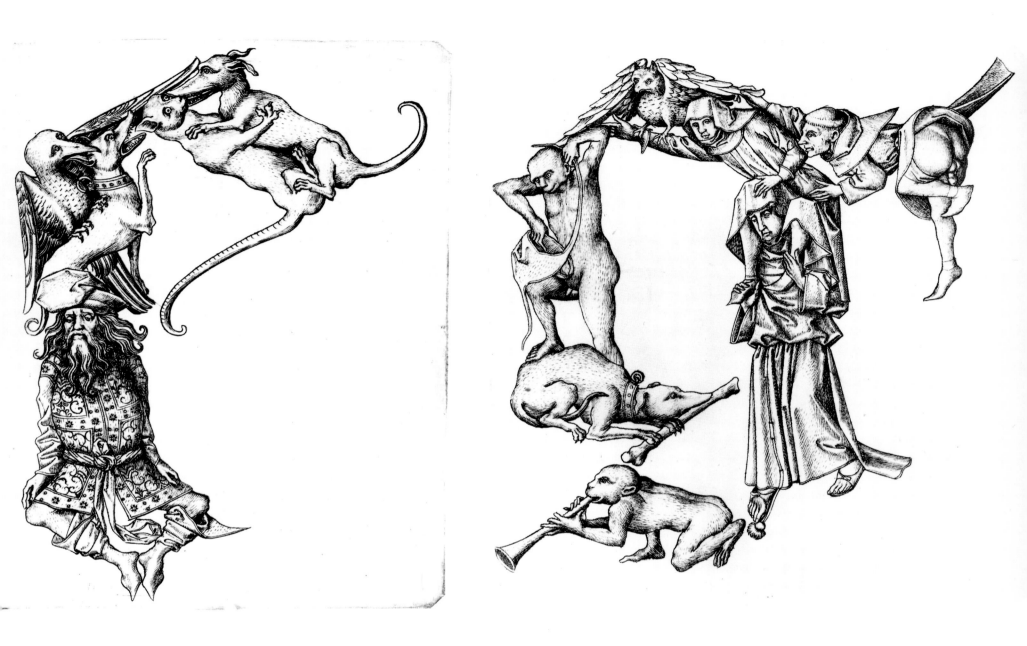

monk's garment and a feather in the wing of a crow flying off to the right with his bare behind and genitals exposed.

The Master E.S. is a so-far unidentified Late Gothic Swiss or German goldsmith and engraver whose most active years fell between 1440 and 1467. His output was enormous, consisting of more than 350 prints of religious and secular subjects. It is clear that he had a sense of humor and liked lampooning his fellow man. His innovations in the new technique of line engraving—especially the production of tonal effects using close parallel lines and cross-hatching—were a great influence on early German print-makers.

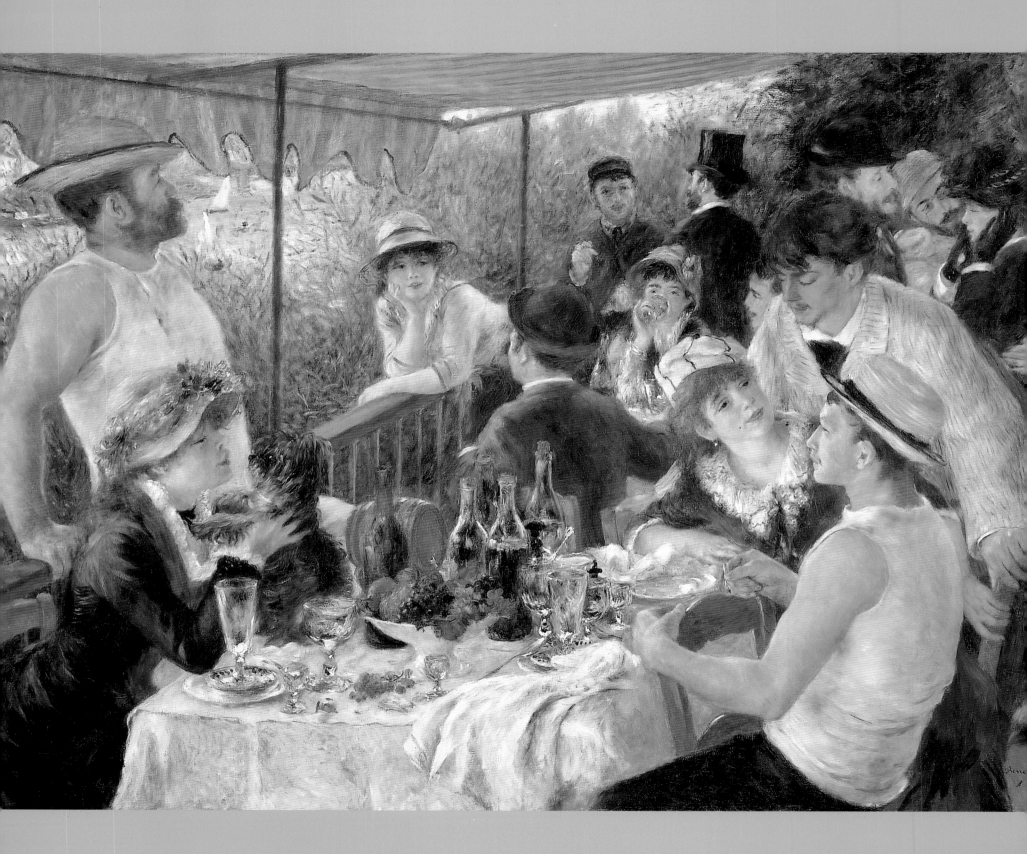

PIERRE-AUGUSTE RENOIR

# THE LUNCHEON OF THE BOATING PARTY

THIS LARGE, SUNNY, and ebullient work is displayed, appropriately, in solitary grandeur in the Phillips Collection, and when you walk through the narrow corridors of the tiny institution and confront it, Pierre-Auguste Renoir's *The Luncheon of the Boating Party* seems larger than life. Sensuous and bubbling with celebration, the work sums up every felicitous moment of that blessed, fortunate, short-lived age of placidity and divine naiveté that existed in France and particularly in Paris just before the dawn of the twentieth century and the subsequent destruction of innocence. Many an unsuspecting visitor, seeing its pure exuberance, shouts, "Wow!" The guards understand.

Renoir was one of the creators of the Impressionist style, and his bountiful, sunny landscapes have become the virtual cliché of the movement, which has been conveniently misinterpreted by its supporters and popularizers. He adored women and he used to brag in French slang, "*Je peint avec mon bitre*" ("I paint with my phallus"). Some of the over-rotund, sensuous nudes show it. Sadly, Renoir wasted his talents and, except for three or four marvelous pictures, created some of the most treacly, superficial works of the nineteenth century, many of them in the Barnes Collection in Philadelphia.

PIERRE-AUGUSTE RENOIR
b. Feb. 25, 1841, Limoges, France
d. Dec. 3, 1919, Cagnes, France

THE LUNCHEON OF THE
BOATING PARTY
1881
Oil on canvas
51 x 68 in. (130 x 173 cm)

Current Location: Phillips Collection, Washington, D.C.

# THE SARPEDON VASE

EUPHRONIOS

fl. ca. 570–465 B.C., Athens

Calyx-krater:

SLEEP AND DEATH LIFTING THE
BODY OF SARPEDON

ca. 515 B.C.

Ceramic

Height 18 in. (45.7 cm)

Current Location: Metropolitan Museum of Art,
New York

THIS RED-FIGURE calyx-krater, which is capacious enough to hold seven and a half gallons of wine, was fashioned by a great potter, Euxitheos, and painted by one of the greatest draftsmen in the history of art, the Athenian Euphronios. The shape of the bell krater is as daring as a modern cantilevered structure with its huge overhanging lip and the large, almost oversized, bell set onto a foot that seems just wide enough to support it. The bold handles harmonize perfectly with the audacious shape.

Brilliant though Euxitheos was, and well deserving to autograph his production, it is the painter Euphronios who gained the prize. There is not a pot more thrillingly decorated than this. (The dish in Munich's Classical Collection showing a Greek soldier impassively thrusting his sword into the neck of the Amazon Penthesilea is as good, but not superior.) The scene on the main stage of this sensational painted clay "theater" shows the twin brothers Hypnos and Thanatos (Sleep and Death) transporting the lifeless body of the Trojan warrior Sarpedon, son of Zeus, from the fields of battle under the supervision of Hermes, to be prepared for a hero's grave. The secondary scene shows warriors donning their armor and is perhaps

a reference to the Tyrant slayers of around 560 B.C.

When Euphronios made this astonishingly complex drawing of various figures—including the nude Sarpedon and the armored and winged twins—he could not see clearly what he was drawing, though surely he didn't need to, having memorized each stroke and overlap like a concert pianist learns each note and its pacing in the most complicated musical scores. The painter used a sort of bag ending in a metal cap with a minute hole in it—a highly sophisticated pastry bag—to deposit lines of slip on the wetted surface of the clay. Only when the vase was fired did the slip turn into lustrous black lines, with the untreated areas turning red. Euphronios made not a single error in his hundreds of lines. But the beauty and genius of this work lies not in its perfection alone, but in the poignant depiction of a fallen hero and the courage of his fellow warriors. They are unafraid of the struggle that faces them, yet they are clearly anxious, perhaps thinking "Will I die tonight?"

Euphronios is considered one of the supreme vase painters of Greek archaic times (indeed of any time), and it has to be understood that a vase painter in that period was in the top rank of artists of all media.

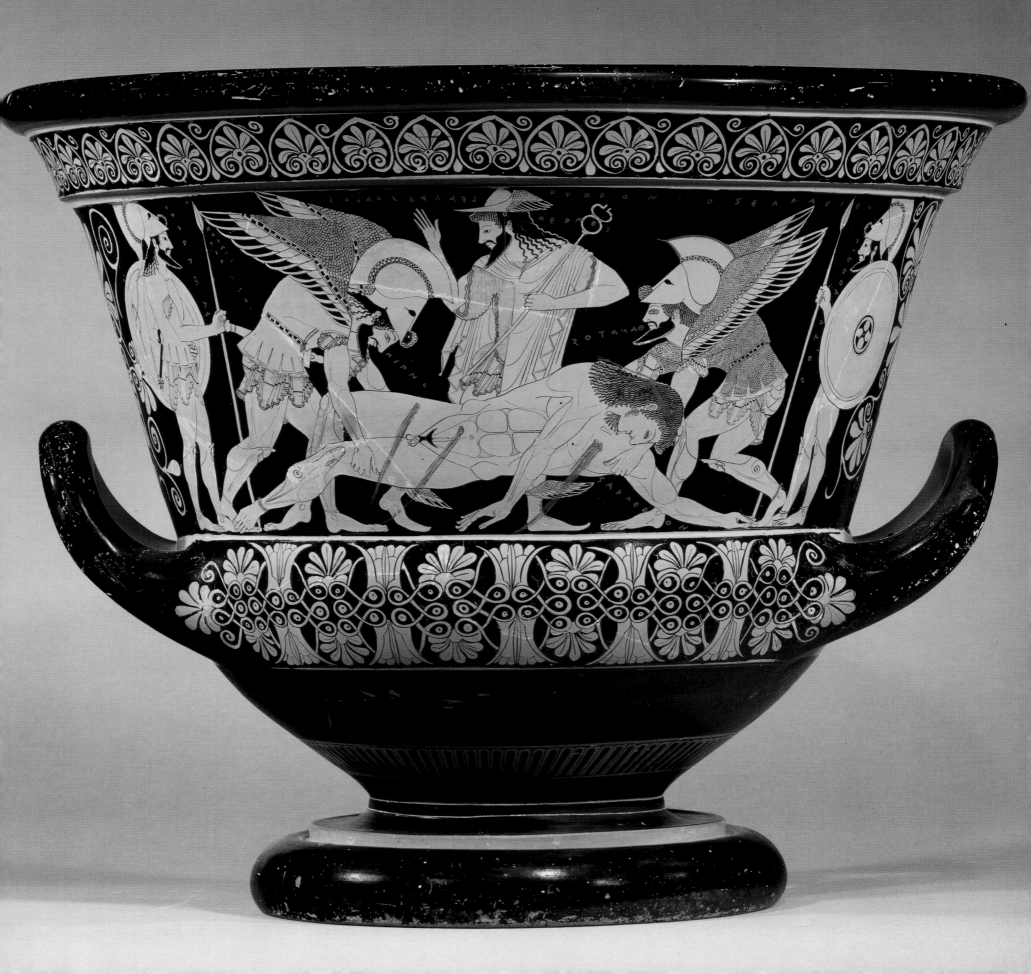

# PORTINARI ALTARPIECE

HUGO VAN DER GOES
b. ca. 1440, Flanders
d. 1482, Roode Kloster (near Brussels)

PORTINARI ALTARPIECE
(Adoration of the Shepherds)
ca. 1475–76
Tempera and oil on panel
Center 8 ft. 3½ in. x 10 ft. (2.53 x 3.01 m);
Wings each 8 ft 3½ in. x 4 ft. 7½ in.
(2.53 x 1.41 m)

Current Location: Galleria degli Uffizi, Florence

THIS MAGNIFICENT triptych by Flemish painter Hugo van der Goes (who committed suicide at 47 years of age in 1482) was commissioned by Tommaso Portinari, who was Lorenzo de' Medici's agent in Brussels and counselor to the duke of Burgundy. The work was originally installed on the high altar of the Portinari family chapel in the church of S. Egidio all'Ospendale di S. Maria Nuova in Florence. The central panel depicts the Nativity and the Adoration of Christ by the Virgin, Joseph, fifteen angels (which represent the fifteen "joys" of the Virgin), and three crouching shepherds with unidealized peasant faces. On the left wing appears Tommaso Portinari with his two handsome young sons, accompanied by Saints Antonio Abate and Thomas. On the right is Maria Baroncelli Portinari with her gorgeous daughter and Saint Margaret and Mary Magdalen. The Annunciation is depicted in grisaille on the exterior surface of the wings. The most striking feature of this work is the depiction of space. It is both infinite and intimate—a quality that only Hugo, of all northern Renaissance artists, managed to achieve. The landscape scenes in the background are entrancing; they include such details as the Three Magi and their servant asking the way to Bethlehem. The still lifes are abundant and gemlike, especially the glass of columbines and the shiny majolica vase holding irises and a lily in the immediate foreground, with the exceptional sheaf of wheat right behind it. The lily symbolizes Christ, who forces the wheat sheaves to topple, the wheat signifying the Old Testament.

The faces of the actors in this quiet drama are expressive and powerfully individual, especially those of the three shepherds, who gawk while falling to their knees as they view the miraculous image of the naked baby—each of the three an "everyman" who has been instantly converted. Thus, Christ's first disciples are shown to have come from the humble poor. Even old, wrinkled Joseph, who is usually depicted sleeping or unaware, seems gripped in a religious trance. One spectacular touch is the angel flying over the

manger and looking down at the Christ Child, with its face shining silvery-gold in an eerie reflection of light from baby Jesus's golden aura.

The members of the Portinari family—particularly the children—and the monumental saints in the wing panels are as captivating as the participants in the central scene. Mary Magdalen, with her luxurious fur-lined, gold-embroidered dress and her spectacular hairdo, is one of the most breathtaking figures in all of Western art.

The colors fashioned by the great Hugo are extraordinary. The wings of the angels in the right foreground of the central panel—blue, crimson, yellow, black, and puce—are more brilliant than any other angel wings ever painted; and the green and snow-white wings of the angels on the left make stunning contrasts.

It is not known where Hugo was born—Ghent, Antwerp, Bruges, or Leiden—for no record exists. He died in 1482, at a monastery called Roode Kloster (or Rouge Cloître) near Brussels. Not a trace of his life exists prior to 1467, the year

he was admitted to the painters' guild in Ghent.

We know that his work was considered near miraculous and that he was swamped with commissions from the city of Ghent, and that his range was vast—he created the odd ceremonial piece, such as a heraldic shield and a processional banner for the marriage of Charles the Bold and Margaret of York in Bruges in 1468. His *Adoration of the Magi* (The Monforte Altarpiece, for the monastery of Monforte de Lemos in Spain), painted between ca. 1463 and 1475, may have been his first masterpiece. Around 1478, at the height of his career, he entered a priory as a privileged lay brother. Although he painted, traveled, and received important guests, he eventually suffered a mental breakdown in 1481 and attempted suicide. His health deteriorated until he succeeded in taking his own life.

Hugo's models were the marvelous works by the van Eyck brothers and Rogier van der Weyden, and if anyone came close to equaling the majesty of the van Eycks it was Hugo. The *Portinari Altarpiece* is doubtless his finest achievement.

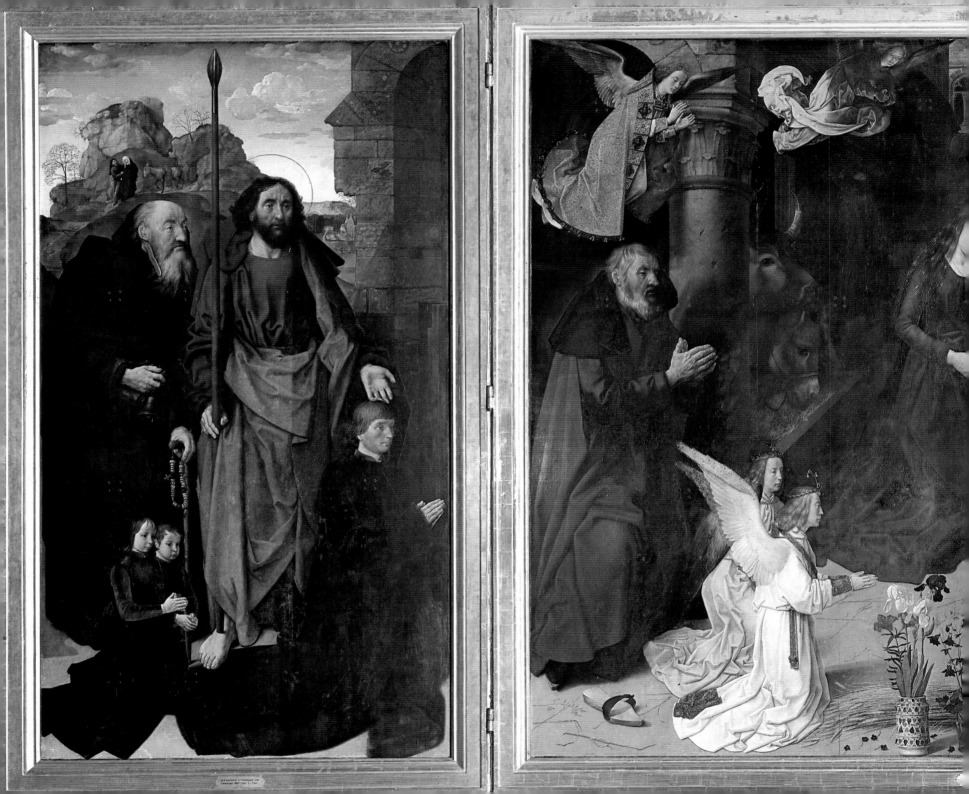

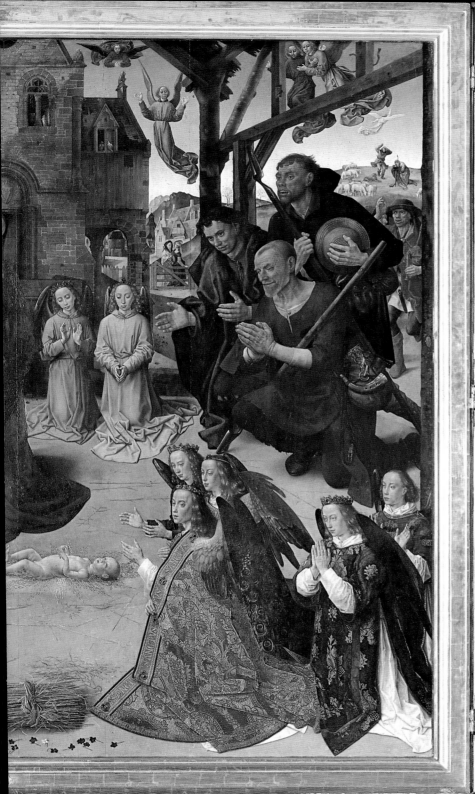

# MARRIAGE À LA MODE

IF FUNNY PAINTINGS are rarely masterpieces, the works of William Hogarth are exceptions. In the 1730s, Hogarth became a master of social satire when he began to make series of paintings showing connected scenes on what he called "modern moral subjects," several of which are both entertaining and great. The series I have singled out as the best is *Marriage à la Mode*, which consists of seven brilliant, splendidly cruel episodes in a common tale of an arranged marriage between a dissolute, poverty-stricken young lord—heir to the title "Count Squanderfield"—and the daughter of a wealthy merchant. The series is chock-full of debauchery and excess that lead eventually to murder and suicide—and what fun Hogarth has along the way, with pretension and hypocrisy as his targets.

The seven acts in this "morality play" are: the marriage contract; the first rabid signs of dissolution, with the count just home from an all-nighter and the countess closing down an all-night card game; the major-domo bemoaning their mounting debts; a pompous salon, with the countess and her current lover surrounded by all sorts of artistic phonies and hangers-on; the countess caught by the count in an assignation at a hotel with her

WILLIAM HOGARTH
b. Nov. 10, 1697, London
d. Oct. 26, 1764, London

MARRIAGE À LA MODE
(*Early in the Morning*)
ca. 1743
Oil on canvas

Current Location: National Gallery, London

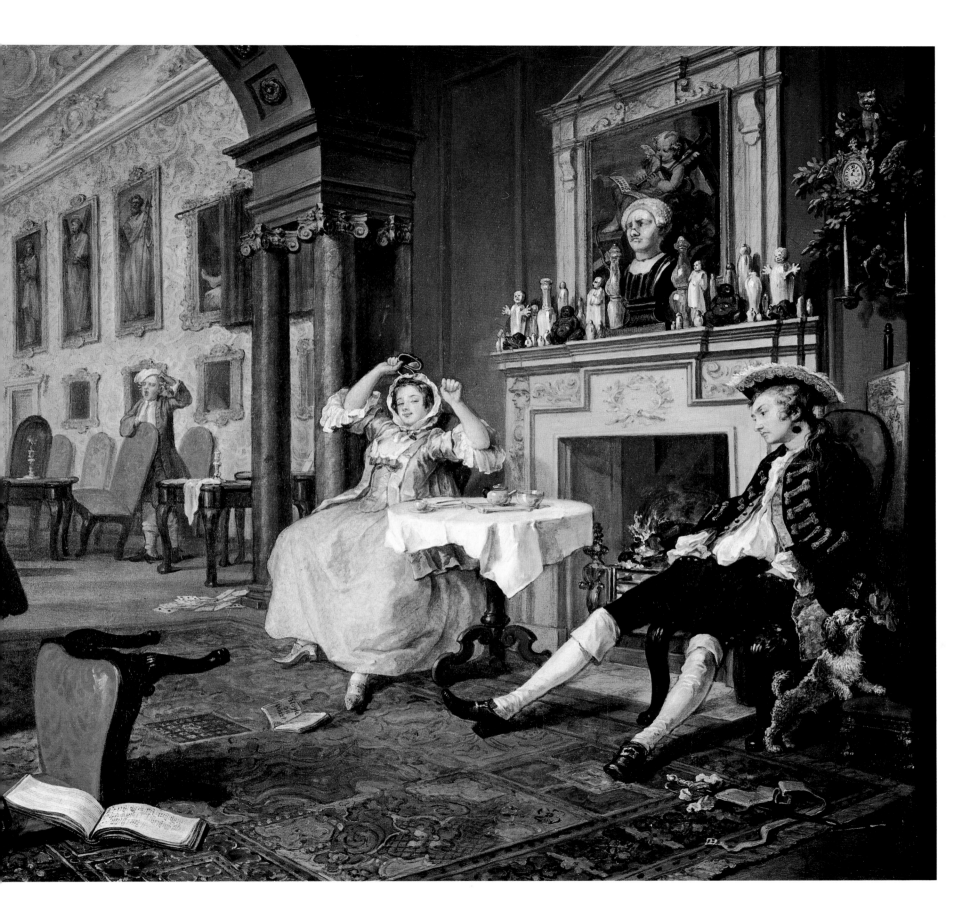

lover; the count slain; and, finally, the suicide of the destitute countess. The figures are classic, crisp, and very believable as real types, just like people we've all known or read about. Hogarth provides us with a most entertaining view of human pompousness and stupidity, served up with guile and a certain majesty. The true genius of this sparkling series rests in the observant details, such as the gestures, the placement of the hands, the facial expressions (especially the faces of the sycophants, which form a gallery of the various masks of hypocrisy), and the acidulous touches of the characters' surroundings. Don't miss the ugly "ancient" Roman bust with the badly restored nose, or the tacky fat Chinese statuettes on the mantelpiece—the kind whose stomachs are supposed to be rubbed for good luck. In the salon scene, a reproduction of Correggio's sexy *Jupiter and Io* hangs on the wall (see page 196), and a small mountain of obviously fake antiquities, just pur

chased, lies on the floor. Especially satisfying about this series is that, despite the fact that these scenes are not cinematographic (and one can cheat by looking ahead in the gallery), there's no loss of surprise or shock at the rapidly deteriorating situation.

Hogarth was one of the most original and perspicacious artists in history and was largely self-taught, after having started off as a silver engraver. Hogarth's father, a schoolteacher and a classicist, received nothing but insults from potential patrons, and this no doubt honed his son's sometimes harsh point of view of his fellow man. Despite his acid parodies of the life and times of outrageous London, Hogarth was gregarious and a witty connoisseur of mankind. He adored the theater and the raucous street life of the city and its many bawdy houses and taverns. He was also a keen intellectual. Hogarth was suspicious of the nobility and preferred the middle class, although he could be unrelentingly cutting about their

foibles as well. He set up his own painting operation at the age of twenty-three and had an initial modest success. He was a gifted imitator who could quickly get any kind of complicated scene down on his sketch pad after he'd seen something that intrigued him—as he put it, "retaining in my mind's eye without drawing on the spot whatever I wanted to imitate."

Hogarth made a habit of attacking the fashionable contemporary taste, which beginning in the 1720s was dominated for several decades by the neoclassical style much favored by the all-powerful art patron the earl of Burlington. Hogarth deliberately decided to joust with Burlington, mostly because the patron he'd set his eye upon, Thornhill, was also on Burlington's "enemies list." Thus he started off his career with a powerful enemy who struck back around 1730 by blackening his reputation in royal circles. Hogarth seems to have been surprised by and deeply resentful about what he should have

known would be the outcome. But soon it developed that Hogarth didn't need royal beneficence, for he began to produce sets of engravings based on the various series of satirical paintings he had been making during the 1730s. Once his vigorous engravings gained the appreciation of the wide public he had been seeking, their great success gave him financial security and creative independence. In 1745 he published his prints of *Marriage à la Mode*.

He was appointed "sergeant painter" to George III in 1757, and that ignited a renewed interest in his portraits, which have an electric energy. His last years were grim—his health began to fail, and he slipped into a state of perpetual anger and frustration over a patron's rejection of one of his paintings.

Hogarth was one-of-a-kind, and his works have a uniquely authentic taste and feel about them. They will probably last longer and loom increasingly larger than the productions of his gifted contemporaries.

# PAREMENT OF NARBONNE

ARTIST UNKNOWN
French, late 14th century

PAREMENT OF NARBONNE
ca. 1375
Grisaille on silk
30¼ x 111½ in. (77.5 x 286 cm)

Current Location: Musée du Louvre, Paris

SURPRISINGLY, ONE of the great drawings of all time is not a sketch on paper by an Old Master but a grisaille-painted altar-hanging called the *Parement of Narbonne* (although there is no connection with that French town). Done in black pigment on fine white silk, it is in flawless condition, no doubt because it was shown only during a few days in Lent each year, the monochrome of the grisaille being fully appropriate for the ascetic season. The altar-hanging was commissioned by French king Charles V around 1375 (the letter K for Karolus, thus Charles, appearing repeatedly on the borders in his device). The artist's name is unknown, but he may have been a manuscript illuminator in the brilliant circle of masters who worked for the Burgundian court and produced many incomparable pieces.

This remarkable work, with its elegant, ethereal figures shown engaged in the highest Christian religious drama with exceptional intensity, is a Western equivalent of an imperial Chinese scroll. The scenes and figures depicted are (from left to right) the Agony in the Garden, the Flagellation, and Christ Carrying the Cross; personifications of the Church and Synagogue (above) and King Charles kneeling (below); the Crucifixion; the Church and Synagogue again (above) and Charles's wife Jeanne de Bourbon kneeling (below); the Lamentation, the Harrowing of Hell, and, finally, the *Noli Me Tangere*.

The refreshing feature is that none of the figures are the usual brusque, take-it-for-granted characters that one all too frequently finds in

medieval art but—within the parameters of the Gothic style—resemble real human beings. In the Lamentation, for example, those who mourn are far from stock religious types, but are passionately grieving souls. There are many artistic innovations, such as the soldier seen from the back in the Flagellation and in Christ Carrying the Cross, and the outspread arms of the mourning Virgin, her fingers wide open, in the Lamentation.

This is an awe-inspiring work of monumental authority and great peace. Imagine the beauty of the Lenten scene in, say, the stained-glass windows of Sainte-Chapelle, where the brilliant colors of the glass contrast with the breathtaking shades of gray on silk, including all the vestments and miters of the priests—also done in grisailles.

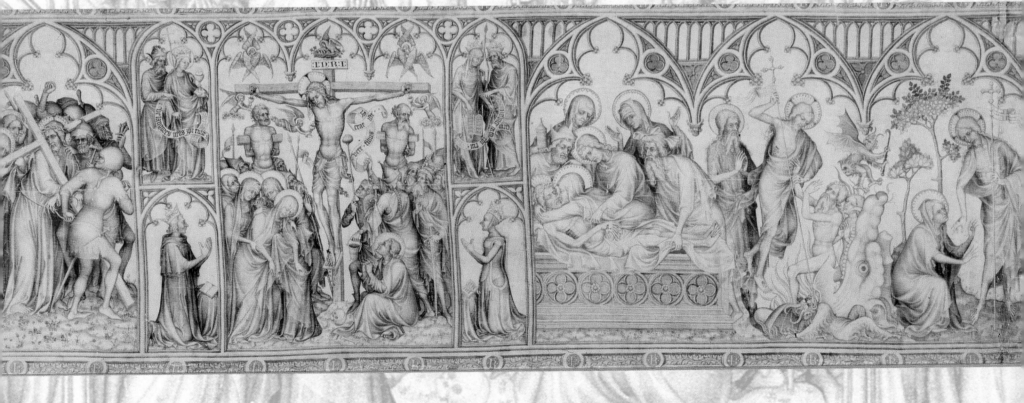

# THE LION HUNT

IN JUST ONE decade in the mid-Victorian period, Assyrian civilization and art emerged from eons of obscurity. Cuneiform script was deciphered around 1850, making tens of thousands of writings legible. The great palaces at Nimrud, Nineveh, and Khorsabad were discovered—by the English adventurer Austen Henry Layard and the French archaeologist Victor Place—and dozens of sublime sculptures, including colossi representing lions and bulls, were sent back to the Louvre and the British Museum. Others—nearly 75—eventually made their way to the United States.

The low reliefs and their accompanying inscriptions constitute a single-minded propaganda. The reliefs show the indomitable rulers hunting or in stately processions and were intended to decorate the throne rooms and assembly halls of the royal palaces. Over and over, they lauded the ruler's accomplishments and enumerated the vast number of vassals who paid tribute to him.

Hunting scenes are ubiquitous, but lion hunts are special because the lion was considered to be the noblest, the fiercest of creatures and was the symbol of the king himself. Of all hunting scenes—there must be a couple of dozen, both large-scale and fragmentary—one stands out not only as one of the most beautifully carved pieces on earth, with its intricate anatomical details rendered to perfection, but as gripping drama. I'd even say that the relief I've chosen is the single most powerful depiction of a hunt for wild beasts that survives. The piece, today in the British Museum, was made for the throne room in the palace at Nineveh for King Assurbanipal, who reigned from 668 to 627 B.C. We know from inscriptions that this particular ruler was a great patron of the arts; he restored the palaces at Nineveh and adorned them with countless scenes of the lofty ceremonial and historical events of his long reign. The style of the sculptures shows a marked development over those of his predecessors (which are splendid on their own) and many of Assurbanipal's reliefs possess an epic quality unparalleled in the ancient world. This was due, no doubt, to the direct influence of the king, who could be counted on to have chosen only the most talented sculptors. The array of Assurbanipal's Nineveh stones, in their own way, rivals the sculptures of the Parthenon.

To me the finest relief—a fragment—shows a number of lions having been slaughtered or expiring,

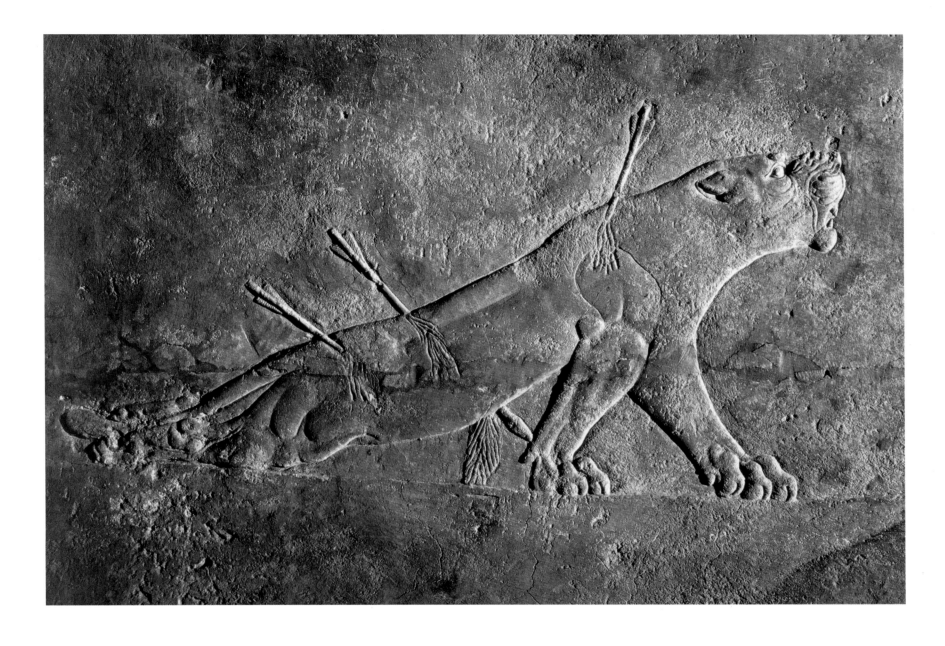

some in such great pain that one almost is forced to look away. Yet at the same time these gorgeous creatures are depicted as almost beloved by the Assyrian sculptor, who has created an exceptionally moving tableau. There are few monuments that so vividly epitomize their times as this one—a time when the hunt was still a religious experience and when a ruler of men, by crushing the king of beasts, was thought to obtain supernatural powers over fellow rulers.

The whole idea of the slaughter of such a number of regal creatures is today abominable, yet we can nonetheless recognize the glory of the art in these reliefs, especially in the one, shown here, in which the crippled lioness, her back legs paralyzed, is still fighting on, maintaining surpassing dignity in her final agony.

# THE SWIMMING POOL

HENRI MATISSE
b. Dec. 31, 1869, Le Cateau-Cambrésis, France
d. Nov. 3, 1954, Nice

THE SWIMMING POOL
1952
Nine-panel mural in two parts: gouache and
paper, cut and pasted, on white painted paper
mounted on burlap
a-e, 7 ft. 6⅝ in. x 27 ft. 9½ in. (230.1 x 847.8 cm);
f-i, 7 ft. 6⅝ in. x 26 ft. 1½ in. (230.1 x 796.1 cm)

Current Location: Museum of Modern Art, New York

HOW RARE IT IS that even the most gifted artists get better with age, and in their eighties create new forms that surpass all of their other creations. I think only one artist has managed this, French painter Henri Matisse, with his cheery and profound paper cut-outs of the 1950s. He gave up painting during the last six years of his life and concentrated on cut-paper works because his fingers were stiff with arthritis. Matisse had long used paper cut-outs as mechanical aids in his compositions. But the paper pieces became his most dynamic works.

The most impressive and monumental of these is the enormous nine-panel mural *The Swimming Pool*. The languid and soothing composition, formed of images cut from paper painted with blue gouache and pasted on white paper (the colors transcend in their brightness and punch what conventional painted images could possibly deliver) and mounted on burlap, shows a host of free-form swimmers in an ensemble that looks like the creation of life from the volcanic waters. Created in a spare and crisp style—Matisse sought to attain forms boiled down to the essentials—the swimmers are also fascinating abstract images. They splash, loll, stretch, and cavort in varying attitudes of pure amusement. There is no more happy or

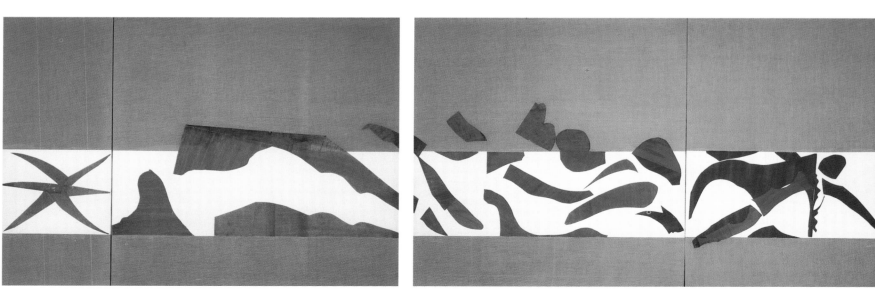

celebratory work of art from the twentieth century.

Matisse started drawing and painting relatively late in life, at the age of twenty, in 1890. In 1891 he dedicated himself to becoming an artist, studying first with the conservative academician Adolphe-William Bouguereau and then with the Symbolist Gustave Moreau. He broke from tradition in 1903 by exhibiting at the somewhat radical Salon d'Automne, begun as a showplace for those opposed to the banality of the official Salon. Two years later, a critic branded the artists who showed there *"les fauves"* ("the wild beasts") and thus Fauvism came into being with Matisse as its leader.

Fauvism was too undisciplined for Matisse to follow it for long—and he despised being in any group. His rational side led him to simplification and a purity of form that manifested itself into such lushly colored, semi-abstract works as *Joy of Life* of 1908 and *The Red Studio* of 1915. He began to winter on the Riviera and his works become more placid and more profound.

In 1951 he completed the stained-glass windows and murals, vestments, and liturgical objects for the Chapelle du Rosaire, at Vence. Before this prodigious work was finished he began making his huge hand-colored paper cutouts.

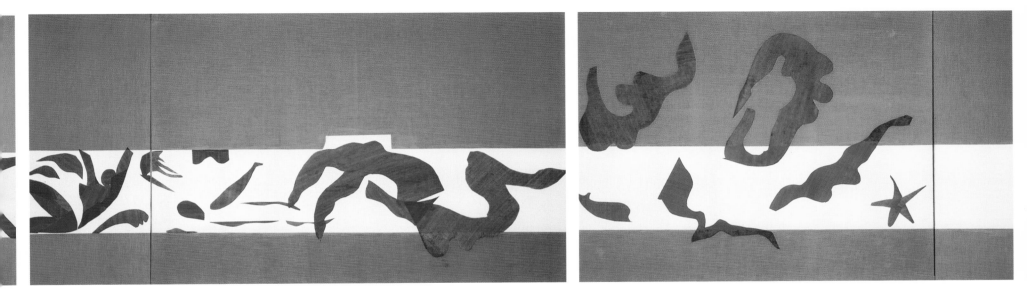

# THE GATES OF PARADISE

LORENZO GHIBERTI
b. 1381, Florence
d. Dec. 1, 1455, Florence

THE GATES OF PARADISE
(East Doors)
1425–37 (installed 1452)
Gilded bronze
15 ft. (4.57 m)

Current Location: Baptistery, Florence

MY IDEA OF ARTISTIC paradise is to be stuck for eternity in a chamber somewhere in Heaven with the originals of Jan van Eyck's *Ghent Altarpiece* (see page 208), Diego Velázquez's *Las Meniñas* (see page 226), Michelangelo's *David* (see page 52), Leonardo's *Woman with an Ermine* (see page 267), the *Bury St. Edmunds cross* (see page 87), Matthias Grünewald's *Isenheim Altarpiece* (see page 215), and Lorenzo Ghiberti's East Doors for the Baptistery in Florence—especially Ghiberti's second doors. Michelangelo dubbed them "The Gates of Paradise" and was so enthralled with them that I'm convinced he loosely patterned the Sistine Ceiling after their Old Testament subject matter and borrowed freely from their classical majesty. Auguste Rodin also used them as inspiration for his *Gates of Hell* (see page 265).

Begun after Ghiberti received the commission for them in 1425 and installed in 1452, these gilded bronze doors are the finest ever made and have an emotional and aesthetic punch that cannot be experienced with any other work. They consist of ten square panels surrounded by a narrow frieze, each panel showing the events of an episode from the Pentateuch—the first five books of the Old Testament—arranged to form a single consistent composition, stretching from foreground to distant space. The figures are like living, breathing jewels and are graceful, agile, and vigorous to a degree seldom achieved anywhere else. The illusion of depth is heightened by Ghiberti's use of high sculptural relief for the foreground figures and of increasingly lower relief for background figures, architectural space, and landscape elements—a convention that he played a significant role in creating and of which he was justly proud. The resulting panels are the most beautifully composed and crafted Old Testament images ever created.

Ghiberti was trained as a goldsmith and he seems to have been a child prodigy. Early in his career he traveled to Pesaro to work with a painter creating works for the ruler Sigismondo Malatesta. But he hurried back to Florence when he learned of the competition for a grand pair of bronze and gilded doors for the Baptistery. Ghiberti won the competition; his test subject was a bronze panel of quatrefoil shape representing, in a very clever manner, the Sacrifice of Isaac in which the nude body

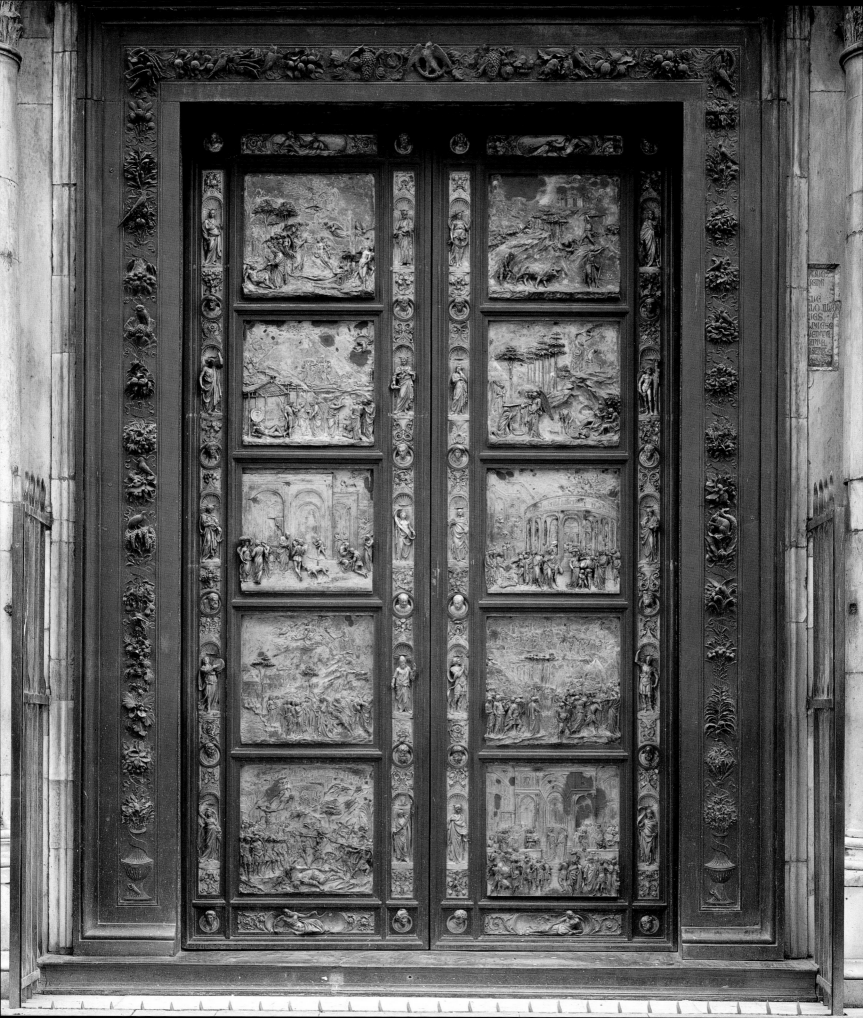

of Isaac is twisted back by his father—just before the Angel of the Lord relieves him of his knife—in a way that is strongly classical in feeling.

The contract for this first set of doors was signed in early 1400 and Ghiberti worked on the panels until 1424. But he didn't shrink from doing other work, for he was in great demand. One of his pieces of note is the bronze image of St. John (1416) for the guild of the merchant bankers to decorate its marvelous office building, Or San Michele. The sculpture was so popular that Ghiberti received two other commissions from wealthy guilds. In the early fifteenth century, Florence was well populated with exceptional artists whom Ghiberti knew and against whom he competed for patrons and commissions. These were the likes of Donatello and Nanni di Banco. Yet Ghiberti more than held his own and perfected his lyrical style of elegance and grace—what is generally called the International Style—marked by sweet faces and flowing trumpet folds that seem to caress and protect the figures clothed in them.

Throughout the 1420s Ghiberti completed most of the modelling and casting of the panels for the first doors. He slowly developed a large workshop-factory and, because of his shrewd business capabilities, became a very wealthy man.

When he was 45 years old he finished the first doors—the effort of more than 20 years of work and one of the major monuments of the International Style. The commission for the second doors followed almost at once. Ghiberti was aided to a significant extent by the young Leon Battista Alberti, a humanist scholar who was busy composing theoretical treatises on the visual arts. Together they experimented with fresh ways of forming pictorial space and invented figures that moved naturally, as if blessed with the gift of real life. Ghiberti's new and dynamic ideas became the essence of the divine second doors, in which there's a matchless combination of the grace of the International Style, a firm knowledge of perspective, and a classical handling of the figures. Lorenzo Ghiberti was one of the giants of the Renaissance who truly combined nature and the antique to create something new, lively, graceful, and everlastingly beautiful.

# MADONNA ENTHRONED

BY THE TIME Giorgione died, before the age of thirty-five, he had revolutionized painting in the early sixteenth century through his new conception of landscape, investing it with a sense of idyllic beauty and poetic atmosphere that dominates the other elements of a picture. This innovation and his practice of giving his images of people a stylish softness, an aura of elegantly detached humanism, were continued and expanded upon by his followers and pupils, including the great Titian (see page 114). Giorgione's achievements as a painter are clear, even though the number of his creations was rather small and, of those paintings attributed to him that remain, only one is signed and dated, while there is consensus about just a few of the rest.

Of those that are undisputed, the most awe-inspiring is the *Madonna Enthroned Between St. Liberalis and St. Francis*, the altarpiece in the chapel dedicated to St. George in the Cathedral of Castelfranco Veneto, some thirty miles northwest of Venice. The painting is thought to have been commissioned by a grieving father to commemorate the death in battle of his handsome, intelligent young son, Matteo Costanzo, in 1504 at the age of

twenty-three. It is one of the most poignant monuments and profound expressions of sadness that has ever been created. Dominating the upper part of the painting are the Virgin and Child seated on a lofty throne of simple marble blocks, behind which is a delicate, early summer landscape. In the foreground below Mary's throne stand two majestic figures: on the left, Saint Liberalis (patron of the Cathedral of Castelfranco), in gleaming armor, and on the right, St. Francis of Assisi. Two tiny figures of soldiers can be seen in the landscape behind St. Francis, one on his knees in honor of the other, who may be Matteo.

What is so especially moving about this great work—which was mentioned as Giorgione's for the first time only in 1635—are the downcast eyes and sad expressions on the faces of the Virgin and the saints, all of whom seem to be looking down (St. Francis is pointing) at Matteo's tomb effigy below the altarpiece. Even the Christ child is depicted as grieving. Because of the muted colors and the somber character of the composition, one might even say that the entire work is weeping for the warrior struck down at so young an age.

One of the difficulties of determining Gior-

GIORGIONE
(Giorgio Barbarelli)
b. ca. 1475–77, Castelfranco Veneto, Italy
d. 1510, Venice

MADONNA ENTHRONED BETWEEN ST. FRANCIS AND ST. LIBERALIS
ca. 1504
Oil on panel
78¾ x 60 in. (200 x 152.4 cm)

Current Location: Duomo, Castelfranco Veneto

gione's true oeuvre is that there are almost no early records concerning his career or describing his works. Giorgione, also known as Giorgio Zorzi (in Venetian dialect, "from Castelfranco"), appears to have left Castelfranco for Venice at an early age, and is believed to have studied there with Giovanni Bellini in the 1490s — a conclusion based on stylistic comparisons and statements by such sixteenth-century commentators as Giorgio Vasari. Vasari also tells us that the name Giorgione means "tall George," or "big George," implying that he was a large man, and that he was a handsome, amorous man of humble origins, with a lofty mind and intense personal charm, but these may have been unfounded characterizations. Giorgione's sole signed painting, *Laura* (now in the Kunsthistorische Museum, Vienna), bears the date June 1, 1506 on the reverse; there are records of payment from 1507–08 for paintings commissioned from him (destroyed later that century) for an audience chamber in the Doge's Palace, and documents showing that around 1506–08 he and his pupil Titian painted frescoes on the facade of the Fondaco dei Tedeschi (now the post office), only fragments of which remain. The problem of proper attribution is further complicated by the fact that certain paintings left unfinished by him at his death were finished by his pupils, such as *Sleeping Venus* (completed by Titian) and *Three Philosophers* (completed by Sebastiano del Piombo); others are thought to have been, such as *Fête Champêtre*. A Venetian connoisseur named Marcantonio Michiel, in the notes that he compiled between 1520 and 1543 on the art collections of Venice, mentioned a dozen paintings by Giorgione, five of which seem to have survived, including *The Tempest* and *Three Philosophers*.

Giorgione's works hold a special attraction because they invariably possess a compelling magic and a sense of mystery. This is particularly evident in his most popular painting, *The Tempest* of around 1505 (in the Accademia, Venice), which is a poetic and enigmatic landscape featuring a nude woman nursing a baby, with a shepherd standing nearby and a lightning storm in the distance. What it means, no one seems to be sure.

Although the altarpiece at Castelfranco is the most celebrated of his religious works, few people go there to see it, because the town is a bit out of the way. It's worth the effort.

# RAHOTEP AND HIS WIFE NOFRET

ARTIST UNKNOWN
Egyptian, 3rd millennium B.C.

RAHOTEP AND HIS WIFE NOFRET
ca. 2610 B.C.
Painted limestone
Height 47¼ in. (120 cm)

Current Location: Egyptian Museum, Cairo

ANCIENT EGYPTIAN art is distinct in history because of its captivating mixture of the unreal and the exceedingly real. The best of it possesses an odd and as far as I know unique mixture of the obvious and the hidden, the poetic and evocative, with a striking pseudo-naturalism (pseudo because the parts are not like nature in the slightest) attaining a mysterious balance through the deft juxtaposition of abstract elements.

Surely amongst the most beautiful and memorable works from the earliest period of Egyptian art, the so-called Old Kingdom dating to the 3rd millennium B.C., and a perfect example of this mixture, is a life-size sculpture in painted and inlaid limestone depicting the exceptionally handsome young man, Rahotep, and his gorgeous wife, Nofret. He was the son of a pharaoh, a general, and the high priest of Heliopolis, where the sun cult was worshipped, all at the same time. His beauty—and hers—makes him deserve to be all those important things. Nofret is depicted provocatively with her nipples nudging through her snow-white garb. The hieroglyphics that tell us their identities, carved into the attractively soft stone, are stark black against the bone-white ground.

What is so appealing about the pair, frozen for all eternity as if they were just about to utter the most refined and amusing things, is their optimism and enthusiasm. They are in love with each other and their world and in love with eternity as well. The condition of the delicate sculpture is almost perfect. The eons have not taken anything away from the freshness of the painted stone. Rahotep is colored darker than his spouse, an ancient Egyptian convention that in this case adds to the effect of naturalism. The carving is almost studiously generalized, yet the details of anatomy are intricate.

One story holds that Giuseppe Verdi got the idea for the tragic climax of *Aïda* because he was in Cairo at the moment when this sculpture was spotted deep inside a mastaba tomb near Meidum. The composer was having dinner with an official when the foreman rushed in to say that the workers had all fled the site when their torches revealed a man and a young woman sitting placidly in the tomb, still alive!

Verdi and the official quickly went to the location and there marveled at the statues of Rahotep and Nofret, their exquisite quartzite eyes seeming to glow with life from the flames of the torches.

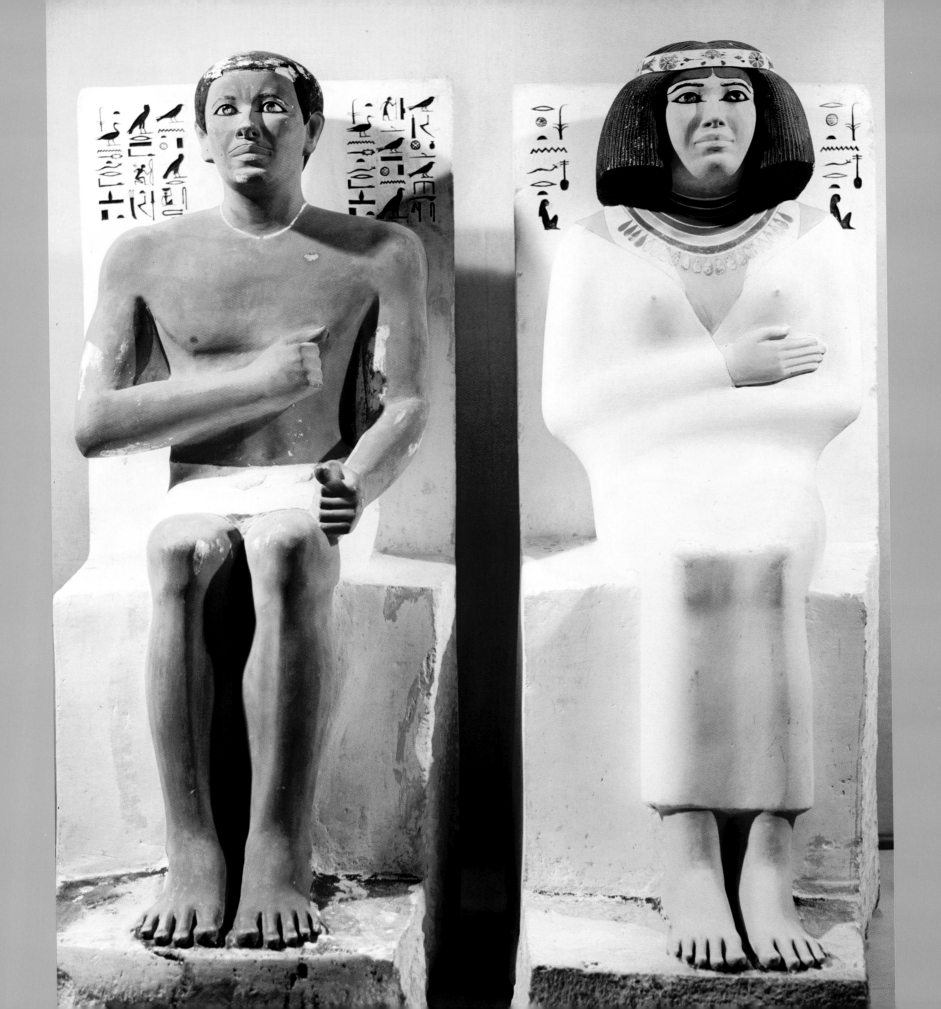

# MICHELANG

## DAVID

**MICHELANGELO BUONARROTI**
b. Mar. 6, 1475, Caprese (near Arezzo), Italy
d. Feb. 18, 1564, Rome

DAVID
1501–04
Marble
Height: 13 ft. 5 in. (4.09 m)

Current Location: Galleria dell'Accademia, Florence

EVERY ASPECT OF Michelangelo's sculpture *David* is stupendous—the concept, the execution, the courage in taking an enormous, flawed block of marble, attacking it directly, and winning over its weaknesses, the godlike anatomy of David's body, the turn of his head, the anxiety in his eyes and across his brow, his casual stance disguising his fear, the crispness of the eyes, the head's impressive mass of curls. It sums up the perfect ideal of both humankind and the divine spirituality of the all-powerful creator and is fairly bursting with what contemporaries described as a *terribilità*, the awesomeness of an over-powering nude figure that only Michelangelo could create. There is not a single imperfection in the entire majestic work.

Michelangelo made this colossal sculpture from a block of marble that had been waiting for a sculptor willing to use it, despite a visible and dangerous flaw, since Agostino di Duccio had abandoned it almost forty years earlier. The *David* was commissioned in 1501 for a pedestal on a buttress of Florence Cathedral high above the ground, but when it was completed in 1504 it was placed in a more prominent position in front of the Palazzo Vecchio as a symbol of the Florentine Republic. (To protect it

from vandalism and exposure to the elements, it was replaced by a copy in the nineteenth century, with the original going to its present location.)

Michelangelo Buonarroti was born in a tiny village east of Florence, but his father brought the family back to Florence before the boy was a year old. In 1488, at the age of thirteen, Michelangelo entered the bustling workshop of the superb painter Domenico Ghirlandaio. Despite his three-year contract there, he left within a year—probably because a better opportunity presented itself.

He had been spotted by the great art patron, banker, scholar, and administrator Lorenzo de' Medici ("the Magnificent"), and became a member of his inner circle of artists and humanist intellectuals. Suddenly, young Michelangelo was surrounded by the works of the Medici collection (which included a rich treasure of classical antiquities), and was working and studying in the Medici art school under the sculptor Bertoldo di Giovanni.

Michelangelo moved to Rome in 1496, where he stayed for five years. There, word spread about the astounding talents of the young sculptor. His first work in Rome was the startling life-size nude *Bacchus*, 1496–97, which is superficially classical

in appearance but which possesses a feral energy (that *terribilità*) that no antique sculptor could possibly have imagined. The success of this work led to the commission in 1498 for the Pietà for St. Peter's, which established Michelangelo's reputation as the foremost living sculptor—a reputation that soared after he completed his magnificent *David* in Florence.

In 1505, Pope Julius II called Michelangelo back to Rome to begin the designs for a grandiose tomb for him, and again in 1508 to paint frescoes on the ceiling and upper walls of the Sistine Chapel. Michelangelo finished his first series of frescoes in 1512, with nine scenes from Genesis as his chief subject, including the famous *Creation of Adam*.

In his fully mature years, Michelangelo applied himself more to architecture and produced two of the greatest architectural projects in human history—the redesign of the Capitoline Hill plaza, 1538–64, and the basilica and majestic dome of St. Peter's, 1546–64. There are only two sculptures from his last years, both of them *Pietàs* that he made for himself, both of which remain unfinished. He was working on the second late Pietà, 1554–64, a few days before he died.

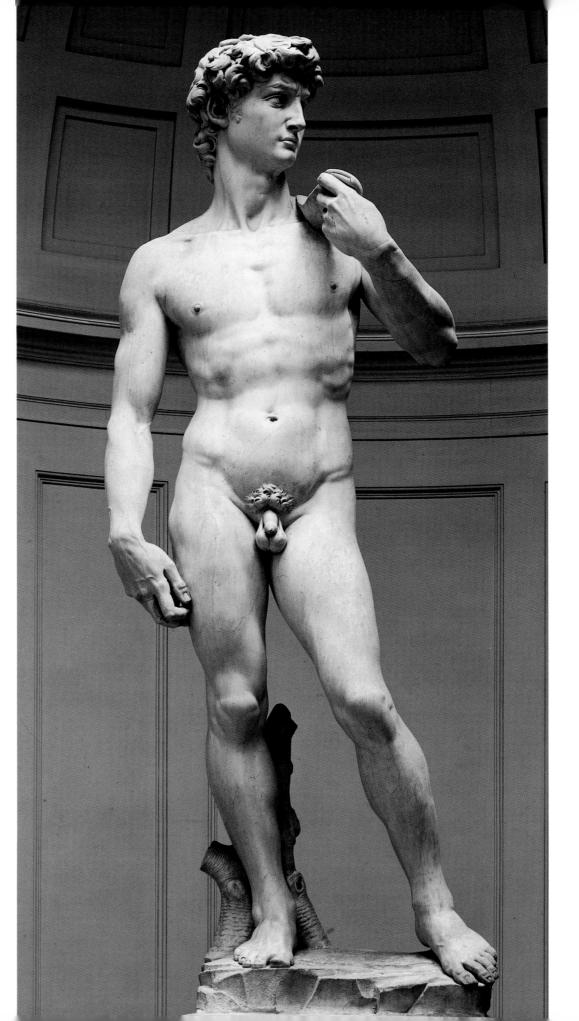

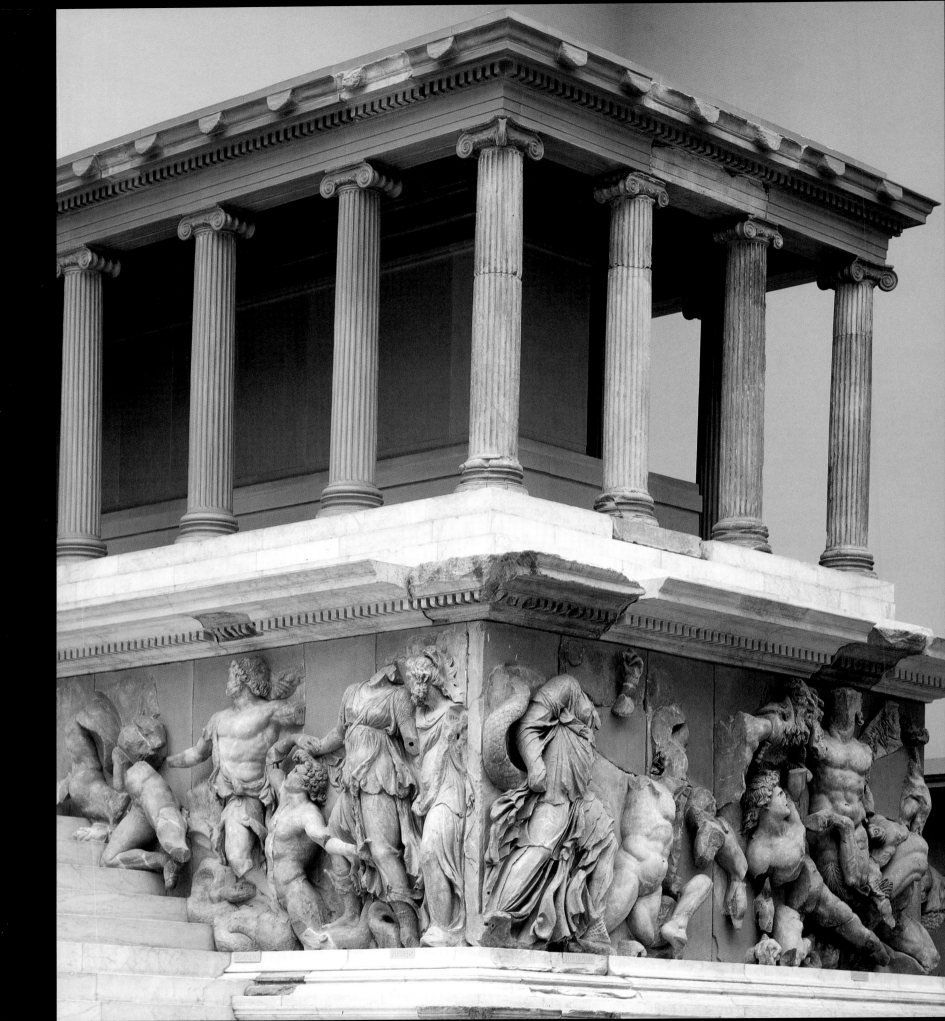

# ALTAR OF PERGAMON

ONE OF THE most exemplary monuments the Greeks ever made is the massive altar of Pergamon (in what is now Turkey) dating from the second century B.C. Today the altar has been partially reconstructed in an immense gallery in the Berlin State Museum. German archaeologists took the great stones back with them from an excavation in the nineteenth century.

Originally, the altar stood on a high promontory above the ancient city of Pergamon. It was a huge and imposing architectural pile with a lofty pedestal, grandiose stairs, and an elevated porch for the sanctuary, embellished by a colonnade of slender Ionic columns running all the way around the altar. On the walls of the pedestal was an enormous carved frieze depicting dozens of participants in the mighty struggle between the gods and a race of giants for the possession of the universe. All the gods and goddesses and their allies—nymphs, heroes, anybody associated with Olympus and who enjoyed a bit of carnage—came out, fought viciously, and won.

The protagonists are carved in marble in the most energetic way, with anatomy that is sublime. These noble figures are shown bursting with strength, their bodies contorted with supreme effort in the most violent battles for life or death imaginable. The faces are emotional, and are among the most powerful works of art of Greek civilization. Of the numerous spectacular vignettes one of the best is to be found on the east side of the frieze and represents Athena attacking the giant Alkyoneos, while Nike (goddess of Victory) flies in from the side to crown her, and Ge (Gaea, or Earth, mother of the giants) begs for her son to be spared. This is the well-known relief in which the fierce, naked giant is depicted with his head thrown back in agony, his magnificent muscles straining in the moment of extremity.

ARTISTS UNKNOWN
Greek, early 2nd century B.C.

NORTHERN PROJECTION
and
ATHENA ATTACKING ALKYONEOS
AND EVE (in background)
from the east side of the
of the Great Frieze of the Altar of Zeus,
Pergamon
ca. 180 B.C.
Marble
Height 90 in. (228.6 cm)

Current Location: State Museum, Berlin

# THE MOSAICS OF SAN VITALE

ARTISTS UNKNOWN
Northern Italy, 6th century

JUSTINIAN AND ATTENDANTS
ca. 546-47
Mosaic
8 ft. 8 in. x 12 ft. (2.64 x 3.65 m)

Current Location: S. Vitale, Ravenna, Italy

EMPEROR JUSTINIAN I and his wife, Empress Theodora (a former actress and, according to some of her enemies, a whore), solidified the Christian world in the sixth century, saved Constantinople from the barbarians, codified and expanded Roman law, and made the Church flourish as perhaps never before. Justinian was an exuberant patron of the arts and lavished his churches with decorations, which by this time were invariably created in shining mosaic, for sculpture had gone out of fashion, perhaps being too pagan-Roman for the age of faith. He was responsible for some of the most striking gold and dazzlingly colored mosaics that have ever been produced: in the Hagia Sophia in Constantinople, in the church of the Monastery of St. Catherine on Mt. Sinai, and, above all, in the relatively small octagonal church of S. Vitale in the sleepy little town of Ravenna, south of Venice on the Adriatic coast of northern Italy. Commissioned by Ecclesius, bishop of Ravenna (528-32), the church of S. Vitale was constructed mostly under Bishop Victor (538-45) and completed under Archbishop Maximian.

The interior of S. Vitale is ablaze with the tightest, most refulgent, most exciting mosaics of the Christian world—they look like frescoes that have been brilliantly back-lighted. They range from a giant Lamb of God in the dome to two wall panels depicting Justinian and Theodora preparing to lead a procession into the church and sit in their separate royal boxes. In the half dome of the apse, a youthful Christ is seated imperially on the globe of heaven, flanked by angels and local saints, while the rivers of life flow by his feet. He hands the crown of martyrdom to S. Vitalis on his right, as an architectural model of the church is being offered to him by Bishop Ecclesius, founder of the church. Three large windows pierce the wall below this, and by the upper arcs of the two lateral windows are the mosaics representing Justinian and Theodora. Justinian, flanked by six soldiers and six bureaucrats and ecclesiastics, is holding a loaf of bread—the gift for the Eucharistic service. The moment is a slight pause in his progress into the church. On the wall opposite is the Empress with her courtiers, one of whom lifts the curtain so as to start the procession. Although the figures are abstract symbols, as flat as playing cards, the heads are realistic portraits, and details such as jewels and garments have been depicted faithfully down

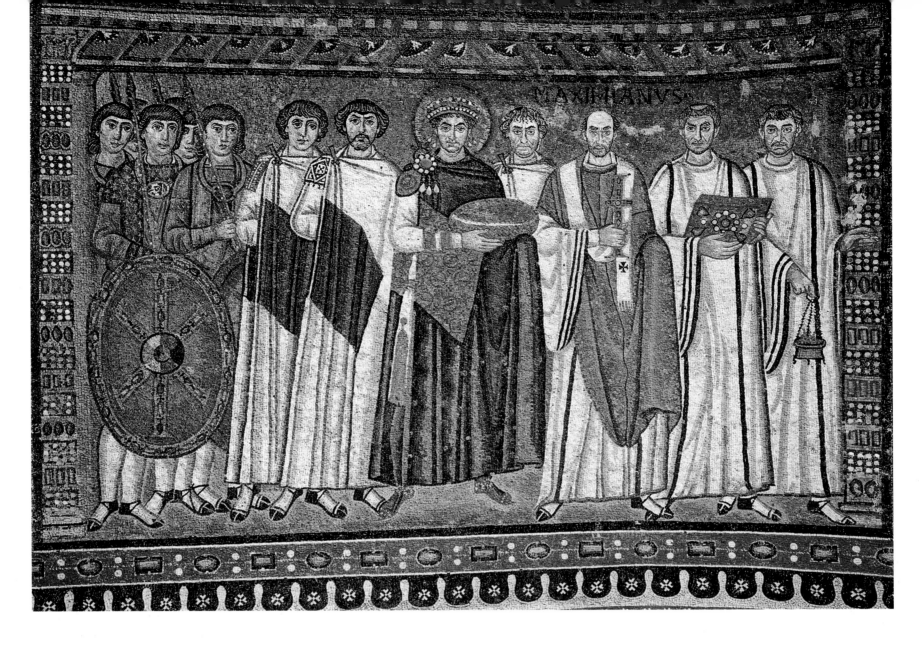

to the smallest detail, especially in the radiant headdress of Theodora. These real-unreal characters seem to walk on air, appearing to step on each other's toes without crushing them, and, instead of looking where they are going, gaze straight at the onlooker. Despite their ethereality, like movie stars, they seem to be highly conscious of being seen and well-aware of the roles they are playing in the ceremony. Although the scenes are rather static, they are heightened by a profusion of colors, by glints of gold and pools of blackness, by darting glows and lightning strikes of emerald green, white, vermilion, pearl-gray, purple, and violet, which transform the orderly array of figures into a fireworks display.

The artists responsible for these brilliant mosaics remain unknown, since the works are unsigned, as is typical for art throughout most of the Middle Ages—primarily because artists then were considered more as builders and craftsmen rather than as "artists" in our contemporary sense of the word. The S. Vitale mosaics were completed just before the consecration of the church in 547.

# ENGUERRAND CHARONTON

## PIETÀ OF AVIGNON

**Attributed to**
ENGUERRAND CHARONTON
(or Quarton)
b. ca. 1410, Laon, France
d. 1461

PIETÀ OF AVIGNON
ca. 1450
Oil on panel
64 x 86 in. (162.5 x 218.5 cm)

Current Location: Musée du Louvre, Paris

OF THE TENS OF thousands of Pietàs created from the thirteenth century onward, this monumental painting on wood from about 1450 is by far the most powerful and successful. It's even more gripping, I believe, than both of Michelangelo's *Pietàs*, the one in St. Peter's and the *Pietà Rondanini* in Milan. The reason is that this artist, whose identity is not securely known, has taken a standard Christian scene, something that was virtually a formula, and has imbued it with human spirit of the most intense dynamism. With figures who are stock, abstract types, he has created an event in which people with indelible characters express themselves in ways that provide a summation of spiritual and human grief. But there is no elegance or sweetness here, and the fact that some of the players are downright unattractive may be why the picture works so well. Far from being idealistic or graceful, this formulaic story has been transformed into something that is as lean and moving as much of the writing in the New Testament itself. This is no symbolic or generic image of the Virgin bewailing the death of her son, so cruelly tortured and slain; looking at this painting, one feels that this is the way it must have been at Calvary. I can think of no other Christian painting that so admirably captures the moment when the body of Christ has been removed from the cross to be revered and grieved over by the Virgin, St. John, and the other believers who were witnesses to the Crucifixion. The painting is not large but nonetheless seems monumental because of the energy with which it has been produced. From the near-abstract faces of the participants in the drama to the haunting and strange landscape surrounding Golgotha, this is unforgettable drama.

Although there is not complete agreement on the identity of the artist who painted the expressive and poignant *Pietà of Avignon*, some art historians believe that it was Enguerrand Charonton (or Quarton), a French master of Late Gothic painting who flourished during the period 1444–61 in Provence, primarily in Aix, Arles, and Avignon. Charonton's style is exceedingly sharp, with an almost brutal characterization of faces, crackling drapery folds, and sere landscape elements. Some of the stylistic elements are evident in the *Pietà of Avignon*; hence, the current propensity to attribute the picture to Charonton. Only two pictures that we know with

certainty to have been commissioned from him exist, though in rather fragile condition. One is the vigorous *Virgin of Mercy* (1452) now in the Musée Condé in the Château of Chantilly not far from Paris. The other is the *Coronation of the Virgin*, (1453) in the Hospice of Villeneuve-lès-Avignon. The detailed contract for the *Coronation* shows that late medieval artists had virtually no say over how they were to depict a given religious subject in a work commissioned from them. The iconography, or the way a specific subject is shown, of religious imagery was all but immutable. Yet the great artists, like this one, managed to break free of any orthodox bounds and create something universal.

# THE SAINT AGNES CUP

GOLD IS NOT A forgiving artistic medium for a work of art. In fact, many of the tackiest pieces ever made are of gold. Look at any imitation Fabergé "objet d'art," the maker of which has mistaken opulence for aesthetic merit. To create a true work of art, gold must be handled cavalierly, slightly roughed up, and embellished imaginatively, even wildly. Such is the case with what is known as the *Saint Agnes Cup* (and its cover), created in Paris by an unknown genius of a goldsmith for one of the greatest art connoisseurs in history, the duke of Berry. As befits its grandeur, the history of this "hanap" (as it is described in the inventories) is known almost month-by-month through the past six hundred years.

The gold cup and cover are decorated with wide bands of figures in breathtaking translucent enamels, and the gleaming surfaces of the unenameled gold are delicately incised in tiny stippling with hosts of birds in luxurious growths of plants and ferns. The subject matter of the painted figures is quite diverse, considering the relatively small size of the cup. The foot of the cup is encircled by a pearl-encrusted border and, above it, the four symbols of the Evangelists: the winged Lion (St. Mark), the Angel (St. Matthew), the Eagle (St. John), and the Calf (St. Luke). Note such splendid details as the ruby red wings of the Lion and the plum-colored robes of the Angel, whose face is of astounding presence and unearthly beauty. The stem of the cup is decorated with red-and-white rosettes. The inside of the cup is painted with an image of Christ seated in a mandorla, holding a chalice in his hand. All the other scenes on the cover and the body of the cup represent episodes from the life of Saint Agnes, chronicling her earliest years until her martyrdom. On the cover, we see her refusal to marry Procopius, the son of the pre-

ARTIST UNKNOWN
French, late 14th century (ca. 1370-80)

SAINT AGNES CUP
Gold, enamel, pearls

Current Location: British Museum, London

fect of the town, who tempts her with a box of jewels. This is the moment she declares her intention to marry Christ. Denounced as a Christian and condemned to solitary confinement, she is assailed by Procopius, who is conveniently strangled by a demon, who is blackish brown like a diseased liver. Procopius is resurrected by Agnes, and receives her pardon. In the end, however, she is condemned to the stake by other evil officials but is slain before the horrible act by a charitable blow of a lance to the neck. On the outside of the body of the cup, Agnes is buried and her sister is stoned to death, while the daughter of Constantine the Great, attending a leper, reaches out to Agnes's body and brings about a miraculous cure, then kneels before the emperor and tells him of Agnes's virtues. Of all the princely jewels and gold that have come down to us, this is the most spectacular—and that includes the great royal treasures.

# CARAVAGGIO

## THE CALLING OF ST. MATTHEW

CARAVAGGIO
[Michelangelo Merisi da Caravaggio]
b. Between Sept.and Dec. 1571,
Caravaggio, near Milan
d. July 18, 1610, Port'Ercole, Italy

THE CALLING OF ST. MATTHEW
1599–1600
Oil on canvas
133 x 137 in. (338 x 348 cm)

Current Location: Church of San Luigi dei Francesi, Rome
Note: To see the paintings well, you must pay to
turn on the lighting in the chapel, which is activated
by stuffing 100 lire coins into a slot. So be warned,
have plenty of coins—at least twenty—before the
visit, and, with other visitors adding coins, too, you'll
be able to keep the triumphant works aglow for your
entire stay in the chapel.

MICHELANGELO Merisi da Caravaggio
was an enfant terrible throughout his short, messy,
brilliant life. In the early seventeenth century, he
changed the course of painting with his style of
uncompromising realism buttressed by dramatic
contrasts of light and dark, almost as if his characters
were bathed in spotlights. He was revolutionary, rude,
physically dirty, and he behaved oddly. He was also
violent: he killed an opponent after a tennis match,
fled Rome to escape prison, was forgiven, and died
on his way back to Rome to receive a papal pardon.

Caravaggio's works contribute generously to
making Rome the art capital that it is. His most
triumphant work is a set of three large canvases in
the Contarelli Chapel of the French church of San
Luigi dei Francesi, near the Piazza Navona, where
Caravaggio lived most of his brief, harried existence
after moving to Rome in 1592 or 1593. The subject
of all three paintings is St. Matthew — his calling by
Christ, his writing the Gospel, and his martyrdom.

In *The Calling of St. Matthew*, Christ, emerging
out of the shadows on the right with a disciple, raises
his arm and points to Matthew much the way God
the Father calls Adam to arise in Michelangelo's
Sistine Chapel ceiling. Matthew sits at the table on
the left surrounded by a soldier and two gamblers.
A diagonal shaft of sunlight accents Christ's gesture
and shines upon the bewildered man. Matthew
points weakly at himself, as if to say, "Who, me?"
Christ speaks not a word, for the outcome, which is
not depicted, is clear: Matthew understands the call.

The martyrdom, which is part of Caravaggio's
truncated life of Matthew, is also one of the finest
works of the brilliant seventeenth century and, for
that matter, of all time. It is a frightening, chaotic
scene of people (including the bearded Caravaggio
himself) screaming and running away from a
swordsman who holds the fallen Matthew's arm in
the air as he runs him through. Two silent, mys-
terious men in breech clouts sit on either side of
the vast canvas, almost in the viewer's space, and
observe the terrifying moment with a chilling lack
of emotion (symbolizing much of humankind, I
suppose). Angels swoop down towards the bleeding
evangelist—whose blood is as vivid as Chinese
lacquer—to take him up to heaven. In atmos-
phere, emotion and mood there is nothing with
which to compare these grand images.

Caravaggio started his career as a student of a
mediocre Milanese painter. He moved to Rome and

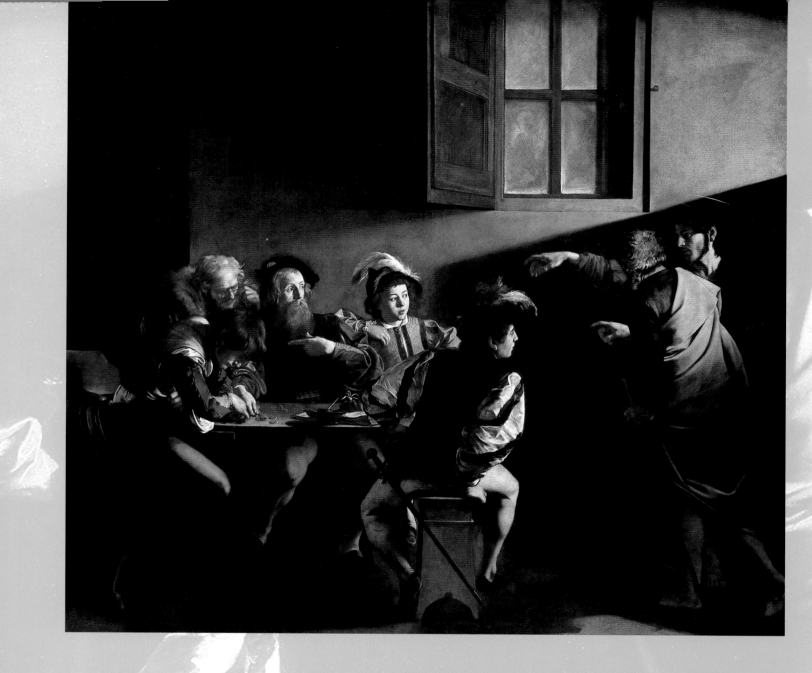

began to work for the patron Cardinal Francesco del Monte, for whom he produced a series of genre pieces distinguished by their strange melding of sweetness and reality. After the triumphant Matthew cycle, Caravaggio devoted himself to religious subjects. His temperament was unruly and he often seems more like a punk biker than an artist of the early seventeenth century. Court transcripts show him as a quintessential "wiseguy" who, after having been picked up unconscious by the police, stated that he had no idea who hit him and anyway, he'd fallen. After his fateful tennis encounter in 1601, Caravaggio fled south, ending up eventually in Malta. Having been assured of a Papal pardon in 1609, he sailed to Port'Ercole, where he was arrested and thrown into jail. It turned out to be a case of mistaken identity, but Caravaggio had caught a fever that killed him, the story goes, as he was running down the beach chasing the vessel sailing south with some of his last works.

# THE SCREAM

EDVARD MUNCH
b. Dec. 12, 1863, Löten, Norway
d. Jan. 23, 1944, near Oslo

THE SCREAM
1893
Tempera and casein on cardboard
36 x 29 in. (91.3 x 73.7 cm)

Current Location: Munch Museum, Oslo

THE MOST POWERFUL image created in the Expressionist style must be Edvard Munch's startling painting *The Scream*. Standing on a bridge in front of an intriguing sunset, a lonely figure holds his or her head in anguish and screams for a moment that seems to last for eternity. The painting perfectly sums up the horrors that mankind has visited upon himself not only since the end of the so-called Belle Epoque but throughout all of our checkered history.

The stunning thing about this abrupt, almost brutal work is that it truly stands alone in art. Before Munch, no one in history portrayed human fear and pain outside of specific depictions of gladiatorial contests, battles and hand-to-hand combat, the torturing of saints, or people being attacked by fierce animals. Frightening though these classic portrayals are, they seem less so when compared to this image of psychological fear. Nothing in the landscape is conducive to the sense of horror shown by Munch. Despite that odd sunset, it's not the end of the world, nor the advent of a holocaust, nor the beginning of a disastrous war. Or is it all of these? That's why *The Scream* works so well. Its power lies in the very peacefulness of its setting and the absence of anything at all to be afraid of.

Born into a politically and culturally prominent Norwegian family, Munch was the second of five children. His mother, father, and one brother died while he was young, and because of these early family tragedies he became obsessed with the specter of death. Yet his often grim works manage to go beyond extensions of macabre childhood impressions and speak a universal human language.

Munch's career was not easy; he received little real training and his early works were lambasted by the Norwegian artists of the late Impressionist period—and not without reason. He first went to Paris in 1885 and was profoundly influenced by contemporary French art. Because of this exposure, he was able to break free from the relatively provincial nature of his hometown and became a radical artist.

Munch was close to all the intellectuals of his day, including playwrights Henrik Ibsen and August Strindberg and French Symbolist poet Stéphane Mallarmé. In 1892, he exhibited in Germany along with the *Verein Berliner Künstler* (Union of Berlin Artists), a society of artistic revolutionaries. Munch's strange, emotional images

caused much controversy and became the nucleus of a growing fight over the limits of the freedom of artistic expression. Munch's form of Expressionism became acceptable, and soon he became well-known, living mainly in Berlin and Paris. In 1894, he took up print-making and blossomed into perhaps the most vital printmaker of modern times. During the six intensively fertile years after his first explosive show in Berlin, he pushed himself to the limit and his mental health deteriorated. Out of his private despair came the tortured masterpiece *The Scream*, often called a symbol of modern man's spiritual anguish. But in 1908 his life became intolerable and he suffered a shattering nervous breakdown and retired to a Danish nursing home. In 1910, Munch returned to Norway, where he lived for the rest of his life. From 1910 to 1915 he created a series of murals for the Festival Hall of the University of Oslo, which are not to be missed. He also rediscovered nature, and his late landscapes, painted freely, even wildly, are simply enthralling.

In his will, Munch bequeathed his wealth and all the works he had kept for himself—the cream of the crop—to the city of Oslo, which erected the Munch Museum in 1963.

# THE GOTHIC GITTERN

CAN A MUSICAL instrument be not only a conduit of melodious genius but also a fine work of art—even a masterpiece of decoration?

Yes. But the instrument I have in mind is neither a Stradivarius nor a fabulously wrought spinet (although there are some of those that are near-masterpieces). The masterpiece I am referring to is an English carved wooden instrument of the late thirteenth century, called a gittern (a medieval guitar), that is one of the proudest possessions of the British Museum (having been snatched away from my curatorial grasp in 1963 when I was director of the Cloisters in New York). It is a prime English national treasure and richly deserves staying forever in its country of origin.

Today this gittern, which is the earliest surviving musical instrument of the Middle Ages, looks more or less like a violin, for at some time—possibly the eighteenth century—it was remodeled as a version of one by the addition of a fingerboard and tailpiece and a new sounding board. We know from a royal coat of arms and a personal badge engraved on the silver-gilt cover for the pegbox that it was once in the collection of Queen Elizabeth I, who presented it to one of her favorites, Robert Dudley, earl of Leicester.

But it was made long before that time, no doubt for some royal personage or musical prodigy. The striking beauty of the gittern resides in the intricate carvings that cover the sides of the neck and the body and both ends. The ends are fashioned out of the most entertaining dragons' heads. Each side of the neck and body is carved with lavish forests of decoration, divided into seven unequal sections, depicting archers hunting deer and rabbits, shepherds and swineherds rounding up sheep and milking goats, and people engaged in fanciful games. Plus there's an abundance of all sorts of trees and foliage, the thickness of some fanciful forest of one's imagination, from oak trees laden with acorns to vines and thickets. In all of art there has never been such a forest—so rich with foliage, so skillfully undercut, and so flawlessly rendered.

In the Middle Ages, the way of experiencing a work of art was diametrically opposed to our stepping back the full length of a spacious gallery to get

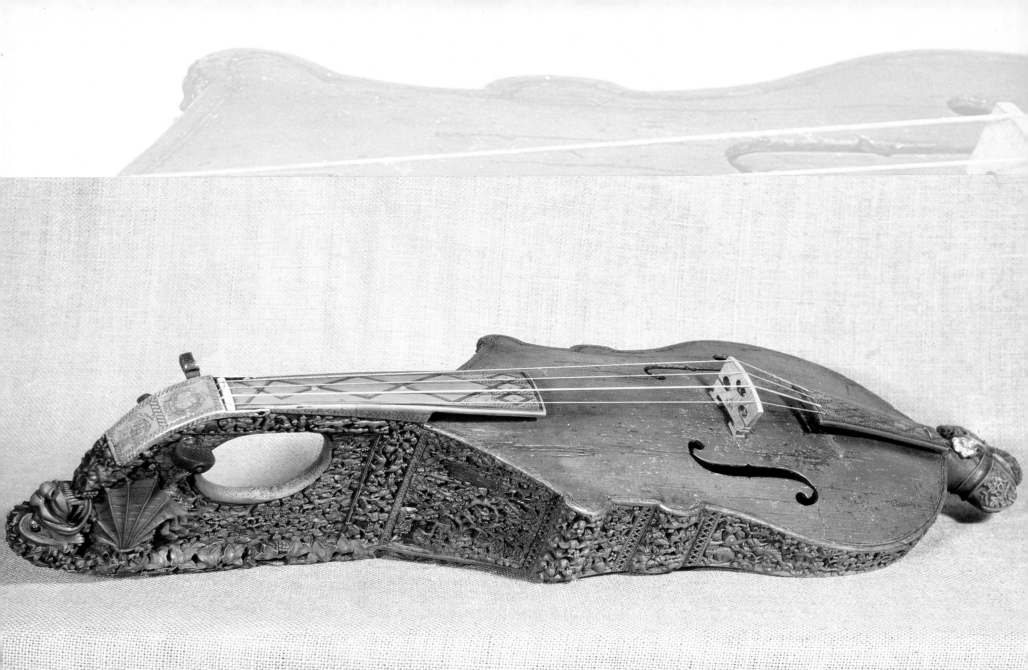

the best impression of some huge abstract piece. Back in the late thirteenth century, as aesthetes of the time recommended, you were supposed to put your eyes very close to and allow your eyes to wander over every tiny curve. Once one does this with the dense world of the gittern's carvings, the full wonder and majesty of this extraordinary work burst into one's consciousness.

# THE CEILING AT WÜRZBURG

GIAMBATTISTA TIEPOLO
b. Mar. 5, 1696, Venice
d. Mar. 27, 1770, Madrid

CEILING OF THE GREAT STAIRS
OF THE EPISCOPAL PALACE,
WÜRZBURG
1753
Fresco

PATRONS CAN BE almost as important as artists, especially if they commission something that becomes not only that artist's best work but a piece that is arguably one of the most sublime painterly creations of history. And that's the kind of patron Prince-Archbishop Karl Philipp von Greiffenklau of Würzburg in southern Germany turned out to be. It was his singular decision to hire Venetian painter Giambattista Tiepolo and his son Domenico to design and carry out the enormous series of fresco cycles in the Hall of the Kaiser, the White Hall, and the Great Stairs of the palace that was just being completed for him by architect Balthasar Neumann. The frescoes, which flow like great waves throughout the three grandiose halls, took only five years of what one imagines to be a volatile period of creativity.

Tiepolo is known for his astonishingly refreshing and colorful paintings bursting with sparkling blues, incandescent reds, glowing yellows, and whites made up of seemingly hundreds of subtle off-whites; faces of such glamour that one's heart stops while savoring their beauty; compositions that surge and recede like flood tides of artistic energy; and, in every work, a sense of celebration unmatched in Western art. The ceiling of the Great Stairs in Würzburg of 1753 must be his finest work of all, and demonstrates his enormous ambition.

The subject is cosmic and witty: Apollo, the sun god, who has just awakened in his shining palace, has lifted the first flame of the sun in his hand—as if in a burst of primal creation—and is calling for his horses to be hitched to the chariot to take him on his daily journey. He is surrounded by the gods and goddesses of Olympus and a coterie of minions who show appropriate adoration. Arrayed on the four cornices are the personifications of the four corners of the globe—Europe, Asia, Africa and America—who are waiting the sun's illumination. Hovering over Europe, but still in the heavenly realm of Apollo is von Greiffenklau. In the crowd of European attributes, you can spot the architect of the palace, Neumann, as well as G.B. and Domenico Tiepolo, along with the muses of music, architecture, and painting. Africa is dominated by a huge image of a dromedary, on top of which sits an amazing black giantess in a pure white robe with immense wheels of gold around her neck as neck-

laces. The symbol of Asia is a grand elephant, sitting astride which is a thrilling turbaned woman in a robe made of brown velvet and the most striking blue fabric ever painted. As exciting as the furious sweep of the figures are little details such as the spectacular parrot just below the cornice. America is probably the most inventive part of the mural, since so little was known about the continent. The personifications are a voluptuous female Indian and a pair of giant crocodiles, one of which, centrally located, is dark and ominous, and the other, slung over the back of some henchman, as white as ivory. The land is accurately epitomized by a horn of plenty held by a grizzled porter wearing a blue outfit so dazzling that the paint almost hurts one's eyes. America is the only corner of the earth portrayed with a subtext of the demonic, in the form of three severed heads with an arrow protruding from one— a symbol of cannibalism and violence.

Born into a rich family, Tiepolo started his artistic career studying with a capable Venetian painter of primarily decorative style. Tiepolo's name first appears on the lists of the Venetian painters' guild as an independent in 1717. He was strongly influenced by the works of the dynamic Venetian Giovanni Battista Piazzetta (1683–1754), but he was a voracious student and studied the works of the leading Venetians and every foreigner he could get a look at. Through this immense examination, Tiepolo mastered a wide variety of forms and moods. In 1726, at the age of thirty, he won the commission for frescoes in the Archepiscopal Palace in Udine in northern Italy, a project that displays the onset of his mature style, full of bright colors and snapping energy of movement. The call to create ceilings in the official rooms of the palace in Würzburg came to Tiepolo at the happiest time of his life, when he was at the peak of his powers. He traveled there, accompanied by his sons, Giovanni Domenico and the teenager Lorenzo. They painted in complete harmony with the architect, Neumann.

Venice's political stability was broken in 1756 when the Seven Years' War began, but Spain remained outside the conflict, and Charles III summoned the master to Madrid to decorate the sprawling Palacio Nacional. Tiepolo arrived there in 1762 with his sons as active collaborators, and in 1764 completed the massive works.

# THE PROCESSION TO CALVARY

PIETER BRUEGHEL THE ELDER

THIS PAINTING by Pieter Brueghel the Elder is the most captivating image of Christ on the way to Golgotha ever created. Both horrifying and majestic, the panoramic biblical scene is one of the most perfect depictions of humanity's mocking cruelty, insensitivity, and capacity for love.

The raucous parade from downtown Jerusalem into the killing field of Golgotha—with drunks, revelers, gamboling children, dogs and cats fighting—is filled with as much laughter as it is with terror, all set in an incredibly beautiful and haunting landscape. The atmosphere evoked by Brueghel is breathtaking in the way it captures light and the brooding possibility of an impending storm. Those clouds give the impression that God Almighty is just over the horizon and not at all pleased with the humanity He has created, for mankind is about to kill His son on earth.

Mary and John and the Magdalene are not, as usual, grouped mournfully at the base of the cross, but are to be found in the right foreground, isolated from the events going on behind them. Just above them is a grisly wheel on a tight pole, with a crow and a tattered shred of cloth—the remains of some unfortunate who was apparently left to starve and be torn to pieces by the vultures. The denouement will take place up on the hill to the right, in the gathering circle of black-garbed citizens who just cannot wait for the agony to begin. For them it's merely an entertaining outing on an overcast afternoon.

The combination of the ineffably sad and the terrifying, the mixture of impending horror and the banal—the notion that life goes on in the face of brutality and terror—makes this scene

PIETER BRUEGHEL THE ELDER
b. 1515, Breda, Netherlands
d. Sept. 1569, Brussels

THE PROCESSION TO CALVARY
1564
Oil on oakwood
48⅓ x 66⅓ in. (124 x 170 cm)

Current Location: Kunsthistorisches Museum, Vienna

even more compelling. The mask of all wretched humanity is in the gray-faced, absolutely terrified thief in the cart, who throws back his head in an anguished, tortured howl.

Pieter Brueghel the Elder (the name is also spelled Bruegel, Breughel, and Breugel) was the most energetic, accomplished, amusing, heady and profound sixteenth-century Flemish painter. His contemporaries bowed down to him and admitted freely that he was the master of them all when it came to inventiveness and richness of technique. Through his sons Jan and Pieter, he became the progenitor of a powerful and unforgettable dynasty of visual creators that lasted well into the eighteenth century.

After being accepted as a master in the Antwerp painters' guild, Brueghel journeyed to France and Italy, traveling as far south as Palermo in Sicily. He set up shop for a time in Rome and worked with a Michelangelo-inspired miniaturist of great bravado by the name of Giulio Covio, who was an important patron of the youthful El Greco. On the way to Italy and back, Brueghel made many drawings and some stunning landscape paintings of the Alps, which compare favorably with the great mountain scenes created by Leonardo and Dürer. He returned to Antwerp in 1554 or 1555.

In Brussels, Brueghel produced his truly awe-inspiring works. The best of the best have been preserved in Vienna's sublime Kunsthistorisches Museum (probably the finest in the world), for the canny, artful, supra-connoisseur Hapsburgs adored his works. Fully one-third of his most triumphant pieces are in Vienna, where the magnificent *The Procession to Calvary* is to be found.

# THE WANDERER IN THE MISTS

CASPAR DAVID FRIEDRICH
b. Sept. 5, 1774, Greifswald, Pomerania, Germany
d. May 7, 1840, Dresden

THE WANDERER IN THE MISTS
1818
Oil on canvas
36⅔ x 29 in. (94 x 74.8 cm)

Current Location: Fine Arts Museum, Hamburg
Note: The lone example of his work in a United States
collection is a tiny mountain landscape in the Kimbell
Museum, Fort Worth, Texas.

THIS ARTIST FROM Hamburg is little known in the United States, probably because there is only one small example of his work in the entire country. Yet Caspar David Friedrich's greatest work in Hamburg, *The Wanderer in the Mists*, is the most profound elegy of Romanticism—and personal spirituality—ever produced. It depicts a man who, by his dress and demeanor, seems to be a divine combination of daredevil mountaineer and philosopher, situated on a miraculous promontory and looking into the misty precipitous view. What is he thinking? What will he do? We shall, of course, never know—which is one reason this mysterious and gripping painting never fails to give one goose bumps wondering what the next move of the intrepid adventurer will be. It's not too much of a stretch to imagine this lonely and captivating figure as a symbol of all humanity struck by the doubts and anxieties we all have about the future.

This is probably also a deeply spiritual painting, for Friedrich loaded his works with an abundance of religious symbols, most of them ambiguous, even to himself. However, in this painting it is clear that these mountains are reminders of God's power, and the compelling mists are the essence of the Almighty, which the wanderer knows he can see dimly but never fathom.

Friedrich is generally regarded by art historians as Germany's most advanced and satisfying Romantic painter, whose works admirably sum up the Sublime—the central goal of the Romantic movement. He studied from 1794 to 1798 at the Copenhagen Academy but was mostly self-taught, as his cautious and impeccable style signals. In Friedrich's landscape paintings—many of them derived from scenes of the Baltic coast and areas of central Europe—spirituality and landscape merge to reveal the cosmic power of nature. His symbolic landscapes have no equal in art. Works such as *The Wanderer* and the brooding *Shipwreck in the Ice* (1822) indicate Friedrich's poetry, his teleological leanings, and his grace.

Amazingly, his work was ignored or overlooked until the twentieth century, when appreciation grew once again for the existential loneliness expressed in his extraordinary paintings.

# ANTONIO CANOVA

## PAULINE BORGHESE AS VENUS

**ANTONIO CANOVA**
b. Nov. 1, 1757, Possagno, Italy
d. Oct. 1822, Venice

**PAULINE BORGHESE AS VENUS VICTRIX**
ca. 1808
Marble
62⅞ x 78¾ in. (1.6 x 2 m)

Current Location: Galleria Borghese, Rome
Note: Because of intensive, continual, and somewhat haphazard reconstructions of the museum, it is advisable to find out in advance if the gallery where this statue is exhibited is open.

EVEN IN THESE artistically bouncy days, it's difficult to imagine one of the most famous sculptors in the world creating a serious portrait of the sister of the world's most powerful man, showing her almost completely nude and depicted as part goddess, part saint, and part harlot. That's exactly what the great Italian sculptor Antonio Canova did with Napoleon's sister, Pauline Borghese.

Madame Pauline is portrayed as sexy, arrogant, willful, intelligent, beautiful, profound, fashionable, and dangerous. Seminude, Pauline seems at first glance to be a reclining Venus after a classical model (though she offers little in the way of classical idealism) on an archaeologically correct Roman couch, rendered impeccably in glistening ivory-colored marble. But this is more than an exercise in classicism. She is imperious as a deity from ancient mythology—the type is called "*Venus Victrix*"—but she's also as wanton as a street cat. There's a subtle hint of other-worldliness, too, that bespeaks sainthood. What a delightfully complex mixture of the Olympian, pure fantasy, and the strictly real! There is simply not another portrait, either in paint or in stone, that is as gripping,

provocative, and, at the same time, endearing. Canova created some of history's most memorable images, but with this sculpture he outstripped his prodigious talents. Imperial power, taste, and will reign supreme in this arrogant creature.

Canova was the most famous stylist of neoclassicism and created hundreds of justifiably famous works, including portraits and tombs of popes, and statues of Napoleon—some of them gigantic—and the Duke of Wellington.

The son of a stonemason who died in 1761, Canova was trained by his grandfather, also a stonemason. He began his formal studies in art at the age of eleven, and in 1775 set up his own studio in Venice. His first sculpture, a Daedalus and Icarus done in 1779, almost destroyed his career. It was criticized as appearing so real that Canova was charged with having cast living humans in plaster. In 1779 Canova went to Rome, where he became entranced by antiquity and with that his mature style was born. He pored over the ruins of Pompeii for inspiration. Although he returned for a while to Venice, his heart was in Rome and there he spent almost his entire life. His fame exploded in 1787

when he completed a magnificent tomb for Pope Clement XIV in the church of SS. Apostoli. Crowds lined up for hours to view the extraordinary images. Napoleon's invasion in 1798 sent Canova to Vienna, but in 1802 he went to Paris—invited by Napoleon to sculpt his portrait—and became the sculptor of the Imperial court. Around 1807 he polished the finishing touches on Pauline Borghese, arguably his best piece. In 1816 the Pope dubbed him Marchese d'Ischia for his part in retrieving from Paris Italian works of art that Napoleon had stolen.

Canova was adored by the public, and words such a "sublime," "superb," and "incomparable" appear frequently in descriptions of his work throughout his long career. He was buried at Possagno, in a little replica of the Pantheon that he had designed himself in imitation of the original in Rome.

# THE TWITTERING MACHINE

PAUL KLEE

b. Dec. 18, 1879, Münchenbuchsee, Switzerland
d. June 29, 1940, Muralto, Switzerland

THE TWITTERING MACHINE
1922
Watercolor and ink on paper
25¼ x 19 in. (63.8 x 48.1 cm)

Current Location: Museum of Modern Art, New York.
Note: Because it is extremely sensitive to light, the
painting is only on view from time to time.

CAN A MASTERPIECE be funny past its own time? Not usually. Not even the great Frans Hals's boisterous cavaliers and drinkers, some of which are gorgeous examples of pure painting, don't really make us want to laugh; and Leonardo's caricatures seem more bizarre than amusing. But many of the works of Paul Klee—which are an uncategorizable synthesis of surreal representation and abstraction—are universally entertaining. Klee's achievement was to combine wit, fantasy, superior drawing, and rapturous color together into a unique image—and for determining greatness, uniqueness weighs in heavily on the scales of quality.

To appreciate this charming picture in water-color and ink to the fullest, say the German title to yourself—*Zwitscher-Maschine* (pronounced "Svitcher Masheenuh")—and look at the heads of the four twittering creatures, and the work comes to life. These thin wiry creatures have white, birdlike heads with an exclamation point, a G-clef, and other musi-cal or semi-musical signs as tongues. The "machine" of which they are a part is so thin and insubstantial that you can be certain that Klee is saying something about the fragility of the machine age. The work is surrounded by a halo of soft, sublime colors, a poetic

series of hues ranging from lavenders and pinks to hazy blues, grays, and off-grays.

Klee was born in a hamlet near Bern, Switzer-land. His father, a German, was a music teacher and his mother had studied music. As a child he fell in love with and avidly studied ancient Greek, a passion that is evident in nearly all his works. He was also a violin prodigy, and at the age of ten played with the Bern municipal orchestra. He went to school in Bern and Munich, traveled to Italy and Paris, and, after four years back in Bern, settled in Munich in 1906. That year, ten of his etchings were exhibited in the historically important Secession Exhibition in Munich. Yet his first one-man show didn't come until 1910, at the Bern Museum, where his work was very well received. Never comfortable with the status-quo, in 1911 he sought out the avant-garde and became a colleague of artists such as Wassily Kandinsky, Alfred Kubin, August Macke, and Franz Marc; and he and Macke became close friends. In 1914, Klee traveled with Macke and another friend to Tunis. There, Klee was trans-formed by the sensational light and color of North Africa and the exotic flavor of the scene.

Having become a German citizen, Klee joined

the German army in 1916 and served in World War I. Macke and other friends had been slaughtered at Verdun in 1914, yet he emerged unscathed. On his return to Munich, his fame grew fast after an influential Munich gallery, Der Sturm, held showings of his works and published a volume of his etchings, and especially after the avant-garde Goltz Gallery mounted a large retrospective in 1920. That same year, Klee was invited to paint at the famous Weimar "monastery" of the contemporary movement, the Bauhaus, where he was given his own studio. In 1922, he began to teach there. Klee broke from the Bauhaus in 1931— before it was closed by the Nazis—and went to teach at the traditional Academy of Fine Arts in the Rhineland city of Düsseldorf. When he was forced from his position there by the Nazis in 1933, he moved back to Bern. Klee had some triumphant shows in Switzerland in 1934 and 1935, and then contracted what turned out to be a fatal illness. In February 1940 he was given a massive retrospective in Zürich's shrine to Modernism, the Kunsthaus, where he was acknowledged to be one of the most imaginative masters of painting ever. He died four months later.

# THE BLACK CLOCK

THE WORK OF the Post-Impressionist painter Paul Cézanne is that of a most infuriating genius. It seems primitive and bumbling and yet at the same time sensitive, delicate, smooth, and sophisticated. His nudes may be the ugliest ever depicted, but they are also among the most memorable; and his early portraits of his friends and family are, frankly, horrible. True Cézanne aficionados find that they adore his works from one decade and feel exasperated by those from the next—perhaps because they are so powerful.

Being so, Cézanne's works were misunderstood in their day by the public, and heavily scorned by the majority of critics, too, but are now recognized to be the most universal pieces of the Post-Impressionist period. The reason is that Cézanne, even more than Picasso, was the creator of and leader into the era of modernist art and abstraction, and therefore many of his early works are full of the kinds of mistakes and half-baked solutions that are found in the creations of any radical experimenter.

One painting of Cézanne's generally fumbling pioneer period is so successful that it must be ranked as one of the top ten of all time. *The Black Clock* is a still life, but it could also be the chronicle of the formation of the earth's surfaces, it is so rich in texture and energy. Like a fully mature master, in this painting Cézanne plays with powerful contrasts of blacks and blue-blacks and variegated whites tempered with a wide range of intermediate tones. The gaping maw of the huge shell with its bloody lips is a most beguiling and unsettling image. This is a virtual epic poem of architectural forms, but it also possesses a certain light-hearted sense of what architecture means. Cézanne has built this still life on a solid masonry of verticals and horizontals and has composed all his elements into a beguiling chaos. The painting's oddest and most exciting feature is that the enameled black clock located on the right has no hands, giving it an uncanny sense of the timeless. I vote this as the finest still life ever produced.

*The Black Clock* was formerly in the collections of Emile Zola, Auguste Pellerin, Baron Kohner of Budapest, the great Parisian dealer Paul Rosenberg, Georges Wildenstein, and the actor and collector extraordinaire Edward G. Robinson, whose collection was purchased as a whole by the Greek shipping magnate Stavros Niarchos, its present owner.

PAUL CÉZANNE
b. Jan. 19, 1839, Aix-en-Provence, France
d. Oct. 22, 1906, Aix-en-Provence

THE BLACK CLOCK
1869–71
Oil on canvas
28⁷/₁₀ x 21¹/₅ in. (73 x 54 cm)

Current Location: Collection of Stavros Niarchos

# DONATELLO

## MARY MAGDALEN

**DONATELLO**
(Donato di Niccolò Bardi)
b. ca. 1386, Florence, Italy
d. Dec. 13, 1466, Florence

MARY MAGDALEN
1454–55
Polychrome wood with gold
Height: 6 ft. 2 in. (1.88 m)

Current Location: Museo dell'Opera del Duomo, Florence

OF ALL THE magnificent works by the fifteenth-century sculptor Donatello, none surpasses the poignant Mary Magdalen in painted wood (originally in the Baptistery and now in the Museo dell'Opera del Duomo in Florence), which he made when he was nearly seventy and in ill health. The sculpture portrays the former prostitute at the end of her life, physically ruined, terminally ill, her face a battlefield of degradation, but alight with the triumphant knowledge of pure faith. It is a unique and profoundly moving religious interpretation.

The lofty Donatello was, with Michelangelo and Leonardo, the most wonderful sculptor—in bronze, wood, and marble—in all of Italian art history. Powerful, sensitive, subtle, amusing, quirky, and lyrical, there's just no one like him. He was a man of simple tastes who seems to have insisted upon utter artistic freedom and received it, in a day when there were strict guild regulations and when artists were considered craftspeople. One thing he seems not to have been was either cultured or overly reverential toward the humanist movement of the time (some of which was rather stultifying). Yet he knew and appreciated classical art, which we can see from the lifelike treatment of human figures right down to the correct Roman-style inscriptions

of his works. He drew upon many sources for inspiration, whether a classical or Etruscan statue or a fine medieval piece, taking motifs from them and transforming them to serve his vision of a new art, full of psychological character and intensity.

It is not known how Donatello (diminutive for Donato) began his career, but it seems likely that he learned stone carving from one of the sculptors working on the cathedral of Florence at the turn of the fifteenth century. By 1403, he was an assistant in the workshop of the great Lorenzo Ghiberti, and some of his earliest works are clearly Ghiberti-esque. Donatello stayed in Florence for most of his career, with the major exception of the period from 1443 to about 1453, which he spent working in Padua. His first mature works include the masterful marble statues *St. Mark*, ca. 1411–13, and *St. George*, ca. 1415–17, which he made for niches on the facade of the Florentine church and guildhall Or San Michele. One of his memorable statues is the 1423–25 *Zuccone* (i.e., "pumpkin," because the head is bald), one of eight marble prophets carved for the campanile of the cathedral. Other works of majesty by Donatello include the *Cantoria* (the singer's perch), 1433–39, also made for the cathedral and now in the Museo dell'Opera del Duomo, along with

the *Zuccone* and the *Mary Magdalen*. His bronze *David*, ca. 1433, is the image of a pouting, somewhat spoiled, but recklessly courageous teenager who is about to topple Goliath—a startling contrast to the sinewy strength and intellectuality of Michelangelo's *David*.

One of the many reasons to visit Padua is to see Donatello's works. In 1443 he was lured to the city by a commission for an equestrian statue of heroic size in bronze portraying a famous and highly popular Venetian mercenary, Erasmo da Narni, who had recently died. The huge bronze was set up on its pedestal in 1445. The face is almost a caricature—something brutal, seemingly swift in execution with wide-open, fearsome eyes and a stern mouth. It caused a sensation. In the 1450s he was able to complete some stunning sculptures for the grand church of San Antonio—a bronze crucifix and a massive high altar with a framework of marble and limestone, decorated with seven life-size bronze statues, 21 reliefs in bronze, and a large limestone of Christ entombed. From 1450 to 1455, a period in which he fell desperately ill, Donatello produced only two works, a wonderful *St. John the Baptist* in Santa Maria Gloriosa dei Frari in Venice and the *Magdalen*.

# BURY ST. EDMUNDS CROSS

ON THE RESTRICTED surfaces of a number of pieces of walrus tusk—one of the most fragile and difficult media to work with—one of the greatest artists of the Middle Ages, Master Hugo of Bury St. Edmunds, carved this cross for the Abbey of Bury St. Edmunds in Sussex. England. Depicting eight scenes from the Old and New Testaments, the Lamb of God, images of twenty-one prophets, and symbols of the Evangelist, the cross is covered on both sides with more than one hundred tiny figures and nearly sixty inscriptions in Latin and Greek.

No work of medieval art is so cunningly crafted or has its various messages so powerfully delivered. The front side of the cross is carved as the Tree of Life (the ivory Christ is now in the Oslo Museum of Art and Industry), with scenes from the Gospels on the three square ends and in the center: *The Crucifixion*, the *Three Marys at the Tomb*, the *Resurrection* and, at the top, the *Ascension*, with Christ's figure seeming to rise through the clouds like a rocket. The other side of the cross presents the symbols of the Evangelists and a cadre of Old Testament prophets holding scrolls that proclaim the inevitability of the coming of Christ. Everything about this small yet boundlessly expansive object—created in a style in which figures play out roles like actors gesticulating forcibly and moving with great vigor, clad in garments whose folds seem like the rushing ripples in a fast-moving stream—is unique. From the ambition of its scope to the placard over the head of Christ identifying the crucified Lord as "King of the Confessors," it is a complex and moving work. Unfortunately, it contains a number of strong anti-Jewish statements, since, at the time, the Jews were considered "infidels."

The cross was probably carved while Master Hugo worked at the Abbey of Bury St. Edmunds, around 1138-70. The archives of the abbey describe his works, and single Hugo out for praise (something very rare in the twelfth century). Among his triumphs were a pair of bronze doors for the abbey's main entrance, this ivory cross (originally flanked by statues of Mary and John the Baptist), and the resplendently illuminated Bury Bible, a book that seems to have had enormous influence on miniature painting throughout the medieval world.

MASTER HUGO of
BURY ST. EDMUNDS
active ca. 1138-70, Sussex, England

CROSS
Ivory
22⅝ x 14¼ in. (57.5 x 36.2 cm)

Current Location: The Cloisters, New York

# THE GROSS CLINIC

THOMAS EAKINS
b. July 25, 1844, Philadelphia
d. June 25, 1916, Philadelphia

THE GROSS CLINIC
1875
Oil on canvas
96 x 77 in. (244 x 196 cm)

Current Location: Jefferson Medical College,
Philadelphia

WHAT'S THE MOST penetrating vision of the United States ever produced in art; something that captures the country's audacity, its creativity, its independence, our European traditions, that never-ending feeling of the pioneer? I don't think it's any of the dozens of breathtaking views of the land, or struggles and conflicts in war, or symbolic pictures of the credibilities of the nation. To me it's the haunting portrait of surgeon Samuel D. Gross operating before his students in his clinic in Philadelphia, painted by triumphant realist Thomas Cowperthwait Eakins in 1875 and presented at the Philadelphia Centennial, where it was considered to be far too daring and was mocked and spurned. That seems to happen all too often in great art, which is frequently ahead of its time. The intense realism and drama of this fine work shocked the art world, offended the public, and made Eakins's reputation as the nation's leader in naturalism. He has often been praised as the painter who carried the style of nineteenth-century American Realism to its pinnacle. The scene as portrayed, however, is hardly what happened at a real operation. Dr. Gross seems realistic, as do all the onlookers and the students, but Eakins has bathed the scene in a purely dramatic light that focuses squarely on the white-haired patriarch, Gross, showing him in a characteristic moment as he turns away from the patient to make some comment. His expression is one of a scout peering over unknown and possibly dangerous country. The flavor of the picture is forward-looking, unafraid, avant-garde. Eakins has brought to this monumental work a superb sense of observation and a refined impression of space. The students all bunched in the gloom of the balcony are like an audience from some scene by Goya.

It has been said that all great portraits have almost no colors and this portrait qualifies, composed as it is of browns, grays, whites, blacks, and russets; the only hue that ignites the scene is the red of the blood oozing from the ankle of the individual being operated on. Off to one side is one of the most convincing touches: a seated woman recoil-

ing in horror—the symbol of how we all feel at this somewhat grisly scene—covering her eyes with hands that are gripped almost in pain. Eakins has portrayed himself hunched in the front row of the audience at the far right, sketching. The paint, lavishly built up on the huge canvas, demonstrates a clear debt to Rembrandt's *Anatomy Lesson of Dr. Tulp*, but that borrowing only makes the picture more compelling.

Eakins was a moody, vain, temperamental cuss who was always getting into feuds with the Academy and other painters, even his patrons. There's hardly a contemporary of his who doesn't lambaste him for being a consummate trouble-maker. He invariably blamed everyone else. It's often difficult to reconcile his annoying personality with his lyrical works, some of them truly labored but never without a spark of genius. Eakins is the kind of gifted image-maker whose works, when you see them across the room in a gallery or museum, are capable of reaching out and grabbing your attention like some sort of a cosmic force.

# FRANCISCO GOYA

# THE THIRD OF MAY, 1808

FRANCISCO (JOSÉ)
DE GOYA Y LUCIENTES
b. March 30, 1746, Fuendetodos, Spain
d. Apr. 16, 1828, Bordeaux, France

THE THIRD OF MAY, 1808
1814
Oil on canvas
105 x 160 in. (2.67 x 4.06 m)

Current Location: Museo del Prado, Madrid

NO OTHER ARTIST in Western civilization can be said to equal Francisco Goya in lyricism or power. Besides that, he may well be the most wickedly observant and courageous painter of all time. Although it's difficult to single out just one work by this towering genius of the late eighteenth and early nineteenth centuries, I'd point to *The Third of May, 1808*, which commemorates the grim end of the popular uprising in Madrid. I have chosen it because it condemns organized human brutality in a way that stands alone in excellence.

This scene of slaughter captures every detail of a group of hateful men callously, even gleefully, destroying their fellow men. Set on the ground in their midst, the great, square, golden-yellow lantern, like the footlights of a stage, illuminates the horror. In contrast to most of the colors, which are not vivid, only the red of the blood gushing forth from the dead and dying seems to be filled with light. Nothing else in all of art equals the violence, the black terror of the moment, with those bayonetted guns pointed at the next group of unarmed victims. The futile gesture of the man with his arms stretched out to the sky—a reference to Christ—

is universal and symbolizes all mankind being terrorized. The anonymous soldiers, no faces visible, bend to their task, their right legs like flying buttresses supporting them in their grim task. These troops all wear their packs as if they've got to make a quick escape. In the near and far background of this tumultuous canvas we also see, as if in millisecond glimpses, guerilla fighters, the friar, the bell tower of the distant church, and the masses watching, never to forget or forgive.

This is an exceedingly difficult painting to look at for extended periods of time and it may even lead to nightmares for days after one's first visit. Yet, once seen, *The Third of May* will become an irresistible magnet.

Goya is generally thought to be one of the most exciting, creative, and important painters ever, unsurpassed in his own time in Spain and throughout Europe. He began his studies in the city of Zaragoza with Jose Luzan y Martinez and then moved to Madrid where he trained with the painter Francesco Bayeu, whose sister he married in 1773. Goya traveled to Rome for a brief time and came back to Zaragoza, where he painted frescoes in the

cathedral, a job he would work on at intervals for a decade. These frescoes are heavily influenced by Tiepolo, who had come to Spain and who had greatly impressed all the artists of the country.

Goya's career in court began in 1775, when he painted a series of some 60 cartoons for the Royal Tapestry Factory of Santa Barbara. These pieces, mostly charming scenes of the sweet side of contemporary life and the frivolities of the aristocracy, had been generated under the direction of the German artist Anton Raphael Mengs, the neoclassic painter who took over from Tiepolo as the art director of the Spanish court. Goya didn't stick with Mengs for long and soon became devoted to the works of Diego Velázquez. From then on, Goya was influenced primarily by Velázquez and Rembrandt.

In 1780 he was elected a member of the Royal Academy of San Fernando in Madrid. In 1785, he was made the deputy director of painting at the Academy and in the next year was appointed painter to Charles III. The death of Charles in 1788, a few months before the outbreak of the French Revolution, ended an era of relative prosperity in which Goya matured as an artist. What followed was a period of reaction and corruption under Charles IV and his unscrupulous wife Maria Luisa, which came to an end with the Napoleonic invasion. Yet it was under Charles IV that Goya flourished, receiving a host of official honors; he adored the adulation. Goya became terribly ill in 1792 and was stricken with deafness. Slowly his style changed from the purely fashionable to include some dark and penetrating scenes of human foibles. In 1799 he published a truly wicked and marvelous series of satires called *Los Caprichos*, in which he attacked the prevailing political and religious nonsense. Although Goya had tried

to disguise the people in the biting engravings, the pieces were withdrawn from sale in a few days time.

He also painted in the conventional "court" manner. He executed the colorful and energetic frescoes in Madrid's San Antonio de la Florida in 1798, with a fresh dynamism of characterization in the figures. Goya was at the pinnacle of his official career in 1808, when the Napoleonic Wars forced the abdications of his major patron, Charles IV, and then his son Ferdinand. Goya recorded his reactions to the grisly war in the etchings *The Disasters of War*, which, however, were published for the first time only in 1863, long after his death.

When the French invaders had been thrown out of Spain and when Ferdinand VII was made king in 1814, Goya was pardoned for having served the enemy and was reinstated as primary painter of the court. This was when *The Third of May* was done. He never disguised what he really felt about his royal patron, and in several portraits of Ferdinand shows him as the cruel and stupid tyrant that he was. At this time, Goya also produced the renowned "black paintings," *Satan Devouring His Children* and *The Witches' Sabbath*, which are in the Prado.

In 1824, bowed down by the tyranny and his deteriorating health, Goya settled in Bordeaux, where he worked on some spectacular portraits of friends who were also living in exile. His last paintings are stark and astonishingly free of details or restricting outlines.

*The Third of May* is on view in the Prado, the home of the great majority of his works. A fair number of paintings by Goya are in the United States, including the gorgeous, not-to-be-missed portrait of the doctor he credited with saving his life, which is in the Institute of Fine Arts in Minneapolis, Minnesota.

# STE.-FOY OF CONQUES

ARTISTS UNKNOWN
French, late 10th century and later

RELIQUARY-STATUE OF STE.-FOY
assembled in the late 10th century with
elements dating from the 5th, 7th, 9th
(with later additions of the 11th, 12th, 13th
and 15th) centuries
Wood, silver gilt, precious stones, crystal,
ivory, and enamels
Height 33½ in. (85 cm)

Current Location: Church of Ste.-Foy,
Conques, France

AFTER THE CHURCH issued the doctrine ascribing miraculous powers to sacred relics—remains of martyrs, and objects associated with Christ, the Virgin Mary, and the saints—they were kept in often elaborate protective containers that were fashioned to enhance their spiritual significance. The nature of the relics contained within these reliquaries was indicated by inscriptions, illustrations, or the shapes of the containers. By the Middle Ages, reliquaries were made in the form of statuettes, towers, or the sometimes odd-looking shapes of the relics they housed—such as a purse, a head, a finger, or a foot. In addition to the venerated object, a reliquary usually contains a parchment scroll attesting to the authenticity of the "holy" fragment. Reliquaries fell out of favor by the beginning of the eighteenth century, when the Church decided that faith was based on belief, not on relics of questionable authenticity.

Perhaps the boldest, most extravagantly primitive, and certainly the most intriguing of these religious artifacts ever made is the reliquary-statue of Ste.-Foy (Saint Faith). The reliquary houses some of the remains of the saint, who is said to have been martyred as a child during the persecutions of Emperor Dacian around 303. The rigidly frontal figure is made of wood covered with silver gilt and adorned with precious gems, cameos, and various enamels, and is seated on a gem-studded throne. The head, which is from the fifth century, is said to contain part of the child-saint's skull. The strangely oversize gold face with disproportionately large, staring eyes is actually that of a fourth-century Roman emperor, possibly Diocletian; around 800 it was given a crown with the distinctive beaded decoration that adorns images of the emperor Charlemagne (who founded the Benedictine abbey that was replaced by the Church of Ste.-Foy between around 1050 and 1120). At some indeterminate point, perhaps in the mid-ninth century, the head was affixed to the body. Over the succeeding centuries—and especially after a miracle in 985, when a certain Guibert's sight was restored while he was kneeling in front of this strange icon—the statuette was encrusted with a dazzling variety of precious and semiprecious stones (emeralds, sapphires, amethysts, agates, opals, jades, carnelian, rock crystal), cameos and enamels of ancient and modern types, lots of filigree, and hundreds of seed pearls. Her spiky little

arms and the filigree attached to them were added in the fifteenth century. The effect of this chaotic decorating is hypnotic, and one becomes half-mesmerized at the sight of that unearthly face and all those gems and enamels and filigree. According to local history, the body of Saint Faith was taken to the church at Agen, about eighty-five miles from Conques, in the early ninth century but was "translated" to Conques on her holy day (January 14) sometime between 864 and 875 in the most outrageous theft perhaps of the entire Middle Ages. A child was seeded by the monks of Conques in Agen so that one midnight when he was a teenager he could swipe the corpse and bring it to Conques, where its reliquary was embellished. Tourists by the thousands on the pilgrimage route to the holy site in Santiago de Compostella, Spain, thronged to see it in hopes of experiencing a miracle.

Looking at this compelling image is like discovering treasures in an upscale junkyard—hundreds of different golden surprises in precious stones, among which, hanging on the back, is one of the most beautiful Carolingian engraved rock crystals to have survived to our day. *Ste.-Foy* is so powerful that one can almost believe in the legend of the miracle.

# JEAN-HONORÉ FRAGONARD

## GIRL WITH HER PUPPY

JEAN-HONORÉ FRAGONARD

JEAN-HONORÉ FRAGONARD
b. Apr. 5, 1732, Grasse, France
d. Aug. 22, 1806, Paris

GIRL WITH HER PUPPY
1775
Oil on canvas
35 x 27½ in. (89 x 70 cm)

Current Location: Alte Pinakothek, Munich

THE LATE EIGHTEENTH century in France really was the Age of Sex—as well as the Age of Enlightenment, to some degree—and no painting epitomizes the situation more pointedly than Jean-Honoré Fragonard's steamy yet sweet study of a delicious young woman lying in bed holding her puppy in the air above her naked body. A chemise covers the plump, pretty girl from the waist up. She's on her back with her legs raised, resting the coiffed puppy on her knees and forelegs, and the dog's long, fluffy tail tickles and covers her pubic hair. Sexual yearnings and exuberant release have seldom been represented with this kind of frankness, even during pagan times, when sexuality was recorded candidly but always blandly. *Girl with Her Puppy* is both a witty counterattack against religion's often mindless anti-sexual propaganda and a lyrical call for unadulterated fun. To many, Fragonard, the creator of delicate and telling images of the good life among the aristocracy, is the epitome of the ancien régime. Not so. Unlike his simpering older contemporary and teacher François Boucher, he was a painter for all ages.

After moving to Paris with his family before the age of ten, Fragonard showed great talent early on, producing sensational drawings. He studied with Chardin for six months before moving on in 1751 to work in the studio of Boucher. That training eventually led to a Prix de Rome scholarship, and in 1756 Fragonard went to the French Academy in Rome. There he met his most devoted patron, a rich amateur painter by the name of the Abbé de Saint-Non. Together, the pair toured Italy extensively and made hundreds of admirable sketches. In 1761 Fragonard came back to the French capital and made a success of himself at showings, and around 1767 he was accepted into the French Academy. His career seemed to be made in 1770 when he was commissioned by the king's mistress, Madame du Barry—one of the most gifted connoisseurs of all time—to decorate her newly built pavilion at Louveciennes. The four large paintings depicting *The Progress of Love* that are today in New York's Frick Collection were thought by du Barry to be too fussy for the severe neoclassical environment of her pavilion, and she rejected them. Always restless

and having not received the accolades at home that he felt he deserved, Fragonard traveled north and fell under the spell of Rembrandt and Frans Hals. A second visit to Italy followed. When he came back to Paris, he fell in love with the fourteen-year-old sister of his own wife. From then on—ironically—he churned out calm, serene domestic images based on Jean-Jacques Rousseau's moralities and the saccharine novels of the period.

At the dawn of the French Revolution, Fragonard made his way back to neoclassicism, tempering the straight-laced historical scenes with his love for the flamboyance of Tiepolo and the brooding colors of his beloved Dutch painters. But engulfed by the surging wave of political correctness during the Revolution, he found it almost impossible to get work. He was able to obtain a government sinecure on the Museum Commission of Paris, but he was dismissed in 1797 and spent the rest of his life reviled or forgotten. Around the middle of the nineteenth century, his works were reevaluated and they began to be seen as radiant and revolutionary in the artistic sense.

# PORTRAIT OF A DANDY

NICHOLAS HILLIARD
b. 1547 Exeter, England
d. January 7, 1619, London

PORTRAIT OF A DANDY
ca. 1587
Watercolor on parchment
5⅜ x 2¾ in. (14 x 7 cm)

Current Location: Victoria and Albert Museum, London
Note: Unfortunately, because of its fragility, it is not
always on view.

TODAY, WHEN contemporary paintings are often immense, and movies made for gigantic IMAX screens are in vogue, it is difficult even for dedicated art connoisseurs to appreciate miniature painting as more than some kind of trick — i.e., a technical feat on the opposite scale, and thus lesser in rank than "normal" size works. But in numerous periods of art history the creations of miniature painters were revered, not so much for the preciousness of their products, but for the satisfying artistic punch they deliver in their restricted formats. Many great painters tried their hand at miniatures—including Rogier van der Weyden, Raphael, Hans Holbein the Younger, Parmigianino, and even El Greco—and their efforts are by and large stunning. Yet none surpassed the works of the single most accomplished miniaturist who ever lived, the English master Nicholas Hilliard, who made a series of diminutive masterpieces for Queen Elizabeth I.

Of Hilliard's many resplendent works, one stands out because it is far from his usual formal images, an intensely appealing portrait, and something of a mystery—for no one knows for certain the identity of the handsome young man. It seems likely that it is Robert Devereux, the second earl of Essex, who had an erratic military career. In his twenties he was a great favorite of Queen Elizabeth, and later was triumphant in a score of battles. Yet he ended his life tragically: He lost his fortune in 1599, subsequently attempted to stir up Londoners in a rebellion, and was executed in 1601.

The Latin inscription above the head of this dandy, "*Dat poenas laudata fides,*" is a fragment from first-century Roman poet Lucan's *De Bello Civili*, in which the eunuch Pothinus counsels Pompey's death, thus linking the portrait to the Earl, who fancied himself a modern Pompey. The lines that begin with these words were translated by Ben Jonson as: ". . . a praised faith/Is her own scourge, when it sustains their states/Whom fortune hath depressed." (Or, in more modern language, faithful love and loyalty bring their own pain and suffering.)

The format is a tall oval, which Hilliard used only this once. Every line is deliciously subservient to an unseen geometric grid, so strong yet so subtle that it influences us without becoming obvious. The dandy, garbed in the Queen's colors of black and white, is flanked by two thorny bushes with lacy branches of delicate leaves and tiny white

flowers. These are eglantine, the white, single-flower five-petaled rose, the image of which occurs repeatedly in Elizabethan mythology. It's amusing to speculate if those thorns placed as a barrier could signify that he's protecting himself from Queen Elizabeth, or playing hard to get. An intriguing story is told that the Queen, who adored him and very likely bedded him, was not told when the earl married the widow of soldier-poet Sir Philip Sidney, a secret that came out two years later when his wife gave birth to his child.

Whatever this image, it's a love object. It cannot be chance that the exact center of this oval composition is precisely the dandy's crotch, which is partially hidden by his doublet. The sweet, yet masculine face—seemingly carved out of unblemished ivory and framed by luxuriant dark, curly locks—is angelic but decidedly human at the same time. The smile is gracious and come-hither, too. The white ruff collar is like some sort of secular halo. Perhaps Hilliard was prescient and made this man—whether or not it is the earl—a fallen angel. He certainly became one.

Hilliard, who is given the role as the primary English painter of the High Renaissance, produced some of the prettiest, most harmonic and gentle portraits in the history of Western art. Many historians attribute the excellence of much late-sixteenth- and even seventeenth-century English portraiture to his influence. Hilliard was an accomplished goldsmith and jeweler as well as a painter. He was appointed goldsmith and limner to Queen Elizabeth I while he was in his early twenties—around the year 1570—and around 1583 became her miniature painter, executing numerous graceful (and true) portraits of her and dozens of her court members.

Hilliard freely admitted that his greatest influence was the work of Hans Holbein the Younger, a gifted German portraitist working in England between 1526 and his death in 1543. Holbein is undoubtedly the source of Hilliard's tendency toward serene, nondramatic lighting and strong contours, as seen especially in our striking portrait of the dandy. When James I took the throne in 1603, Hilliard continued as a court painter, but the atmosphere of gaiety was no longer there. Life ended sadly for him. Always a spendthrift, he went bankrupt more than once in a period when that was a near-mortal sin. He was imprisoned for debt in 1617 and died two years later.

# THE VENUS OF WILLENDORF

ONE OF THE most powerful religious images ever produced during man's long span of history is not Christian or Greek, but of an unknown religion created long before any religion or cult was recorded. It is a tiny stone figurine at least eighteen thousand years old, found in 1908 in a Paleolithic site at Willendorf, Austria, and is called the *Venus of Willendorf*. The image is a female of such womanhood and fecundity that this dazzling statuette might well stand for the universal portrayal of female power. Her face is hidden by a sort of stocking cap, which in all likelihood is some sort of royal mask. She is marked by enormous breasts, a large pubic triangle, and ample buttocks, which symbolize early man's reverence for the life-giving powers of the human form. They vividly depict woman's capacity to give birth and to nurture and suckle new life. Originally, the figure was covered with red ocher, the sacred color of blood, the fundamental material of human and animal life. When one finds the diminutive statue in its case in the Museum of Natural History (just across from the Kunsthistorisches) one literally steps back in astonishment at the power and vitality of the work.

Carbon dating and other circumstantial evidence suggest that this banner achievement of Paleolithic man was produced sometime between 28,000 and 18,000 B.C.

ARTIST UNKNOWN
Paleolithic era, in what is now Central Europe

VENUS OF WILLENDORF
28,000-18,000 B.C.
Stone
Height 4¾ inches (12 cm)

Current Location: Museum of Natural History, Vienna

# BOOK OF KELLS

ARTISTS UNKNOWN
Irish(?), late 7th-early 8th century

LIBER GENERATIO
or CHI-RHO MONOGRAM PAGE
(fol. 34r) from the *Book of Kells*
ca. 800
Ink and pigment on vellum
13 x 9½ in. (33 x 24.1 cm)

Current Location: Trinity College, Dublin
(Ms. 58, A.1.6)

THE *BOOK OF KELLS*, a 680-page illuminated Latin manuscript of the four gospels, is a luxurious work of art so strange that it seems to come from an alien culture. When was it illuminated? Probably around 800. Where? No one knows for sure, although it is thought to have been either in the island monastery of Iona off the west coast of Scotland or in the monastery of Kells in County Meath, Ireland, which the monks of Iona founded when they abandoned their island haven after a series of devastating Viking raids. Iona was founded around 561 by St. Colum Cille, to whom the *Book of Kells* was traditionally attributed. The book was stolen in 1007 and its gold covers wrenched off. A few of the pages at the front and back were shredded, and all the pages were pared down about an inch. Since the seventeenth century, the book has been in the library of Trinity College, Dublin. It was probably never finished, and the monks who wrote the text made dozens of errors, but the illuminators were flawless. The decorative pages—including many full-page miniatures of saints, narratives of the life of Christ, carpet pages, and ornamented canon tables—are made up of incredibly fine mazes of brilliantly colored ornaments and totemic figures wrapped in geometric folds of metallic drapery. Throughout the text pages run richly colored arabesques of animated initials made of the twisted bodies of fantastically stretched-out beasts. The pigments are mini-treasures in themselves. There is an abundance of ultramarine, which in the late eighth century was worth several king's ransoms.

To me, the finest illumination is the *"Liber generatio,"* which faces the beginning of Matthew's genealogy (Matt. 1:18: *"XPI h generatio"* or *"Christi autem generatio").* It is often called the *Chi-Rho Monogram Page* after the two Greek letters in Christ's name illuminated on it. The Chi (the Greek X) looks like a P, the Rho (the Greek R) looks something like an R, and the I looks like an inverted L. But it doesn't matter what the letters are or whether they can be read or not, because this is untrammeled artistic fantasy. There is a large diamond-shaped decorative element where the two strokes of the letter Chi cross each other, and at its center is a smaller diamond of pure white pigment that comes across, at least to me, as the essence of nothingness, or the neutrality that existed at the birth of the universe. I prefer to look at the countless mazes of red and gold interlaces and sweeps, sallies, and curlicues that surround that

diamond of nothingness as a mystical cosmic field, as dense as the Milky Way and several times more beautiful. Except for the images of several human heads (one at the Rho's curved end), the three angels (along the Chi's descending vertical stroke), and a number of animals playing, there is an uncanny—and refreshing—absence of anything that suggests the presence or the creative force of humanity. One twelfth-century monk called the *Book of Kells* and its complex mazes within mazes "the work of an angel, not of a man." Could be. The interlinked motifs made up of thousands of lines and whorls and loops, all perfectly proportioned, flow into one another with a degree of vitality equivalent to the energy activating the entire cosmos. This work is both hoary with tradition and sparklingly contemporary, looking like some religious subject of abstract expressionism. There are strong and curious ties to early Christianity and subtle and unmistakable links to the new and dashing Carolingian style, which attempted to revive the high style of humanistic classical antiquity (see *Utrecht Psalter*, page 116). This combination of a very old, even "primitive" flavor with the contemporary gives these decorations their raw power.

# EDOUARD MANET

# A BAR AT THE FOLIES-BERGÈRE

IN THE CURRENT madness for all things Impressionist, the work of Edouard Manet (who never exhibited with the Impressionists) has always been a bit ignored—possibly because of his statement that he wanted to produce modern paintings that would be accepted to hang in the greatest museums of France. Maybe he's not considered sufficiently radical. Yet he deserves almost as much credit for the birth of contemporary art as Paul Cézanne.

To me, his preeminent masterpiece and one of the most compelling paintings created in the West is a preachy sort of painterly wonder called *A Bar at the Folies-Bergère*, which he finished just around his fiftieth birthday. The picture shows a barmaid (posed for by an actual Folies-Bergère barmaid named Suzon) waiting to serve her customers, while in the mirror behind her the feet of some acrobats can be seen doing their tricks. The performers are being casually watched from the floor, also reflected in the mirror, by some notorious members of the Paris demi-monde, the world existing exuberantly on the fringes of Belle Epoque society. The fact is that these marginal characters are far more interested in themselves than the active performers.

The most intense feature of this grand practice of illusionism is the dynamic contrast between the courtesans and whores residing in the background of the picture and the still, calm, melancholy young woman. She is presented to us almost like some ancient goddess who stands far above the crowd of fashionable humanity in front of her. Is she the only object not for sale?

Some individual passages of this painting are exceptional: those self-absorbed courtesans at the tables hungrily gazing at each other (in a frenzy to see and be seen); the fragments of the acrobats; the marvelous blaze of the emerald-green shoes of the trapeze artist; the deep-space green of the bottle in the lower right corner; and the astoundingly fresh details of the still life in the foreground. But it's the mirror that energizes the work, both as a means of developing a startling reverse perspective and also because it places the demi-monde where we observers stand, with "La Belle Suzon" awaiting our next move. This is as much a statement about manners and mores as it is about the art of painting.

EDOUARD MANET
b. Jan. 23, 1832, Paris
d. April 30, 1883, Paris

A BAR AT THE FOLIES-BERGÈRE
1881–1882
Oil on canvas
37¾ x 51¼ in. (95.9 x 130 cm)

Current Location: Courtauld Institute Galleries, London

# THE ROHAN BOOK OF HOURS

THE ROHAN MASTER
fl. ca. 1410–25, southern France and Paris

DYING MAN BEFORE CHRIST
from *The Rohan Book of Hours*
ca. 1415–1425
Illumination on vellum
10 x 7 in. (25.4 x 17.8 cm)

Current Location: Bibliothèque Nationale, Paris
(MS. Lat. 9471)
Note: The manuscript is not shown very much,
owing to the damaging effects of light, but it is
possible to make an appointment to see it.

TO ME THE most powerful and moving work of expressionism is not a twentieth-century painting but a manuscript from fifteenth-century France—the richly illuminated *Rohan Book of Hours*, named for a member of the Rohan family who became its owner several decades after it was completed. According to the most likely theory, this extraordinary work may have been commissioned by Duchess Yolande of Anjou. It is generally believed that the images in this book were painted probably not long after the Limbourg brothers' *Très Riches Heures* (see page 232), because some of the figures seem to be derived from that work.

The most triumphant of the 127 remarkable illuminated pages is one of sixteen designed to mark the Office of the Dead: the *Dying Man Before Christ* (or *God the Father*, according to other interpreters), representing a scene from the Last Judgment (on folio 159). The Rohan Master's version of this gripping drama possesses a combination of fearsome boldness and poignancy unparalleled in art, enhanced by the juxtaposition of subtle hues and thunderously brilliant colors. The pale pinks in the mantle of Christ—white-haired like God the Father—are set off by the yellow lining and the gold of his pallium, orb, crown and aureole, and by the electric blue of the background; and the Chinese lacquer red tunic of St. Michael and the red stripe that surrounds the body of the dying man like the flame of resurrection itself are daring and appropriate. The cadaverous white of the skulls and bones scattered around the body is deliciously harrowing.

Among the many startling passages in this audacious image, take particular note of the sword of Christ, the scrolls with their messages (one in Latin and one in French, referring to the Office of the Dead), the rhythmic placement of the skulls and the twenty-five bones—the best dance of death ever depicted—and, above all, the bearded, naked, dying soul, which is one of the most strikingly beautiful of such images in the history of art and the climax of this work. One bony hand is relaxed in eternal peace—the one nearest to

Christ/God, of course—while the other appears to be scrabbling, desperately clutching at the worldly purple-blue and gold robe and its blood-red trim, as if never wanting to leave life and the pleasures and the riches of this earth. A gossamer loincloth reveals the dying man's little genitals, another symbol of faded vitality. The body's diagonal position is deliberately ambiguous, for the figure could be either falling down or rising up to Christ. And the portrayal of Christ is splendid, with a face that appears serene, sad, pitying, delicate, and craggily—almost demonically—powerful.

Very little is known about the French miniaturist and painter called the Rohan Master, named after the greatest of the approximately thirty-five Books of Hours assigned to his workshop. He flourished between 1410 and 1425. His earliest works indicate that he began working in Provence and then in Troyes (with several visits to Paris), from about 1410 to 1414. By 1414 he moved to Paris with one or two assistants and collaborated with ateliers there, such as that of the Boucicault Master.

# TANCRED AND ERMINIA

NICOLAS POUSSIN, the epitome of the school of classical painting of the seventeenth century, has always been misinterpreted by art historians. They laud him as one of the greatest masters who ever lived, yet at the same time they imprison him as a cool, detached, somewhat passionless man. At his best he is a master conjurer of mood and the romantic moment, and a compelling storyteller. He is also a master at improving himself, something masters seldom bother to do.

Take the divinely romantic and affecting scene of *Tancred and Erminia* from Torquato Tasso's poem *Jerusalem Liberated* (1581) when Erminia, the practitioner of spells, whose black magic has led to the death of the knight Tancred, whom she loves, becomes aware that it is she who has slain him. Poussin has portrayed her holding her sword over the fallen Tancred at the very moment when she realizes that she has committed a heinous crime, against Tancred and against herself. The kernel of the drama—and the center of the composition—is directly over her heart, which is where, one suspects, her sword will instantly be turned. Of course, all the noted Poussinesque clichés are evident: the staged composition, the

paired magnificent horses, the historical correctness of the scene. But there is also a flood of pure emotion accentuated by the muted primary colors, here made russet, poetic beyond description in the twilight of perpetual sorrow.

Poussin is acknowledged to be the preeminent seventeenth-century painter of France, a practitioner of the classical, lyrical mode and one of the most gifted artists to have ever lifted a brush to canvas. Poussin's works are distinctive; even the best school copies and the most wily fakes fail quickly when compared to one of his known masterpieces. His rendering of scenes from the Bible and from Greek mythology influenced several generations of European painters, including David, Ingres, and even—remarkably—Cézanne.

Poussin painted two versions of this subject. The earlier one (now at the Barber Institute of Arts, Birmingham) is sloppy and without drama; the one shown here is the later version, a masterpiece of properly sentimental theater. Another work by Poussin comparable in quality to this splendid *Tancred and Erminia* is his self-portrait in the Louvre, which may well be one of the most penetrating self-portraits ever created.

NICOLAS POUSSIN
b. June 1594, Villiers, France
d. Nov. 19, 1665, Rome

TANCRED AND ERMINIA
1630s
Oil on canvas
$38^{15}/_{16}$ x $57^{7}/_{8}$ in. (99 x 147 cm)

Current Location: The Hermitage, St. Petersburg

# THE GREAT OLMEC HEAD

THE FIRST COMPLEX civilization in pre-Columbian America was the Olmec. What archaeologists call the early formative period dated to around 1200 to 900 B.C. One of the richest sites is San Lorenzo, atop a plateau overlooking the Rio Chiquito branch of the Coatzacoalcos River. This place, occupied and abandoned over a period of 2,500 years, attained its cultural and political zenith between 1200 and 900 B.C., when more than eighty stone monuments, including ten colossal heads, were created. The basalt heads comprise some of the boldest stone sculptures of the ancient world and significantly influenced the pre-Columbian art of South America. Most scholars today agree that these heads are portraits of living or recently deceased rulers, primarily because there are distinct signs on some that they were recarved from existing thrones—enormous rectangular stone objects which themselves were embellished with representations of the ruler and his divine ancestry.

These stone heads are breathtaking. This one, which I think may be the best to have survived, shows the ruler in his odd ceremonial headdress—apparently of great importance in antiquity—which resembles an old-fashioned leather football helmet. His face with its slanting eyes, broad nose, and slightly open mouth reflects a confidence and serenity that is equal to any of the most imposing royal portraits ever made.

ARTIST UNKNOWN

THE GREAT OLMEC HEAD
(San Lorenzo Monument no. 8)
1200–900 B.C.
Andesite stone
84 x 63⅗ x 63 in. (21.4 x 161.5 x 160 cm)

Current Location: Museo de Anthropologia, Xalapa, Mexico

# THE GREAT SPHINX

COLOSSI DO not usually weigh in as great works of art, being more curiosities than pieces that give us a profound aesthetic boost. Except one, the *Great Sphinx* at the edge of the Giza plateau, representing pharaoh Kephren (fourth king of the 4th dynasty, 2575–2465 B.C.) as the embodiment of the sun god Ra. The first time I saw this amazing monument it was dusk and my guide, who was an official and could thus get me in through the front door, insisted I approach the pyramids from their proper entrance—the sphinx. It is immense, some 240 feet long and 66 high. But to me the astonishing feature was that the sphinx appeared far larger than it was and the great pyramid smaller—very much in human scale. I would have thought the opposite would be true and am convinced the architect of the cemetery complex intended the impression to be just that.

As the sun set, I was moved by the haunting image and I experienced romantic frissons similar to those that travelers have experienced throughout the more than 4,500 years the powerful sculpture has guarded its king.

In Arabic the sculpture is known by the name of "Abu al-Hawl," or "Father of Terror." When night had fallen I could easily understand why.

ARTIST UNKNOWN

THE GREAT SPHINX
2575–2465 B.C.
Sandstone
240 x 66 ft. (73.1 x 20 m)

Current Location: Giza, Egypt

# TITIAN
## RAPE OF EUROPA

TITIAN

(Tiziano Vecellio)

b. 1488/90, Pieve di Cadore, Italy

d. 1576, Venice

RAPE OF EUROPA

1559–62

Oil on canvas

73 x 81 in. (185.4 x 205.7 cm)

Current Location: Isabella Stewart Gardner
Museum, Boston

IF I WERE TO select the single most exciting painting in the West, I might choose Titian's *Rape of Europa*. Painted for Philip II, King of Spain, the grandiose picture illustrates the legend of Jupiter appearing in the guise of a white bull to seize and make love to Europa. It is both a pagan celebration and a morality play painted with the richest colors, hues, and glazes ever applied to canvas.

In the foreground swims Jupiter as a great grizzled bull looking back at his prey with a hysterical white-rimmed eye dominated by a black pupil that is as threatening as a weapon. Underneath him is a vicious-looking sea monster, while a putto follows right behind the perpetrator on a huge fish. The bull's tail quivers in anticipation. The entire atmosphere is threatening, yet the waters are calm, and the sky is divinely crepuscular—obviously the calm before a storm. The whole picture seems to be imbued with a profound sense of tortured despair. Europa is thrown back into an extremely sexy pose, yet her face shows both anguish and delight in what's coming. The red robe flung over her head seems to be a warning that Jupiter might not find this encounter so sweet. Her friends in the distance are screaming, but are helpless to do anything.

Titian, whose real name is Tiziano Vecellio, was the son of a modest government official and was born in a small village high in the Italian Alps close to the Tyrol. At the age of nine he went to Venice, and his first contact with art was in the workshop of Zuccato, a mosaicist, but he soon moved on to study with Giovanni Bellini and then with his own slightly older contemporary Giorgione. His early pictures show the strong influence of Bellini and of Giorgione.

Among his best works, which are in the Galleria Borghese in Rome, is the glowing *Sacred and Profane Love* (ca. 1515), a symbolic portrait of two women in an idyllic landscape. It is generally thought that the two women, one clothed and the other nude, are the twin Venuses, according to Neoplatonic symbolism. The earthly Venus, clothed, stands for the forces of nature, while the nude Venus represents eternal and divine love. Another fine work by Titian is *The Feast of the Gods*, which Bellini also worked on extensively. Titian's late works are fabulous, especially *The Flagellation* in Munich's Alte Pinakothek. Yet, with all his masterpieces, the *Rape of Europa* still emerges as the best of the best.

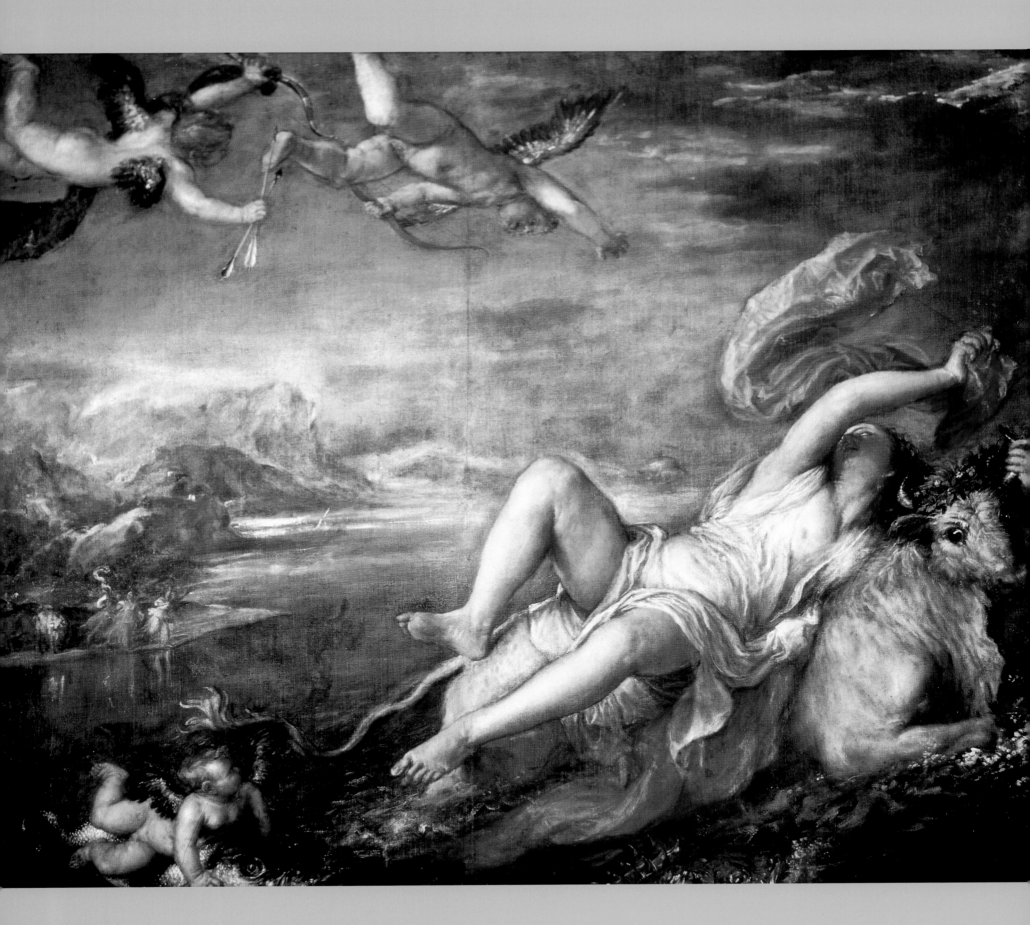

# THE UTRECHT PSALTER

ARTISTS UNKNOWN
Reims, 9th century

PSALM
from the Utrecht Psalter
816-35
Pen and ink on vellum
9⅞ x 13 in. (24.9 x 33 cm)

Current Location: University Library, Utrecht, Netherlands (Ms. script. eccl. 484)
Note: The psalter is not on public display, but the librarian of the rare books and manuscripts section will show it to scholars and others who demonstrate keen interest. (There is also an eleventh-century English copy in the British Museum.)

THE ART PRODUCED in Western Europe during the reign of Charlemagne (Charles the Great) —king of the Franks (768-814) and emperor of the West (800-814)—and his ninth-century successors is known as Carolingian art. Charlemagne and his artistic and religious advisors instructed the artists who painted frescoes, carved ivories, and illuminated manuscripts to use early Christian (specifically Constantinian) models for their inspiration. Charlemagne, who saw himself as the "new Constantine," wanted to proclaim his spiritual and philosophical kinship with the Roman emperor who had allowed Christians to worship without fear of persecution nearly five hundred years earlier.

One of the most splendid works of this singular period is a deeply religious manuscript known as the *Utrecht Psalter*, which is fanciful and invigorating as a work of art. This Book of Psalms is the first to attempt a visual translation of every element of those biblical verses, combining them in an integrated scene on a rectangular page for each psalm. The unknown artists—four or five, according to some experts in the determinations of individual styles—conceived the drawings as a series, with an almost continuous landscape peopled with figures drawn in red-brown ink in sketchy, fuzzy lines charged with nervous energy. Sometimes the muscular landscape consists of strange hummocks that look like the knuckles of a huge clenched fist. Many of the drawings' multiple scenes are in three registers (though with no lines actually dividing them). In the top register of several drawings, Christ as warrior is shown attended by angels or a great, dynamic hand of God bursting out from a cloud. In some of the lower registers, the dark powers of the underworld pour forth from mysterious chasms, while in the middle register, the Blessed struggle with the nonbelievers, and God intervenes with His angelic host to crush their enemies. The agitation of these battle scenes and the frantic byplay of the tiny figures are extremely exciting; the onlooker cannot fail to be caught up in the action. Every figure, every element of the landscape, every animal possesses an ethereal lightness. The Blessed move like quick elves, buoyant and free, or are shown poised on tiptoe like ballet dancers.

Although the artists of the *Utrecht Psalter* made use of the best early Christian models, the high level of creativeness is all theirs. What a difficult task it was to render in visual form the often

complicated and arcane Psalms, with their many teachings and injunctions, without an overall dramatic narrative or a sequence of colorful events as in an epic poem. The artists made the most of the Psalms' verbal imagery, creatively seizing on key words that lend themselves to the invention of the picture. Note, for example, in the group of scenes that illustrate Psalm 73, the visual interpretation of verse 23 ("Nevertheless I am continually with thee: thou hast holden me by my right hand") at the upper right by showing God grasping the hand stretched out to Him; of verse 22 ("I was as a beast before thee") just below that by a beautiful mare and her foal; and of verse 20 ("As in a dream") at the middle left by a charming image of two men sleeping in neighboring beds.

# THE KRAKÓW ALTARPIECE

VEIT STOSS

EVERY DAY AT the stroke of noon, in the church of Notre Dame in the splendid central market square of Kraków, a nun approaches the gigantic painted wooden triptych over the high altar, carved in low relief with the most beguiling and energetic scenes of the life of Christ and the Virgin. Trumpets flare as she opens the huge wings of the immense altarpiece and folds them back on their enormous hinges. For a visitor admiring the exquisite low reliefs carved by the late Gothic master Veit Stoss, this might seem to be an inconvenience. But you have an amazing surprise in store for you. To see the interior of the enormous altarpiece is one of the most uplifting art experiences in the world. Carved in heroic size, the Apostles prepare for the Dormition and the Assumption of the Virgin. Crisp, powerful, and delicate, with poignant faces expressing profound emotion, these figures are on a par with the pediment sculptures of the Parthenon by Phidias and with Michelangelo's *Moses*. But these are, if anything, even more impressive, for they are deftly painted and gilded and surrounded by storms of crackling drapery, which add to their intense emotional fire.

Stoss is generally thought to be one of the most gifted sculptors and wood-carvers of sixteenth-century Germany. He was born in Swabia sometime between 1438 and 1447. In 1477 he gave up his citizenship in the city-state of Nuremberg and moved to Kraków in Poland, where he received the commission for the great altarpiece in 1477 and completed the massive work in 1489. He spent twenty years in Kraków, where his other works include the red marble tomb in the Cathedral for King Casimir IV Jagiello of 1492. In 1496, he returned to Nuremberg a wealthy man but lost his money because someone embezzled his life savings. He attempted to recoup them by becoming a forger, was nabbed and branded, and died embittered and in poverty even though the Holy Roman emperor Maximilian I granted him a full pardon. In Nuremberg there are spectacular pieces by Veit Stoss—especially, the *Annunciation* and *Christ Crucified* for the church of S. Lawrence. A diminutive boxwood statuette of the *Virgin and Child*, dating around 1510, can be found in the late medieval galleries of the Victoria and Albert Museum in London. It is so delightful and full of energy that it is worth going to the institution for the Stoss alone.

VEIT STOSS
[or Wit Stosz or Stwosz]
b. 1438/47, Swabia, Germany
d. 1533, Nuremberg

THE KRAKÓW ALTARPIECE
1477–1489
Wood
Height: 46 ft. (14 m); Width 40 ft. (12 m)

Current Location: Church of Notre Dame, Kraków

# EMBARKATION FOR CYTHERA

IT IS THE MOST perfect late summer's day, and the breath of autumn is in the air. Gorgeous men and women whose faces seem to flash brilliance are languidly walking in their refulgent silks down a delightful path to Venus's island. Or so it could be in this large oil painting by the early eighteenth-century genius Watteau. More likely, though, *Embarkation for Cythera* is a gentle parable about death and the incredible lightness of being that is said to come at the very end of life. Whatever the interpretation of this delicate and poignant work, the feathery style, the infinitely subtle colors, and the flawless depiction of landscape and human beings are breathtaking.

Watteau was quintessentially a Rococo artist but possessed a depth and a sensitivity toward humanity that has seldom been equaled. His works depicting the Commedia dell'Arte are incomparable.

ANTOINE WATTEAU
b. Oct. 10, 1684, Valenciennes, France
d. July 18, 1721, Nogent-sur-Marne, France

EMBARKATION FOR CYTHERA
1717
Oil on canvas
51 x 76 in. (1.3 x 1.9 m)

Current Location: Musée du Louvre, Paris

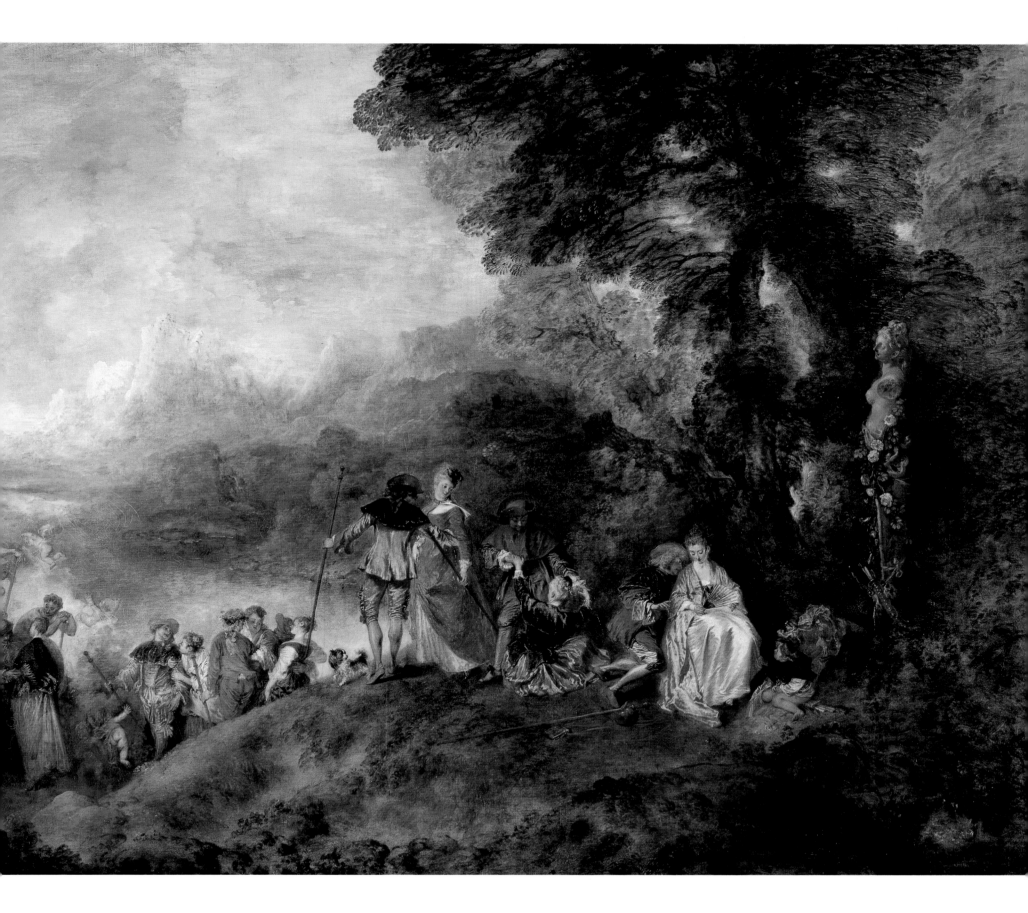

# THE BAYEUX EMBROIDERY

ARTISTS UNKNOWN
English (Canterbury?), late 11th century

BAYEUX EMBROIDERY
ca. 1073–83
Wool embroidery on linen
Height: 20 in.(50.8 cm)
Length of entire work: 229 ft. 8 in. (70 m)

Current Location: Musée de Peinture, Ancien
Evêché, Bayeux, France

ONE OF THE most thrilling works ever made is often called the *Bayeux Tapestry*, but it is really an embroidery. It was once thought to have been started by Mathoilda, William the Conqueror's consort, and carried out by the lonely wives of troops who invaded England with William and helped him vanquish King Harold in 1066. But it was probably made by a large workshop of skilled artisans specially trained for the task. Nearly 230 feet long, the *Bayeux Embroidery* was conceived as a grand propaganda banner that was displayed in Bayeux Cathedral like a movie or cartoon strip after the great victory had been achieved. It was also a memorial to the fallen troops. In its vigor, scope, and sheer bravado, and its depiction of brutal conflict, there is nothing to compare to this heady visual record of one of the most significant events in European history.

The *Bayeux Embroidery* consists of eight pieces of coarse linen of uneven length divided into seventy-five scenes (or 58 or 99, depending on how one describes a scene; it may have been even longer originally). The cast involves 623 people (of which only 6 are women), 202 horses and mules, 55 dogs, and 505 other animals, and there are also depictions of 37 buildings (ranging from huts to churches), 41 ships and boats, and 49 trees.

Although the figures are almost "stick figures," they project a great deal of character and a sense of being flesh and blood. The details add the final dash. The embroidery's grandeur comes from its exceptional size, dynamic vision, and agility of communication. It may have been made as an attempt to justify William's brutal war of conquest waged under the pope's banner.

The narrative starts with the English king Edward the Confessor planning to send Harold—himself interested in the kingship—to Normandy to offer the English throne to William. After an expedition to Brittany, the group goes to Rouen, where Harold is asked to take the oath of fealty to William. He does. Harold returns to England when Edward is dying. He is offered the English crown by what is conveniently described as an illegal parliament. Above this scene, Halley's comet appears as if to indicate the treacherous nature of the event (that would have been between April 24 and 30, 1066). William hears of the treachery and has trees cut down for the armada. Before the invasion there is a farewell dinner, which looks remarkably like

the Last Supper. Thereupon follow incredibly vivid scenes of the invasion, with fascinating vignettes and details showing the gathering of supplies, weapons, and so many wine casks that one wonders how the soldiers could have gotten on their feet to fight. Once on English soil, the battles of the cavalry and infantry are exceptionally dramatic. Even William's famous feint is alluded to, when his troops pretended to be routed, turned Harold's flanks, surrounded him, and slayed him with an arrow through his eye.

This staggeringly ambitious work was commissioned for the Bayeux Cathedral by the ambitious archbishop of Bayeux, Odo, William's half-brother, who became archbishop of Canterbury after the victory. He, not Mathoilda, paid for the work, which was done in England; the style of the figures shows close similarities to the best illuminated manuscripts from Canterbury. The *Bayeux Embroidery* may well have existed in the form of a splendid illuminated manuscript before it was worked in fabric.

# BENIN IVORY MASK

THIS IVORY MASK is intended to be worn on the belt of a great chief of the Bibi tribe in ancient Benin (today's Nigeria). Created by an unknown artist, it is one of the most skillful and imposing representations of royal power, intelligence, and authority ever made — something that the Romans would have loved. To think that some people still call this "primitive" art!

The mask is quite small, but one could imagine this face on a monumental statue twenty feet in the air in some city square. The two iron inlays on the forehead are thought to represent tribal scar marks, and the linked "skull" figures crowning the head and curving below the face like a collar are stylized heads of some Portuguese mercenaries the chief had bought and paid for and thus could be toyed with in any conceivable way. Although the date is unknown, it is generally agreed by experts to date from the seventeenth century.

Benin was one of the most significant kingdoms of the western African forest region and lasted from the thirteenth until the nineteenth century. The *obas* or kings were warriors, magicians, mystics, and intellectuals; from the sixteenth century on they were known to Europe, especially to the traders of Portugal and Holland; these nations sent ambassadors to the court of Benin. The art of Benin, starting with the fifteenth century, is remarkable for its excellence. The numerous craftspeople were organized into European-type guilds. Particularly noteworthy were the bronze castings and wood and ivory carvings. The kingdom collapsed in the late nineteenth century, in part because slavery in the west was stamped out. (Benin had been deeply involved in the nefarious trade and the weaker and more impoverished the kingdom became and the closer the borders were squeezed, the more the rulers indulged themselves in mad cycles of large-scale human sacrifices.) In 1897, the nation was incorporated into British Nigeria.

ARTIST UNKNOWN
Bibi tribe, Benin (Nigeria)

MASK
17th century
Ivory
Height: 9 in. (23 cm)

Current Location: Metropolitan Museum of Art, New York

# THE ALEXANDER SARCOPHAGUS

THIS MAGNIFICENT stone sarcophagus, found in 1887 in the royal cemetery at Sidon in Phoenicia, is the single most precious work carved in stone to have survived from the Hellenistic period. Though not made for Alexander the Great, one relief is thought to depict him leading his troops against his enemies, the Persians, in several long reliefs that still contain some traces of delicate print. The other relief shows a hunt with Macedonians and Sidonians. Everything about this unique coffin is mindboggling, from the tensile architectural details—it's a mini-Parthenon—to the dramatic sweep of the struggles between Greeks and Persians, to the details of their faces—many of which give the impression of being portraits—and the exquisitely carved hair and even fingernails. Despite the physical agony, the soldiers crying out in pain, no one seems hurt at all. It's like a play staged by some of the most captivating actors of the third century B.C.

The artist is unknown and so is the identity of the man for whom the coffin was carved. Some believe it might be Abdalonymus, one of Alexander's favorites who distinguished himself in the battle of Issus in 333 B.C. The piece is generally dated to the years 280–200 B.C. The work is today installed in a special, radiant gallery in the Archaeological Museum of Istanbul.

ARTIST UNKNOWN

THE ALEXANDER SARCOPHAGUS
280–200 B.C.
Painted marble
Length: 76¾ in. (195 cm)

Current Location: Archaeological Museum of Istanbul

# THE STREET

BALTHUS
[Count Balthazar Klossowski de Rola]
b. Feb. 29, 1908, Paris

THE STREET
1933
Oil on canvas
76¾ x 94½ in. (195 x 240 cm)

Current Location: Museum of Modern Art,
New York

TO ME, THE MOST powerful painting of World War II is not about fighting, or the atomic bomb, or outright violence—unlike Picasso's *Guernica* (which I've always thought to be superficially bombastic and theatrical)—but a mysterious, quiet work laden with unspoken threats and darkness. *The Street*, by Polish painter Count Balthazar Klossowski de Rola, or Balthus (as he prefers to be known), presents the most penetrating spectacle of the immediate pre-war European environment. Using subtle symbolism, it contains hints of all the horrors that Hitler boasted about in *Mein Kampf*, which became inevitable after 1933. In the first split-second of seeing this anonymous street, one feels a sense of dread. Nothing is right. There is a balance about to become imbalanced, a harmony about to turn discordant. It is the minute of stillness before the arrival of Armageddon.

The characters in *The Street* are almost stock types—children playing, a mother carrying a baby, a chef, a construction worker, a boy garbed in a sailor's suit. Yet, once you look at them closely they become profoundly disturbing, for they are weighed down with portents. The face of the child playing with the blue racquet and ball, who appears retarded, is distorted by a pathetically grotesque facial expression. The chef with his exaggerated toque seems to be in a trance, or maybe a dead man walking. The sailor boy wears a smile that's half fun and half idiocy. The woman passing him in black wears a hat with a red cross that's reminiscent of the red mark on a black widow spider. Another woman holds a child who is no child but an ancient dwarf dressed to look like a child, whose eyes are firmly closed as he is carried into what he believes will be something hideous. The street itself is nowhere and everywhere; the signs on the shops are all blurred or obliterated. The mood of *The Street* is such that any minute one imagines that one will hear the first air-raid sirens of the war and the pounding of bombs. The people are just like those who were to die in the death camps—except for the worker in white carrying the slab of wood hiding his head, who, to me, is quite possibly the symbol of the most dreaded horseman of the Apocalypse: death himself.

Balthus was born in Paris to a noble and highly talented Polish family. When Balthus was just eleven, the great German poet Rainer Maria Rilke took a liking to his work. *The Street* was Balthus's

first major painting. The original version had one erotic detail that was removed before it was exhibited in 1934: a man sexually caressing a very young girl. The change scotched ugly rumors about the painter's proclivities, but a host of later pictures of a decidedly erotic and superficially "Lolita-esque" nature (almost always misunderstood by critics) gave Balthus the reputation for being overly interested in adolescent girls, at least in his art.

For a long time Balthus was the director of the prestigious French Academy in Rome and made wholesale renovations to the deteriorating sixteenth-century Villa Medici, its residence since 1803, thus saving it for posterity. Some fifteen years ago he retired to Switzerland with his second wife, and, now in his eighties, is still painting at a deliberate pace. His works are highly praised critically and hang in the finest museums in the world.

# ST. GEORGE AND THE DRAGON

ONE OF THE surest signs that a work of art is one of the highest creative achievements is that it can be visited dozens of times and continues to be an object of inspiration. Such is the case with the series of nine paintings by the Venetian painter Vittore Carpaccio, *Scenes from the Lives of St. George, St. Tryphon, and St. Jerome*, 1502–08, that are in the chapel-meeting room of the tiny Scuola di S. Giorgio degli Schiavoni. This *scuola* (society) was established in 1451 by *Schiavoni* (Slavs) from Dalmatia (roughly today's Croatia)—mainly merchants, artisans, and sailors—who built their first headquarters between 1480 and 1501 on this site. (It was torn down in 1551 and rebuilt.) They commissioned Carpaccio to make a series of paintings of their patron saints, and he complied with two each on St. George and St. Tryphon and three on St. Jerome, plus two unrelated scenes (*The Calling of St. Matthew* and *Christ on the Agony in the Garden*). The principal delight of this series comes from the high excitement developed by the painter, and from the impeccable figure style and the sharpness of the myriad details. There is also a thrilling contrast between the dramatic scene of

the armored St. George slaying the dragon astride a most vigorous horse and leaning way over its neck in his pell-mell attack, which takes place over a rocky landscape strewn with grisly body parts of the dragon's recent meals—skulls, bones, and partly devoured bodies of various victims—and the quietude of St. Augustine seated in his study, about to respond to a letter from St. Jerome, surrounded by artifacts of such wonder and beauty that we might hope to find one of them in an antiques store somewhere.

Carpaccio is the quintessential Venetian painter of the period just before the explosion of color and light in early sixteenth-century Italian painting. He was a sublime chronicler of Venetian activities, and his scenes of the canals and streets of Venice filled with a variety of people—such as *The Miracle of the True Cross*, 1495, and several of the nine paintings in the series *Scenes from the Life of St. Ursula*, 1490–95 (all in the Accademia di Belle Arti, Venice)—are among the most penetrating ever created. Most of his works are characterized by fanciful invention, a particular clarity of light, detailed observation, stateliness and grace, and

VITTORE CARPACCIO
b. 1465, Venice
d. 1526

ST. GEORGE AND THE DRAGON
1507
Oil on canvas
55½ x 140 in. (141 x 360 cm)

Current Location: Scuola di S. Giorgio degli Schiavoni, Venice

richness of color. One of the wonderful things about the series in the Scuola di S. Giorgio degli Schiavoni is that the entire original work is here, unsullied by any later restoration.

Carpaccio may have been the pupil of the Venetian Lazzaro Bastiani, yet the dominant influences in his work come from the painters Gentile Bellini and Antonella da Messina. One of his major works—sadly most of his documented altarpieces have been dispersed—is the superb *Presentation in the Temple*, made for S. Giobbe, which is now in the Accademia in Venice. His final two works are two shutters for a grandiose organ—dated 1523—now in Capodistria.

# THE BLUE BOY

THOMAS GAINSBOROUGH

THOMAS GAINSBOROUGH
b. ca. May 14, 1727, Sudbury, England
d. Aug. 2, 1788, London

THE BLUE BOY
ca. 1770
Oil on canvas
70 x 48 in. (177.8 x 121.9 cm)

Current Location: Huntington Library,
San Marino, California

THIS DROP-DEAD portrait by Thomas Gainsborough is proof that, when it came to the fine arts, the seventeenth century didn't have it all—although the painting does owe an obvious debt to that golden age. Gainsborough painted the youthful Jonathan Buttall, the son of a hardware merchant who was a close friend of the artist, in a costume that is similar to those in pictures by Van Dyck, whom Gainsborough admired enormously.

The portrait is extraordinary—an uncanny combination of direct, almost brutal realism with soft romanticism and melodic poetry. The boy's face is presented straight-on, like a Renaissance sculpture (there's more than a little resemblance to Donatello's *David*) and he stands in a pose far more classical than Van Dyck would ever have achieved. What confidence! How relaxed, with one arm akimbo! This is not a pretty boy, but a confident, amusing spry young human being. One wonders what happened to him—everything good, one hopes. The treatment of the landscape, with the oncoming stormy clouds and the sunset, is equal to the magical handling of paint in that impossibly blue costume, which is perhaps the most invigorating passage of paint in all of the eighteenth century. The contrasting silver piping is what makes the costume.

Gainsborough was the youngest son of John Gainsborough, a maker of woolen goods. When he was thirteen, he talked his father into allowing him to study painting in London, and started on a career that flourished for the rest of his highly creative life. In 1746 in London he married Margaret Burr, illegitimate daughter of the duke of Beaufort, and returned to his native Suffolk and settled in Ipswich. He went back to London in 1774 and soon became extremely popular with the royal family and a favorite of King George III, and obtained the cherished commission to paint the king and queen.

Of all the eighteenth-century English painters, Gainsborough was the most inventive and original, always prepared to experiment with new ideas and techniques.

NICHOLAS OF VERDUN

# ALTARPIECE OF KLOSTERNEUBURG

NICHOLAS OF VERDUN
active ca. 1150-1210

ALTARPIECE OF KLOSTERNEUBURG
completed 1181
Gold and enamel plaques
Length: 85¾ in. (220 cm)

Current Location: Abbey Church, Klosterneuburg, Austria

ONE OF THE most resplendent gilded and enameled treasures of the Middle Ages—when glitter was considered to be very holy—is the altar retable (originally a pulpit frontal, scholars believe) made by Nicholas of Verdun for Klosterneuburg Abbey, near Vienna, and which today graces the crypt of the abbey church.

The wall of gold and gleaming colors consists of five tri-lobed, bronze-gilt and champlevé enameled plaques in three registers—the most exuberant, revolutionary, and creative work of this kind ever produced. In three bands episodes from the Old and New Testaments are depicted in thrilling scenes. The scenes selected from the Old Testament are close parallels to the life of Christ—regarded in medieval times as typological scenes that prefigure incidents in the New Testament, and interpreted as proofs of Christ's legitimacy. Each scene is a depiction of humanity as divine decoration. Among the most beautiful are the *Birth of Isaac, Isaac and the Queen of Sheba*, the *Last Supper* (with Judas lurking in the foreground like a wild beast about to

leap and kill), *Samson and the Lion*, and the *Mouth of Hell*. The enamels are mostly blue and green, with some speckled ones in red and blue. The figures have been outlined in enamel so that they seem to have been drawn with an unerring pen. The anatomy of the human figures is amazingly accurate and expressive for this early period, and the drapery of their garments seems to course over their bodies in liquefied patterns that strengthen the feeling of anatomy. The faces are emotional, with strong, individualistic expressions and penetrating eyes. This altarpiece is the most ambitious work of bronze and enamel in the entire twelfth century, and may well be the most satisfying work of art from the late Romanesque period.

Nicholas of Verdun, whose active years seem to have been between 1150 and 1210, was a metalworker, enameler, sculptor in bronze, and the most accomplished goldsmith of the twelfth century. He was an itinerant craftsman whose life is known only from his spectacular works, some of which are signed and dated—unusual for the Middle Ages—

which indicates that he held an exceptionally lofty position. Another one of Nicholas's masterpieces is the immense bronze-gilt, gold, silver, and enameled *Shrine of the Three Kings* in Cologne Cathedral (ca. 1190-1200, remodeled later). His work represents a transition from late Romanesque to early Gothic style, and shows a number of influences, including Byzantine art (twelfth century and earlier) and the illuminations of Master Hugo of Bury St. Edmunds (see page 87).

# BIRD IN SPACE

CONSTANTIN BRANCUSI

CONSTANTIN BRANCUSI
b. Feb. 19, 1876, Hobitza, Romania
d. Mar. 16, 1957, Paris

BIRD IN SPACE
1928
Bronze (unique cast)
54 x 8½ x 6½ in. (137.2 x 21.6 x 16.5 cm)

Current Location: Museum of Modern Art, New York

FEW WORKS OF abstract art have crossed the line from flashy contemporary to time-less, especially those that combine abstraction with a bit of naturalism. But Constantin Brancusi's arching and ageless *Bird in Space* has succeeded brilliantly. There is not much in this glowing polished piece other than a stout base, a diminishing waist, and then an expanding shape on top, but these forms add up to a feeling of soaring majesty.

This is a sculpture that pulls one over to it to caress, yet at the same time frees one's mind from mundane matters. Whenever one comes upon one of the various versions of *Bird in Space* in a museum or private collection—the one shown here is the first of several—one is immediately lifted into the air, both mentally and physically.

From his early life, you would never imagine that Brancusi would have become a great artist. In 1886, at the age of ten, he left school to work as a shepherd, not able to read or write. But in 1894 he entered a local crafts school, where he took up wood carving, joinery, and smithing, and three years later he went to Vienna to work in a furniture factory. From there he went to art school in Bucharest, where he excelled in sculpture, and graduated in 1902.

Struggling to support himself, Brancusi slaved away at carpentry in his home town in Romania and by 1904 had made enough money to enroll at the Ecole Nationale des Beaux-Arts in Paris. Although he declined an invitation by Rodin to work as an assistant in his studio, he made sculpture for a while in the manner of the older master, but soon developed his own radically different style, an abstraction that was eerily private and quiet. The works are sometimes in wood or stone or a combination and are stocky, dynamic abstracts looking sometimes as if two elegant gray cinder blocks are having a love affair. His style became solidified after his friendship with the Italian artist Amedeo Modigliani began. Mature works include the striking *Sleeping Muse*, in which the polished brass head of a woman stands as the sleeper alone. His fame spread through America in 1933, after he was shown at the Brummer Gallery in New York to rave reviews and his works were collected by the Museum of Modern Art.

In 1952 he became a French citizen and was praised as one of the country's finest artists. He died on March 16, 1957, and willed the contents of his studio to the Museum of Modern Art there.

# THE BOHEMIAN MADONNA

BOHEMIAN HIGH court art of around 1380 to 1420 is so luminous that the entire movement is called the Beautiful Style. This Madonna and Child of around 1410 is unquestionably the best of the best. Who, other than this unknown painter who was deft enough also to carve the tiny figures in the frame—each one of which would be considered a masterpiece of the period if it alone had survived—would dare represent the mother of Christ as a gorgeous woman of the court.

The refinement of gesture, face, and movement is unequaled. This is a beauty that risks everything, for the painter came very close to the brink of becoming cloying. But the sincerity of the style preserves it as something grand. The colors are so vibrant they seem more like precious gems, melted down and then solidified onto the wooden panel, than mere swatches of pigment.

The Beautiful Style grew out of the works of art produced in the Court of Burgundy and notably from the artists who worked for the great patron of the arts, the duke of Berry. The movement ignited all of Europe and soon moved to Bohemia, where the finest elements of the style were perfected.

We have no idea of the identity of this superb Bohemian painter and sculptor—for whoever painted the Madonna also carved the tiny, impeccable figures of saints in the frame.

ARTIST UNKNOWN

THE BOHEMIAN MADONNA
ca. 1410

Current Location: National Museum of Prague

# NORTH RIVER

NOT MANY DEPICTIONS of the dead of winter are finer than this bravura landscape by George Bellows, the first painting he sold to a museum. It's a grandiose painting. The scene is the Hudson River (also called the North River) from a spot in northern Manhattan across from today's built-up Fort Lee, New Jersey. Winter has the city and the river in almost a death grip, yet the ice hasn't formed to block the waters. There's snow on the ground. The wind is harsh from the southwest and the plumes of the steam from the funnels of the tugboats race sideways. It's colder than one can imagine.

The surface of this picture is so vibrant it seems to be still wet after nearly 100 years. The texture and handling of the paint are thrilling—chunky, juicy, brisk, and sure. Indeed, if one were to judge based just on his handling of paint, there is no more accomplished painter than Bellows, an underrated genius.

The critics of the time lauded *North River.* An anonymous review in the *Herald Tribune* described it as "original and vivacious . . . An artist need never leave Manhattan if it yields him pictures like that."

Other artists of his time were the members of the so-called Ashcan School—such as George Luks and Everett Shinn—but Bellows goes far beyond the mere recording of the perils and the grimness of the tenement dwellers of New York City at the turn of the century.

GEORGE BELLOWS
b.1882, Columbus, Ohio
d. 1925

NORTH RIVER
1908
Oil on canvas
32¾ x 42¾ in. (83 x 108.5 cm)

Current Location: Pennsylvania Academy of Fine Arts, Philadelphia

# THE GARDEN OF DELIGHTS

THE THREE paintings in Hieronymus Bosch's triptych *The Garden of Delights* are the most wonderfully imaginative and enigmatic series of exotic scenes ever depicted in the history of art. Endlessly provocative, almost like some pictorial and philosophical puzzle, the subject matter defies categorization and resists definition altogether. Although the panel on the left shows Eve in the Garden of Eden and the one on the right the terrors of Hell, the grandiose and extraordinarily complex central panel is bewildering beyond description. What did Bosch intend the multiple images of humanity and animal life in this sweeping scene to signify? Paradise? The rewards of being good? Luxury? Senseless hedonism? The nanoseconds before the Last Judgment? A gentle and persuasive Sodom and Gomorrah? The deadly sins? Humankind gone mad? Whatever it is, Bosch seems to have been fascinated with the evil that lurks in the good life and the good that can exist in evil. Throughout, he is dedicated to conveying the dogma that excess is a false route to happiness and that flesh has always been weak.

In the panel on the left, Christ tenderly holds Eve's hand just after having fashioned her from Adam's rib. Adam is shown lying back languidly on the perfect greensward, looking slightly confused. Eden is shown as flowering with trees and flowers and populated with animals, situated in an unreal landscape studded with a series of towers and castles fashioned out of jewelry and gewgaws. The feeling is benign and optimistic.

This is definitely not the case in the right panel, where one finds a hoard of trapped, tortured, and anguished characters. This is the land of the damned and Bosch presents us with a stunning nightmare portrayal of Hell, dominated by a central chalk-white, warped and twisted egg shell with stunted legs, which is fitted out with a grotesque, evil human face that looks around at us as if to say, "You're next." This is a terrifying place, abounding with one's worst fears. Knives seem to walk. Musical instruments have become weapons of destruction. In the direct center of the foreground, a massive hurdy-gurdy is screeching away, devouring people; nearby a stricken soul seems to be crucified in the strings of an evil harp. Fire sweeps through the skies. The damned—who are mocked, threatened, and screamed at—are being stuck and pricked, squeezed and mouthed by a host of foul monsters,

HIERONYMUS BOSCH
(Jerome van Aeken)
b. ca. 1450, Hertogenbosch, Brabant
d. Aug. 9, 1516, Hertogenbosch

THE GARDEN OF DELIGHTS
ca. 1500
Oil on panel
Center panel: 7 ft. 2½ in. x 6 ft. 4¾ in.
(2.2 x 1.95 m)
Each wing: 7 ft. 2½ in. x 3 ft. 2 in.
(2.19 x 0.96 m)

Current Location: Museo del Prado, Madrid

right up to the brink of death, for in Hell no one ever dies, they suffer for eternity.

The central panel is cryptic—is it before or after the Last Judgment? It's impossible to say, which makes the picture very exciting. Whatever it is, dozens upon dozens of naked men and women cavort, loll around, and bask in a phantasmagoric lakeside landscape. This lake is surrounded by four captivating edifices. On the left front, there's a pink castle made out of marble and rosy cuttlebone. In the distant left is a structure made of heaped up bluish rocks surmounted by a great juicy gray pearl. The distant edifice on the right is fashioned out of pink rocks, roseate coral, and reddish egg shells decked out with curious feathers sprouting from some oddly shaped windows. The structure on the right front is a blue orb of some indeterminate substance with a lively spray of rock crystals sprouting skyward. At the center of the lake is an entrancing "castle," an amazingly inventive never-never-land tower of silky blue glass decorated with five spectacular turrets reaching toward the heavens.

On a greensward immediately in front of the lake is a joyful circular procession (proceeding counterclockwise—toward Hell?) of naked men and women riding horses, unicorns, camels, deer. In the foreground dozens of naked souls are shown cavorting, embracing, kissing, seated or lying back. Some are plucking and eating enormous and succulent grapes, many are drinking what must be nectar from the giddy and pleased looks on their faces. Everyone seems to be delighted with his lot.

Hieronymus Bosch (also spelled Jheronimus Bos) was born Jerome van Aeken, the son of a painter, and spent almost his entire life in the town in which he was born. He was a fundamentalist moralist who was skeptical about the existence of human rationality, and his pictures really ought to be read as unrelenting sermons against sin and depravity. Over and over he made paintings about people being gripped by earthly temptations. Most of these works are filled with groups of human figures and fantasy creatures—half-human, half-animal—in equally fantastic architectural and landscape settings. He also made more conventional religious pictures, such as *The Crucifixion* and *The Adoration of the Magi*. It is impossible to determine the chronology of his works, since only seven out of about forty works said to be by him are signed, and none are dated. *The Garden of Delights* is one of the seven.

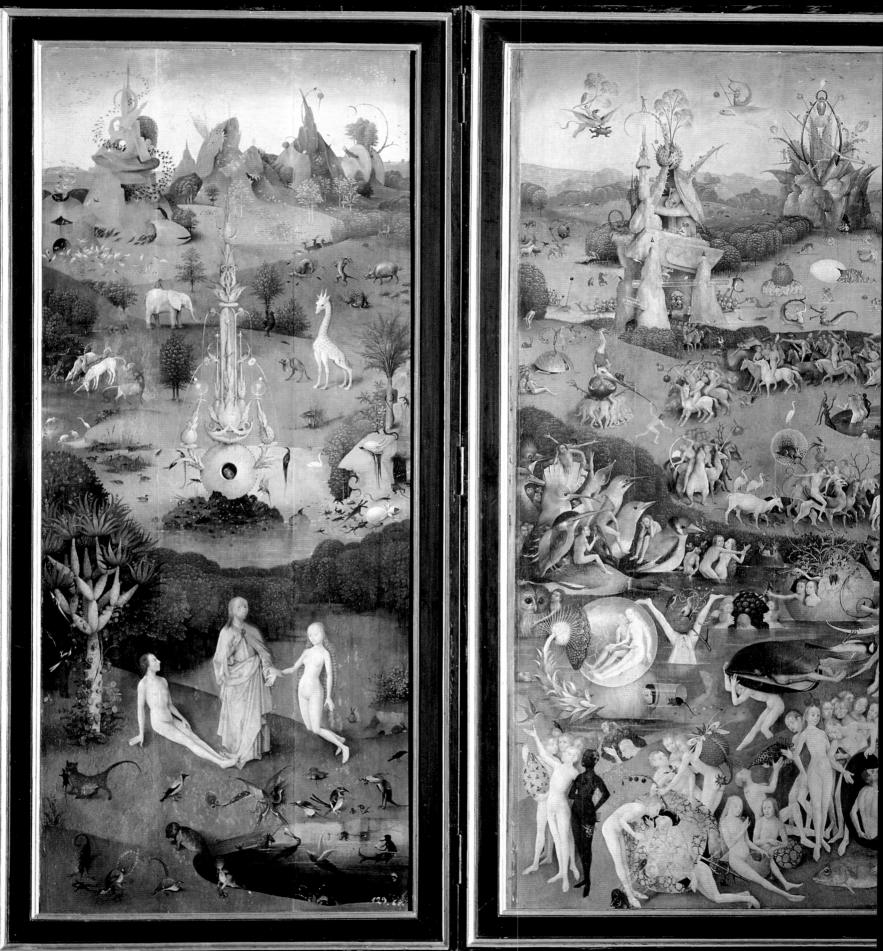

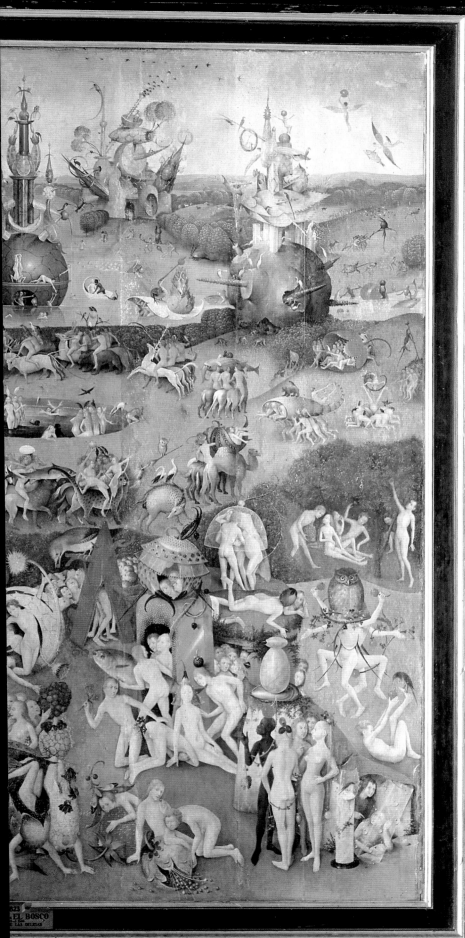
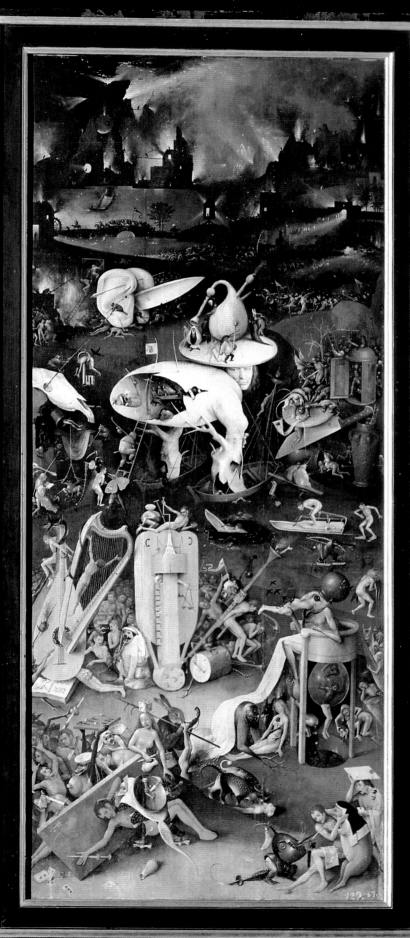

# BENEDICTIONAL OF ST. ETHELWOLD

ARTISTS UNKNOWN
English, late 10th century

BENEDICTIONAL OF ST. ETHELWOLD
*The Entry into Jerusalem* and
*The Incredulity of St. Thomas*
971-84
Ink and pigment on vellum
11½ x 8½ in. (29.2 x 21.6 cm)

Current Location: Library of the British Museum, London (ms. Add 49598)

Note: The manuscript is always on view in one of the cases in the rare book section of the British Museum, and the pages are turned on a regular basis.

IN THE TENTH century, perhaps no school of manuscript illumination in the world was superior to that of Winchester in England. The best masters of the style created paintings that crackle with an energy not seen until the drawings of the High Renaissance or the Baroque. The influence of the Winchester style spread throughout England and lasted for generations.

The *ne plus ultra* of the Winchester scriptorium is called *the Benedictional of St. Ethelwold*, which was for the personal use of Ethelwold, bishop of Winchester from 963 to 984. There are twenty-eight surviving illuminations (fifteen have been lost over the centuries), and they are all large and dramatic. Like most luxurious illuminated books of the period, this benedictional was painted not by one man but by perhaps four, who remain unknown and unlauded. The bishop himself, though not one of the illuminators, was deeply involved in the creation of the Benedictional. The dedicatory verses at the beginning of the book tell us that a "bishop, the great Ethelwold, whom the Lord had made patron of Winchester, ordered a certain monk subject to write this present book. . . . He commanded also to be made in this book many frames well adorned and filled with various figures decorated with numerous beautiful colors and with gold." They met and perhaps even surpassed his wildest expectations. The "frames" referred to are in the form of elaborate rectangular arcades or trellises enclosing the illustrations and the big initial letters at the beginning of the more important passages of the text. They appear to be overgrown in sprouting and intertwining acanthus leaves, known as the "Winchester acanthus."

One of the most compelling illustrations in this extraordinary book is *The Incredulity of St. Thomas*, which occupies a full page. Every element in *St. Thomas* is spectacular. The beautiful written words are themselves high achievements in calligraphy, and the gestures and poses of the dynamic figures are intense. Seldom in art have there been figures as captivatingly vital. The best passages may be the drapery of the figure's garments, which seem to be charged with electricity. Opposite *St. Thomas* is a page ornamented entirely with geometric motifs and acanthus and other luxuriant foliage, in a design so organic that it seems to be living and breathing. The foliage is a wonder world, especially the bold acanthus leaves, with their exaggerated curling tips like fanciful ostrich plumes.

# THE GREAT SALTCELLAR

THIS UNIQUE GOLD sculpture was created for French king Francis I by Renaissance sculptor and goldsmith Benvenuto Cellini in three years of frenetic and joyful labor. It depicts the naked sea god Neptune lolling back and admiring a non-blushing nude figure personifying the Earth, or Tellus, who is so entranced by his attention that she fondles her left breast and nipple in a gesture of sensuality (which became a cliché in the sixteenth century). Poseidon guards over a boat-shaped basin for salt, while Tellus protects a small triumphal arch where the pepper or rare spices would be kept. The arch is embellished with another female nude in a turban—no doubt the symbol of the Orient. Under Poseidon, there are a pair of fierce sea horses; under Tellus, a wet and goggled-eyed sea elephant. These highly charged figures are seated on an elliptical gold-and-enamel base representing the ocean floor, upon a gold pedestal supported by four wind gods and the personification of the four parts of the day (day and night, morning and evening).

Cellini was typically ecstatic about his work and described the day his royal patron first saw the model he had made for the sculpture: "I brought back a wax model . . . when I uncovered it, his Majesty exclaimed in his astonishment: 'This is a hundred times more divine than I ever could have imagined. The man is a wonder! He should never lay down his tools.' Then turning to me with a most joyful face, he said that the model pleased him very much, and that he would like me to carry it out in gold. . . . Next morning I set to work on the fine salt-cellar, and threw the greatest energy into this."

The saltcellar is truly one of the artistic wonders of the world. The splendid "machine" gives the impression of having been carved out of a solid hunk of buttery gold and finished off not only with an intense devotion to details but with a rough panache that makes the piece sublime.

Cellini was not only a sculptor and a goldsmith, but a writer and raconteur, celebrated for his entertaining *Autobiography*.

Another of his great works is the stalwart 18-foot-high bronze *Perseus and Medusa*, 1545–54, displayed in the open air in the comely Loggia dei Lanzi in the Piazza della Signoria in downtown Florence.

BENVENUTO CELLINI
b. Nov. 1, 1500, Florence
d. Feb. 14, 1571, Florence

THE GREAT SALTCELLAR
1540–43
Gold
10¼ x 13⅛ in. (26 x 33.33 cm)

Current Location: Kunsthistorisches Museum, Vienna

# MONTEZUMA'S HEADDRESS

THERE SEEMS little doubt that the spectacular feathered headdress in Vienna's ethnology museum is one of those made for Montezuma, ninth Aztec emperor of Mexico, and given by him in 1519 to Hernán Cortés, who, after his conquest of Mexico in 1521, gave it to the Hapsburg emperor Charles V, ruler of the Holy Roman Empire. For years it was in the Schloss Ambras, which belonged to Charles's younger brother Ferdinand, who later became archduke of Austria and King of Germany, and ultimately succeeded his brother as emperor in 1558. It appears on an inventory of 1596, where it was called the "Moor's Headdress."

Part of the divine regalia representing the Aztecs' highest god, Quetzalcoatl (the "Plumed Serpent"), this remarkable work of art is made up of five hundred dazzling green, red, blue, and white quetzal feathers, with three-foot-long iridescent green tail feathers radiating from a multicolored semicircular band. It (or one like it) was presented to Cortés in Veracruz by Montezuma's envoys, for he was regarded as the personification of Quetzalcoatl, whose return had been foretold. "They put him into the turquoise serpent mask with which went the quetzal feather head fan."

The name of the bird, quetzal, means "the resplendent," and its back and tail feathers are the most glittering iridescent green imaginable, relieved by a scarlet breast and white underparts. The tail of this majestic creature has wavy green streamers up to two feet long. In ancient times, feathers from the rare bird were sometimes woven to create sacred images of the "Plumed Serpent." According to Aztec legend, the quetzal flew over Quetzalcoatl's head in battle and sometimes furnished feathers to decorate the walls of one of his temples. The Aztec lords made it a crime to kill one of these birds. A few feathers at a time could be plucked, but that was all. Imagine what the great headdress was worth when it was fashioned!

Visitors to the gallery where this and a few other feathered mosaic artifacts are on display will be surprised and delighted at the stunning glory of the headdress, which is in strikingly pristine condition.

ARTISAN UNKNOWN
Aztec (Mexico)

FEATHERED HEADDRESS
Quetzal feathers

Current Location: Museum für Völkerkunde, Vienna

# CREGLINGEN ALTARPIECE

TILMANN RIEMENSCHNEIDER
b. ca. 1460, Heiligenstadt (near Göttengen),
Germany
d. July 7, 1531, Würzburg, Germany

CREGLINGEN ALTARPIECE
ca. 1505–10
Limewood (with some polychromy) and pine
32 x 12 ft. (9.75 x 3.65 m)

Current Location: Herrgottskirche, Creglingen, Germany
Note: Creglingen is a very small church way off the
beaten track, and it would be wise to make sure that
it will be open when you plan to visit.

IT'S FAIR TO characterize Tilmann
Riemenschneider as the Lorenzo Ghiberti of the
North. His works are completely different in style
and feeling—being Late Gothic rather than early
Renaissance, and possessing not a scintilla of human-
ist spirit—but when it comes to daring, ambition,
finesse, and artistic skill, the two have much in
common. Almost everyone who encounters the
magnificent *Creglingen Altarpiece* is overwhelmed
by the perfection of its artistry, an experience com-
parable in some way to seeing Ghiberti's *Gates of
Paradise* (see page 44) for the first time.

Riemenschneider was prolific—for he was
the most sought-after sculptor of his time—and
his huge workshop was almost an assembly-line
operation, yet the level of quality of his signature
pieces is exceptionally high. His specialty was
large, complicated wooden altarpieces with dozens
of figures in scenes from the New Testament, and
they are breathtaking. Riemenschneider was
equally gifted carving wood or stone (limestone,
sandstone, marble, and alabaster), but he favored
limewood because of its gentleness as a medium

and because he adored the soft blond-beige color
of the untreated material.

His best work is the *Creglingen Altarpiece*, in a
small church—the Herrgottskirche—in the tiny
town of Creglingen, west of Nuremberg, which
depicts the Assumption of the Virgin. The church
marks the place where a peasant is supposed
to have found a sacred wafer. This altarpiece is
the only one by Riemenschneider that escaped
the widespread practice of staining in the nine-
teenth century, and may be the only work by
him not injured by incompetent restoration. Here,
unchanged, is the original subtle effect of the pale
limewood used for the figures juxtaposed with the
reddish pine of the elaborate architectural frame-
work. The result is stunning. The work's condition
is so good that one can easily see where Riemen-
schneider delicately painted the lips and nostrils of
his figures red and tinted their eyeballs, eyelids,
and eyebrows gray and black. This slight coloration
adds an extraordinary energy to the ensemble.

The soaring Gothic armature, 32 feet tall and
12 feet wide, frames a variety of scenes. The central

drama is the Virgin being taken into heaven by five angels, rising just above the Apostles. Below this are scenes of Christ as a child, while on the wings to either side are the *Visitation*, the *Annunciation*, the *Presentation*, and the *Nativity*. The robes of all the figures carved by Riemenschneider himself—in this case, the majority of them—feature the crackling, meandering, deeply cut folds of drapery that are a hallmark of his style.

Riemenschneider is known as the most important German sculptor of the Late Gothic period (although his work is really in the Northern Renaissance style). He was the son of the mint master of Würzburg and, at twenty-three, opened up a successful sculpture workshop. He seems never to have hungered for commissions and his style soon set the standard throughout Lower Franconia. Riemenschneider was a councillor(1504–20) and burgomaster (1520–25) but got in trouble with the establishment when he sided with the revolutionaries during the Peasants' Revolt of 1525; he served time in prison. He spent his last years in Kitzingen, restoring altarpieces and carving.

# WHENCE COME WE?
# WHAT ARE WE? WHITHER GO WE?

PAUL
GAUGUIN

PAUL GAUGUIN created this enormous painting—his largest—in about a month's time during his second stay in Tahiti. This richly colored, sensual canvas is far from a luxuriously hedonist expression; it is his spiritual testament. As is the case with so many sublime works of art, *Whence Come We?* is open to a host of interpretations; yet surely its principal message, highlighted by the glowing blue idol in the left background, its arms raised in an Orant gesture of forgiveness and universal protection, is that of the spirituality of nature's wholeness and the wholeness of mankind. Without a hint of Christianity, or any other religion—not even paganism—it succeeds as one of the most powerful and moving spiritual depictions painted in the last hundred years. Gauguin completed this refulgent work just before attempting suicide with an overdose of arsenic, although he was saved when his body violently rejected all of it. He intended it to be a suicide note that would, he hoped, slow down the decay of the western world. It may be that the supreme effort of painting it in such a rabid mood saved his soul in some mysterious way.

Scanning the huge painting from right to left, one can identify the stages of life—from birth to fecundity to advanced age and death, which is, significantly, not specifically shown. Perhaps Gauguin may have intended to say death happens only to the flesh. The panorama from foreground to background expresses man's mysterious origin. But so much is left unexplained, for, as Gauguin himself wrote in a letter to Charles Morice, the essential part of the work is precisely that which is not expressed.

When the piece, painted on very coarse burlap to impart the feeling of an old Italian wall painting, was shown in Ambroise Vollard's gallery in Paris in 1897-1898, few observers understood the basics of its complex message. With the clarity that accom-

PAUL GAUGUIN
b. June 7, 1840, Paris
d. May 8, 1903, Marquesas Islands

WHENCE COME WE? WHAT ARE WE?
WHITHER GO WE?
1897
Oil on canvas
54¾ x 147⅝ in. (139 x 375 cm)

Current location: Museum of Fine Arts, Boston

panied what he thought was certain death, Gauguin knew perhaps for the first time in his life who he was and what he was after. In the fury of making the painting, he had become, as he wrote to a friend Daniel de Montfried "a savage, a wolf let loose in the woods." The words admirably sum up mankind in the twentieth century, a pious savage let loose in the world. *Whence Come We?* is at once a humble and exuberant mirror of civilization.

Gauguin's career was spotty and tempestuous. He was largely self-taught and although he became a darling of the Symbolists and a friend of Van Gogh, he was a loner—an odd combination of Romantic and realist who just slightly ratcheted up forms and colors taken boldly and directly from the lush scenery of the Pacific islands, where sand really is pink and the foliage almost aquamarine.

He was born in Paris in 1840. In 1874 he started painting as an amateur and began to collect works by Manet, Cézanne, Pissarro, Renoir, and Monet. He trained as a stock broker but after a crash in 1883 quit and turned to painting full-time. His first sojourn in Tahiti extended from June 1891 to July 1893. He came back to Paris, then in 1895 returned to Tahiti until 1901. From 1896 he suffered a series of serious illnesses. Despite the increasing deterioration of his health, some of Gauguin's most exalted paintings—pieces such as *Nevermore* and *Whence Come We?*—were painted in 1897. In 1901 he departed for the Marquesas and settled at Dominica in September. The next year his heart began to fail him. Suffering horribly, Gauguin wanted to return to Paris for treatment but a friend talked him out of the idea. In 1903, after bitter confrontations with the local government, the church, and the police for his wild support of natives' causes, Gauguin was jailed for three months. Broken in health if not in spirit, Paul Gauguin died on May 8, 1903.

# EARLY SUNDAY MORNING

EDWARD HOPPER
b. July 22, 1882, Nyack, New York
d. May 15, 1967, New York City

EARLY SUNDAY MORNING
1930
Oil on canvas
35 x 60 in. (88.9 x 152.4 cm)

Current Location: Whitney Museum of American Art, New York

EDWARD HOPPER is sometimes so awkward with paint that you wonder if he ever went to art school—as if that mattered. But gradually one learns that what seem to be awkward passages in Hopper's paintings are thoughtful, shrewdly placed, painterly elements that are deliberately rough and pleasantly raw—like the fundamentals of life.

This American "Old Master" created many memorable works but none as timeless and heady as *Early Sunday Morning*, with its red splash of deeply shadowed, deserted Brooklyn tenements, which could be buildings from almost any Western country in any not-too-distant era. That legendary "rose-red city half as old as time" never looked this poetic and mysterious. The image is boldly and frankly theatrical, almost as if illuminated by klieg lights. There's some justification in thinking that the legitimate theater inspired Hopper. He was fascinated with theater sets and obsessed by artificial lighting. He was also a fanatic moviegoer and once said, "When I don't feel in the mood for painting I go on a regular movie binge! . . . If anyone wants to see what America is, go see 'The Savage Eye.'"

Hopper often cropped his pictures as if he were intending them to look as if they'd been captured by the lens of a movie camera. Indeed, *Early Sunday Morning* might well be a frozen frame from a film. Yet he has neither catered to the cliché feeling of movies nor fallen victim to their superficial stylistic quirks. What makes this a masterwork of an urban landscape is not only the climate, the color, and the light, but the inspired solitude with which it is imbued. Once you see it, the image haunts you for the rest of your life and you yearn to go one day to that street.

Hopper studied under American Impressionist painter William Merritt Chase at the New York School of Art. He was also taught by Robert Henri, one of the progenitors of the Ashcan School. Hopper made the mandatory trip to Paris but seems not to have been greatly impressed with the artistic life or to have thought he needed to fit into it. Paris had no impact on him: he heard vaguely of Gertrude Stein, but not of Picasso at all.

His career started slowly; at his first show in 1920, he didn't sell a picture. Steadily, however, the word got out about this painter who was something

of a loner and loved driving pell-mell around the country seeking for his subject matter mundane and overlooked scenes. What interested him were things that most people couldn't conceive as being "artistic." The scenes that Hopper painted are not filled with loneliness but are simply about lonesome people.

By 1930, his mature style was completely developed and until his death he did something that is almost unimaginable today: he painted resolutely, never changing his style, having a series of successful shows almost until his death. His genius was that everything he touched is stamped by a fire of creativity. His works make one think again and again.

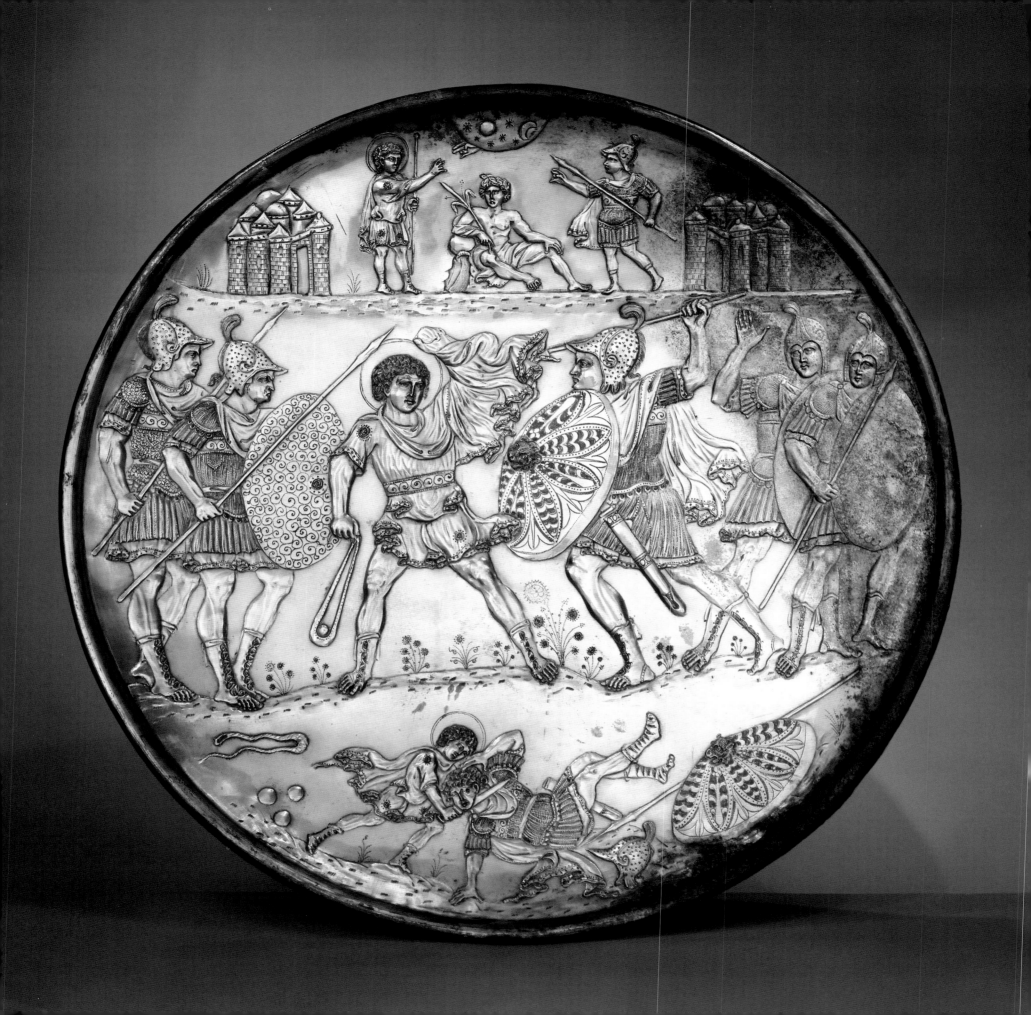

# THE CYPRUS PLATES

THERE ARE FEW surviving works of art of the early seventh century, and most of them are not very exciting. This was the time that used to be called the Dark Ages, and the existing art from this period—mostly illuminated manuscripts—is crudely executed and looks as if the artists had completely forgotten how to fashion the human figure; all of the spirit and every reverberation of Classical antiquity has vanished. Perhaps the only exception is a remarkable series of ten silver plates depicting scenes from the life of King David, made in Constantinople during the reign of the emperor Heraclius (r. 610-41). Six of the plates are in the Metropolitan Museum of Art and four are in the Cyprus Museum, Nicosia, on the island of Cyprus, where they were all excavated at the turn of the twentieth century. They were made in this barren time yet they are richly accomplished, a triumph of the ancient Classical manner.

The largest of the plates in the Metropolitan Museum shows David meeting, fighting, and slaying Goliath and is one of the most energetic and superbly drawn examples of a scene that has been depicted hundreds of times. This Cyprus plate,

arguably the best of the series, possesses a profound Classical feeling, yet it has an extra punch that seems almost medieval in its bravado.

Not too many years ago, Erika Cruikshank Dodd, a gifted scholar then working at the Byzantium Institute of Washington's Dumbarton Oaks, deciphered the many tiny stamps on the backs of the plates—which up until then nobody had figured out—and proved that they belonged to the Eastern Roman emperor Heraclius. Heraclius was a usurper, and apparently he commissioned the plates, depicting a well-known usurper of biblical times, and instructed the artists to render the story in a style more suited to around 400 A.D. to give the magnificent artifacts—and hence his rule—the appearance of legitimacy.

The Metropolitan's six plates were previously in the collection of J. P. Morgan, and were once considered to be forgeries. (Morgan scoffed upon hearing this, and demanded that the forger be presented to him so that he could purchase his entire inventory.) The prime reason for the doubts was that the style didn't seem to fit in anywhere in the late Antique period of the fourth and fifth centuries A.D.

ARTIST UNKNOWN
Byzantine, early 7th century

THE CYPRUS PLATES;
*The Combat of David and Goliath*
628-30
Silver
19½ in. (49.5 cm)

Current Location: Metropolitan Museum of Art, New York

# THE PULPIT IN THE CATHEDRAL OF PISA

NICOLA PISANO
active 1258-78, Tuscany, Italy
d. between 1278 and 1284, Pisa

PULPIT
1259-60
Marble

Current Location: Baptistery, Pisa

ONE OF THE most creative revolutionaries in all of Western art was the Tuscan sculptor Nicola Pisano. In his thrilling carvings he brought about a rebirth of Classical style that in many ways rivaled the more famous Renaissance of the fifteenth century. Nicola drew mainly upon antiquity for inspiration, especially the figures on the Roman sarcophagi in Pisa that he studied after he arrived there around the year 1250. His innovative new style combined the spirit of ancient Greece and Rome with a stark thirteenth-century spirituality.

Nicola's grandest work is the hexagonal marble pulpit for the Baptistery of the Cathedral at Pisa, which he proudly signed and dated March 25, 1259 to March 24, 1260, and added an inscription proclaiming himself the greatest sculptor of his time. The pulpit is raised up on elegant columns, three of which rest on the backs of white marble lions. The upper part of the pulpit consists of five panels, each with a relief depicting a scene (or a combination of scenes) from the New Testament. These are supported by arches decorated with figures of prophets and evangelists in the spandrels and with a figure standing on top of each column at the six corners, which personify acts of heroism, the virtues, and saintly and good works—

Hercules, Charity, Faith, Hope, John the Baptist, and the Archangel Michael killing the devil. Nicola's magnificent pulpit, with its reliefs, is one of the most confident and universal works of all Christendom. It is a watershed of artistic style, representing a complete departure from the formulaic Romanesque tradition that governed Tuscan art during that period. These sculptures influenced artists for generations. One of the artists inspired by Nicola's avant-garde creations was the other great innovator of around the same time, Giotto di Bondone. The secret to Nicola's success and to his genius is that his figures are tremendous in size, bulk, and energy, and seem to explode from the restricted surface of the stone. In the panels, their power is increased by the way Nicola has compressed them into a relatively small rectangular space (less than 3 feet by 4 feet), which resemble the sides of Roman sarcophagi. Like the work of most experimenters, Nicola's pulpit shows the influence of a number of styles, ranging from the Roman Classicism of many of his figures to a hint of French Gothic in some decorative ornamentation. In the *Annunciation*, the Madonna is as domineering as Classical Greek images of Mother Earth. The Magi in the *Adoration* look like

Zeus and his brothers. No more Classical scene appeared in ancient art than this *Presentation in the Temple*. The *Crucifixion* is populated with chunky, monumental figures that are ruggedly emotional as well as anatomically impressive. In the *Last Judgment*, the figures of the damned look as if they were modeled after fragments of Classical statuary. Nicola based his corner figure representing the virtue Fortitude on a nude figure of the hero Hercules on a Roman sarcophagus in Rome's Baths of Diocletian. But Nicola makes his Classical model look a bit cramped and unsure of himself. This Hercules is both pagan and Christian.

Of Nicola's life, we know very little. He may have been born around the year 1220, perhaps in Apulia (in southeastern Italy), and he died in Pisa between 1278 and 1284. With his own workshop of assistants—including his highly talented son, Giovanni, and Arnolfo di Cambio—Nicola designed and supervised the sculptural work for the tomb of St. Dominic at S. Domenico in Bologna (1264-67) and carved another great pulpit, for Siena Cathedral (1265-68), which is more complex than the one in Pisa but less powerful. His last known work, done with the assistance of Giovanni, is the *Fontana Maggiore* at Perugia (completed in 1278).

# QUEEN NOFRETITI

ONE OF THE most captivating works of realism ever to have survived from ancient Egypt is not some official sculpture carved into a tomb or on the facade of some funerary temple, but a portrait bust (a model used for official portraits). It was found in the unknown artist's ramshackle studio at Tell el-Amarna, the site of the major palace erected by the heretic Pharaoh Akhenaten (Amenhotep IV), the man who, perhaps foolishly, threw out the many gods who swarmed through the imaginations of ancient Egyptians and proclaimed a single god, the sun-god Aten. This work, the painted limestone portrait of Akhenaten's wife, Nofretiti, was discovered by a teenage worker in an archaeological crew of German excavators at the site in 1912. He gave it to the foreman Mohammed, who handed it over to archaeologist Ludwig Borchardt, who was struck dumb by its beauty. The sculpture is life-size, painted in the most delicate manner to show the gorgeous long-necked queen adorned for a ceremony wearing the banded deep blue crown of Upper and Lower Egypt and a large necklace consisting of four bands of semiprecious and glass stones. The woman is virtually alive, she is so well made, and gives the impression of being both queenly and ineffably vulnerable.

Borchardt promptly had it smuggled out of Egypt, in violation of his contract with the Egyptian government requiring him to show them everything found on the dig and make an "appropriate" partage. The Egyptians have complained bitterly ever since, and today there are many Cairo Museum posters showing this beautiful creature despite the fact that the sculpture is in Berlin.

It's best to approach this startling rendition of majestic humanity so that you see her right profile first (i.e., the left side of her face if you looked at it straight on), for the glass inlay of her left eye is missing, but the right eye is absolutely intact. As you draw near, the queen seems almost to become a living, breathing human being. Nothing quite equals her shell-like ears, nose and lips of inexpressible elegance, and impossibly thin, long neck. That, however, must have existed in real life, because we know that Akhenaten demanded total realism from his artists, even when they portrayed him in an unflattering manner. Whoever he was, he married the most beautiful woman of all time.

ARTIST UNKNOWN
Egyptian, Eighteenth Dynasty

QUEEN NOFRETITI
ca. 1365 B.C.
Painted limestone
Height: 20 in. (50.8 cm)

Current Location: Ägyptisches Museum, Berlin

# GEORGES SEURAT

# SUNDAY ON THE ISLAND OF LA GRANDE JATTE

GEORGES SEURAT
b. Dec. 2, 1859, Paris
d. Mar. 29, 1891, Paris

A SUNDAY AFTERNOON ON THE
ISLAND OF LA GRANDE JATTE
1884–86
Oil on canvas
81½ x 121¼ in. (207 x 308 cm)

Current Location: Art Institute of Chicago

THE SMALL ROUND dots and splashes of color that Georges Seurat painstakingly applied in a technique he called "Divisionism" (and critics dubbed "Pointillism") to create this unearthly masterpiece are not perfectly round and "regularized"; they are careful brushstrokes, some of them certainly minute, but universally irregular and ever-changing. Despite this nearly suffocating formula of dabs and splashes, the atmosphere almost miraculously comes alive when viewed from the proper distance— say fifteen feet, minimum. Then, the panorama of humanity on a bustling Sunday on the island of the Grande Jatte in the river Seine, on the western outskirts of Paris just north of the Bois de Boulogne, is transformed from some curious ode to science into a penetrating image of living human beings. What is so fabulous about this unique canvas is how successfully these seemingly "machine-turned" individuals and creatures have been captured forever, as if by an early photograph, and made immortal by the infinitely subtle colors. The *Grande Jatte* may be one of the most important colorist pictures since the paintings by Giambattista Tiepolo.

Seurat was influenced by the aesthetic theories of Humbert de Superville, a painter-engraver from Geneva—as published in his "Essay on the Unmistakable Signs of Art" (1827), which discussed the relationship between lines and images—and the research of a French chemist, Michel-Eugène Chevreul, who analyzed the effects of the juxtaposition of complementary colors.

Using this ponderous technique of Pointillism, Seurat created a host of brilliant works—often painting their frames as well with his tiny splashes and "points" of pure primary color so that his works seem to live in an enchanted environment of their own, detached from the real world but vividly depicting it at the same time.

Seurat began this painting in 1884, finished it during the winter of 1885–86, working on the island of the Grande Jatte, and exhibited it from May 15 to July 15, 1886, at the last Impressionist group show. He was reviled by the stodgy critics but was praised in the avant-garde magazine *La Vogue* by the perceptive essayist Félix Fénéon, and that established his reputation. The work was also exhibited by the eminent Parisian dealer Paul Durand-Ruel in Paris and after that in New York City.

Seurat was born in Paris, the son of a bailiff. After high school he enrolled in the Municipal

School of Design and haunted museums, copying the old masters—especially Holbein, Raphael, and Poussin. In 1878, he started at the Ecole des Beaux-Arts and seemed to be as interested in science as in art, poring through professional treatises.

From 1881 to 1887, he concentrated primarily on drawing. His drawings are highly structured and finished, mostly made with the darkest of pencil strokes punctiliously overlapping—strikingly different from his paintings. Around 1885 Seurat began to perfect his enchanting small, separate touches and strokes of shading. His work on the *Grande Jatte* involved thirty-eight different studies and twenty-three marvelous Stygian-black pencil drawings. He later exhibited works at the 4th Salon des Indépendants (1888). He was working on his *Cirque* when he was stricken and died of fever on March 29, 1891, at only 32 years of age.

# EL GRECO

## THE BURIAL OF COUNT ORGAZ

EL GRECO
(Domenikos Theotokopoulos)
b. 1541, Crete
d. Apr. 7, 1614, Toledo, Spain

THE BURIAL OF COUNT ORGAZ
1586
Oil on canvas
16 ft. x 11 ft. 10 in. (4.88 x 3.61 m)

Current Location: Church of Santo Tomé, Toledo

IN MANY WAYS El Greco's *The Burial of Count Orgaz* is, after the Ghent altarpiece (see page 208), the most beautifully crafted religious painting of all time, but it is a mystical light year from the solid, fleshy cast of characters that people van Eyck's masterpiece. This enormous colorful canvas dominates a chapel in the tiny church of Santo Tomé in the lovely town of Toledo, which seems to be jammed with tourists except in the middle of winter. This sounds unpleasant, but it's not really. For no matter how many people cram their way into the tight space, there is silence. This glowing piece of theater is awe-inspiring.

The painting commemorates the burial in 1323 of Don Gonzalo Ruiz, Lord of Orgaz, a benefactor of the church. The faces of the participants in the ritual burial are powerful and sensitive. Their garments—of silks and satins—are painted in dazzling *trompe-l'oeil*. Everything is swift and exciting. Two areas of the cosmos—earth and heaven— are depicted. Some passages of the painting are sublime, such as the count's armor in silver and gold, and the splendidly embroidered copes of St. Augustine and St. Stephen, in gold, white, and red.

The little scene of Stephen being stoned, in faux embroidery at the bottom of St. Stephen's cope, if it were extracted from the huge painting and exhibited on its own, would be considered a rare treasure. In the upper half of the picture, the figures, the colors, the energy—of Christ, Mary, St. John the Baptist, the other saints and the dazzling angels, the image of the Last Judgment with the souls virtually leaping into heaven—are unlike anything ever created before or after, floating in an ambiguous space filled with undulating drapery and swirling clouds. After seeing the painting, one leaves the church feeling regenerated.

The magnificence of *The Burial* is admirably summed up by art historian Don Manuel Gomez Moreno: "El Greco composed the scene with an apparent normality that seems to include the miracle, arriving at a solution in which the supernatural is made human by contact with the human, and the celestial, in contrast, is freely exalted."

One can see in the upper half of the painting some of the strange elongation of figures that became more prominent in his later works. The story goes that El Greco painted such weird wraith-

like figures that seem almost to dissolve into ecto-plasm because he suffered from an astigmatism and couldn't see straight. What nonsense! It's the copyists, the fakers, the members of his family who churned out "originals" for years after his death who had the "ailment." A genuine work by El Greco combines realism and a profound spiritual-ism in an uncanny way.

How many art masterpieces came about because of a successful lawsuit? *The Burial of Count Orgaz* did. In fact, there's an old Spanish curse that may have something to do with the genesis of this great picture: "May God send you lawsuits and you win them!" In his will, Count Orgaz had left a sizable bequest to the parish of Santo Tomé, which the officials of the town of Orgaz refused to honor, and Andres Nuñez, the parish priest of Santo Tomé, brought a lawsuit against them. The case was decided in favor of Father Nuñez in 1569, with the result that the small chapel became rich beyond imagining. In 1586, Nuñez decided to redecorate the chapel con-taining the tomb of Count Orgaz, and commissioned El Greco to depict the miracle that had immortalized the funeral of this Castilian grandee.

The superbly painted inscription below the magnificent painting explains: "When the priests were preparing to bury him [Count Orgaz]—wonderful and extraordinary to behold—St. Stephen and St. Augustine descended from heaven and buried him there with their own hands. WHY? They said Gonzalo [Orgaz] bequeathed 2 sheep, 16 hens, 2 skins of wine, 2 wagon loads of wood and 800 coins . . . all to fall each year from the inhabitants of the domain of Orgaz. For two years they refused to pay this pious tribute, hoping that with the passage of time their obligation would be forgotten. It was enforced by order of the Chancellery of Valladolid in 1570, the case having been energetically pleaded by Andre de Nuñez of Madrid, priest of this church, and the steward, Pedro Ruiz Duron." El Greco took on the commission for the altarpiece on March 18, 1586, when he was forty-five years old. He completed it that same year.

Born in Crete, which was then a Venetian possession, El Greco studied in Venice under Tintoretto. When he went to Spain in the mid-1570s, he got rid of all his annoying Italianate stylistic traits and took off courageously on his own—sometimes to the bewilderment of his contemporaries—and developed his unique, signature style that is so profoundly moving. He was also adept at sculpture and architecture.

There are literally thousands of works by El Greco around and about, and many of them look weak. The reason for this is that his son and members of his family kept on finishing his incomplete works and jiggering up new "El Grecos" for a generation after his death.

Other masterpieces by El Greco are in the Prado, and a huge altarpiece by him that is just second to *The Burial of Count Orgaz* is the *Assumption of the Virgin* in the Art Institute of Chicago.

# THE DEATH OF SARDANAPALUS

EUGÈNE DELACROIX

EUGÈNE DELACROIX'S grand, passionate, anarchical, emotional painting, the wildly Byronic *The Death of Sardanapalus*, is a riot of excess, eroticism, and sadism. One might easily call it one of the most romantic paintings of the entire Romantic epoch; when it was first exhibited it produced a frisson of admiration mixed with horror at the barbarism of the image. The painting shows King Sardanapalus, an Assyrian king whose empire was being toppled by the ravaging Medes— apparently unconcerned that his life, time, and empire have come to a crashing end—lolling back on his royal bed. His enemies have breached the inner walls, his once-loyal palace guard have fled or been slaughtered, and fires are licking at the walls of his throne room and bed chamber. His seneschals are dragging before him all his treasures, so he can be sure they are destroyed before they fall into the hands of "the unclean." And what treasures! A plethora of stunning jewels, rich fabrics, animals of exceptional beauty, and some of the most gorgeous concubines in the history of modern painting—figures that Peter Paul Rubens would have looked upon with envy. What genius of execution, detail, texture, and composition. Every time I see this marvelous work I hear the smash of battle and pillage, I can smell the smoke and hear the piteous cries of the dying and those about to die. It's Byron come to life on canvas. Yes, it's a bit incoherent, but that only increases its appeal.

Delacroix was at times criticized that he was a slave to color and weak when it came to drawing, yet looking at this tightly composed and minutely drawn series of exuberant elements, it is difficult to understand what the naysayers were talking about. Delacroix belongs up there with Rubens, Rembrandt, Caravaggio, and Goya as one of the great creators of the indelible visual statement, the kind of painting that never leaves one's memory.

He was a descendant of the Oeben-Rieseners, a clan that became famous for the furniture it made for the *ancien régime* (and which today is incredibly costly). His father was ambassador to Holland (although there were rumors that Delacroix was the illegitimate son of the great French statesman Talleyrand, for he shared an uncanny physical resemblance to him and seemed to get continual commissions despite considerable criticism of his

EUGÈNE DELACROIX
b. Apr. 26, 1798, Charenton-Saint-Maunce, France
d. Aug. 13, 1863, Paris

THE DEATH OF SARDANAPALUS
1827
Oil on canvas
152¾ x 193½ in. (392 x 496 cm)

Current Location: Musée du Louvre, Paris

paintings). Until the age of 17, he pursued classical studies and had a passion for theater and music. His early artistic training was straight-laced academic, and he didn't free himself from the stultifying style until quite late, when he burst forth as a wildly coloristic, near-Impressionistic, brush-stroking genius of the high Romantic movement.

His debut at the Paris Salon of 1822 was extraordinary, for there he exhibited the stunning *Dante and Virgil in Hell*, now in the Louvre, which embodies the strengths of both Dante and Michelangelo. Two years later he showed the monumental *Massacre at Chios*, depicting the contemporary slaughter of Greeks on the island of that name, a picture that gained instant fame. (In this work, one can see the luminous influences of John Constable.) In 1825 Delacroix traveled to London and his painterly technique was further influenced by Constable and Turner. Between 1827 and 1832, Delacroix produced an unbroken string of masterpieces—*The Death of Sardanapalus*, *The Battle of Nancy*, and *Liberty Leading the People over the Barricades*, to honor the July revolution that had placed Louis-Philippe on the French throne.

In 1832 he went to Morocco for seven months, where he was overwhelmed by the exotic sights, the beauty of the famous horses, and the Arabs in their wondrous costumes. He made hundreds of sketches and notes, which he would later use to create most of his works—he depicted Arab subject matter for the rest of his career, along with his history paintings and portraits of his friends Frederic Chopin and George Sand. He died in 1863 and the sale of his studio was huge—6,000 drawings, watercolors, and prints were sold.

# THE SISTINE MADONNA

SINCE THE BEGINNING of the industrial age, the work of Raphael seems to have been needlessly downgraded and in general overlooked by all but a handful of specialists. Today it is more fashionable to look upon the *terribilità* of the contemporary whom Raphael hated, Michelangelo, as providing a richer recipe for genius. Such a comparison is unfair. They were both geniuses— just different kinds of genius producing different expressions. In reality, Raphael was just as fine an artist as Michelangelo (and not far behind him in architecture design, either). The work of Michelangelo is harsher and superficially more brutal, and thus has more appeal to the world in which we live today. Raphael's works are admittedly more sweet, far more harmonious, and a great deal more subdued than those of Michelangelo and the other giants of the High Renaissance. But sweetness is not a weakness, and at times Raphael could add a molybdenum toughness to his ideal images, making a subtle combination that his rival never achieved.

To me, the finest painting by Raphael is *The Sistine Madonna*, a picture that appears to have been influenced not only by the monumentality of Michelangelo's Sistine Ceiling frescoes (1509–11) but also by Raphael's own triumphant series of frescoes in the private chambers of Pope Julius II (also 1509–11). Here he has used canvas instead of panel to obtain a brighter range of colors, like those in his frescoes, and he has made the scene vivid by the illusionism of the curtain to break what might otherwise have been yet another rectangular altarpiece. What makes this picture exciting is that he has created figures that are far larger than any in his earlier works, thus producing a greater emotional impact.

The Child is represented—not as essentially dear or active, squirming around to do baby things, as in Raphael's early works—in a sort of prophetic repose; and, in contrast, the Virgin is shown as walking briskly forward. For those intrigued by sublime formal elements—and one can be sure that Raphael was—one of the most intriguing is the way in which the Virgin's left arm and the Child's right thigh continue and complete the circle that is established by her marvelously billowing veil. Another satisfying formal element is the taut pyramidal structure formed by the Virgin and the

RAPHAEL
(Raffaello Sanzio)
b. Apr. 6, 1483, Urbino, Italy
d. Apr. 6, 1520, Rome

SISTINE MADONNA
1513
Oil on canvas
8 ft. 8½ in. x 6 ft. 5 in. (269.5 x 201 cm)

Current Location: Gemäldegalerie, Dresden

two stolid figures kneeling beneath her. Pretty daring for the times is the slightly uneven placement of the adoring saints, for normally they were set at the same level. St. Sixtus looks at the Virgin and gesticulates toward us, while St. Barbara shrinks away from us with lowered eyes. Completing the composition is a pair of putti looking upward from the very bottom of the painting.

The more one looks at this forceful image, the more one appreciates it. And, of course, that pair of angelic putti has bailed out more card companies than Raphael painted paintings.

Raphael got his early training from his father, whom the art chronicler Giorgio Vasari snipingly referred to as a painter of no great merit. But he must have been a fine teacher because the young Raphael flourished and by age 17 was recognized as an exceptional talent. He arrived in Perugia around 1495 and by 1500 had a fairly important commission. He worked with and absorbed the lessons of Pietro Perugino, one of the top-notch masters of the day. The influence of Perugino can be seen in Raphael's excellent *Marriage of the Virgin* of 1504, in the Brera Gallery, Milan, which is inspired by Perugino's *Giving of the Keys to St. Peter*, but in which Raphael has transformed the slightly formulaic figures into real human beings endowed with a high degree of grace and sweetness.

After Perugia, Raphael seems to have gone to Siena and subsequently to Florence, principally because of the exciting artistic goings-on embodied in the works of Leonardo and Michelangelo. Between the years 1505 and 1507, Raphael produced a series of superb Madonnas, including the so-called *Belle Jardinière* of around 1507 (in the Louvre), a work that is influenced significantly by Leonardo's *Madonna and Child with St. Anne*. Leonardo's style was instrumental in forming Raphael's use of a technique called *sfumato*, which is the employment of fine, soft, and subtle shading instead of lines to build up forms and facial features. In 1507 Raphael painted the energetic and sinuous *Deposition of Christ*, which is in the Borghese Gallery in Rome.

He was summoned to Rome at the end of 1508 by Pope Julius II, at the suggestion of the architect Donato Bramante. He was hardly known in the city but almost at once made a favorable impression not only on the pope but on other artists. It helped that

he was exceptionally handsome and charming—he was soon known as the "prince of painters." Raphael spent the last twelve years of his life in Rome and his output—including architectural design as well as painting—was prodigious. He is best known for his frescoes in the private papal chambers—the *Stanze*, or rooms, called *della Segnatura* (1508-11), *d'Eliodoro* (1512-14), and *dell'Incendio* (1514-17), in which he manages to combine monumentality, a keen appreciation of classical antiquity, and his unique elegance of style. In 1511, he also managed to paint an entire fresco cycle depicting the frolics of Galatea in the Villa Farnesina—certainly one of the delights of the Renaissance and a must-see in Rome; it never seems crowded because it's slightly off the tourist run. He also had time for a sensational series of Madonnas, including the *Alba Madonna* in Washington's National Gallery (of ca. 1508) and the extraordinary *Sistine Madonna*. He also produced one of the most penetrating portraits that has survived, the dignified epitome of the Renaissance man in the *Baldessare Castiglione* of 1516 in the Louvre.

Pope Julius II ordered him to create the designs for a 10-tapestry series intended to be placed in the Sistine Chapel—today they are in the Vatican Museum—and their cartoons, or life-size colored drawings, are some of the highlights of the Victoria and Albert Museum in London.

Raphael was also an avid student of antiquity and archaeology and in 1515 was appointed by Leo X to be in charge of the preservation of ancient monuments that carried important historical inscriptions—in those days the inscriptions were considered more significant than the sculptures themselves. In 1517, Raphael was made the commissioner of antiquities for Rome, an enormous job which he carried out with his usual capability and good will. His last great work is the *Transfiguration*, which hangs in the Vatican Museum, started in 1517 and finished by his chief assistant Giulio Romano. This is equal in quality to the *Sistine Madonna* and shows an intriguing shift from his signature sweetness to a work in which the figures are portrayed as tense, even turbulent in their gestures and attitudes. Raphael died at the age of 37—his funeral was held in the Vatican with the *Transfiguration* exhibited at the ceremony. He was buried in the Pantheon, where one can see his tomb today.

# THE ECSTASY OF SAINT THERESA

GIAN LORENZ
BERNINI

GIANLORENZO BERNINI
b. December 7, 1598, Naples
d. November 28, 1680, Rome

THE ECSTASY OF SAINT THERESA
1645–52
Marble

Current Location: Cornaro Chapel, Church of Santa
Maria della Vittoria, Rome

THE CHURCH OF Santa Maria della Vittoria in Rome is simple, even drab. But it contains a chapel created for the Cornaro family by the master sculptor and architect of the Baroque period, Gianlorenzo Bernini, a most stunning piece of religious theater that merges sculpture, painting, and architecture in entertaining and emotional ways and is unsurpassed in all of art.

The chapel, which was commissioned by Cardinal Federico Cornaro and constructed between 1645 and 1652, can be found on the left side of the small church in a shallow transept. The focal point of the decoration is the exceptional sculpture representing *The Ecstasy of Saint Theresa*, which depicts the mystical experience of the great Spanish Carmelite reformer Theresa of Avila, during which an angel pierces her heart with a fiery arrow of divine love. Bernini followed Theresa's own writings describing the event. The saint is revealed within a niche over a richly decorated altar. On both sides of the main sculpture, in spaces resembling opera boxes, various members of the Cornaro family are shown in relief—chatting, reading, or praying. Natural daylight from a small window in the vault of the chapel illuminates the figures and highlights Theresa.

Saint Theresa's eyes are closed, and a look of orgasmic pleasure shines upon her face. But this is a pleasure that is far from one of the flesh. It is the ultimate ecstatic transport to a spiritual paradise—the departure of the spirit from the soul to unite with the divine spirit.

As a result, the ensemble is one of the first multi-media works since antiquity. Looking at the transfixed figure of Saint Theresa, among the most beautiful portrayals of a woman in all of art, one may at first experience an almost shocking sexual feeling, but this is immediately suppressed with some degree of shame. Bernini must have been striving for such a reaction. For out of such a fleeting carnal desire comes a conviction that the saint must indeed have confronted her maker in the recesses of her imagination.

For Bernini, Rome was the city of his greatest triumphs of architecture and sculpture. A child prodigy, he was working in full flower at the age of fourteen, even before he was admitted into the sculptors' guild. His first major work, a Pan leaping into a tree, is in the Metropolitan Museum of Art.

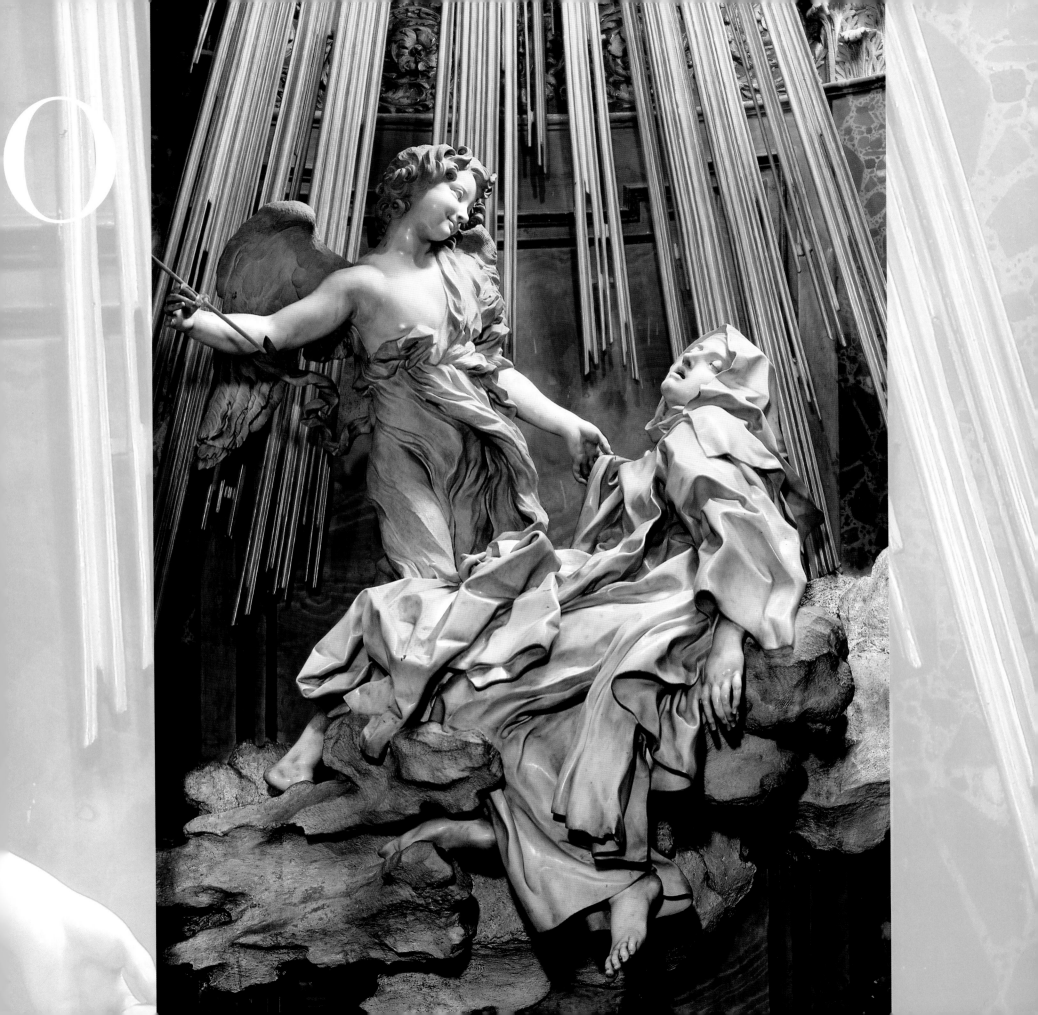

O

The young prodigy was remarkable as an artist but seems also to have been a gifted sales person of himself and his works. He earned the praise of the sixteenth century's leading artist, Annibale Carracci, and the patronage of Pope Paul V, and soon established himself as an independent sculptor. From the beginning he was entranced by classical antiquity but never allowed his obsession to dominate his own works—it's as if Greece and Rome are hidden deep within his stones. He doted upon the creations of Michelangelo. Reflections of the master are apparent in Bernini's early triumph, the dynamic marble *Saint Sebastian* of 1617, made for Cardinal Maffeo Barberini, who would later become Pope Urban VIII and Bernini's most active patron.

Bernini's early highly theatrical works, in which figures gesticulate somewhat madly (and marvelously), captivated another powerful and wealthy patron, Cardinal Scipione Borghese, who was a member of the reigning papal family. For him, Bernini created those astonishing life-size groups, *Aeneas, Anchises, and Ascanius Fleeing Troy* of around 1619 and the wild *Pluto and Proserpina* of 1621–22, both of which are treasures of the Borghese Gallery in Rome.

Bernini flourished under the patronage of Urban VIII between the years 1623 and 1644. For Bernini, of course, this meant architecture—and even a few paintings—as well as sculpture. During this period, Bernini made, over a long period of time, the awesome gilt-bronze baldachino over the chair of St. Peter's in the Vatican, with its twisted columns and soaring domical structure and the great fathers of the church (Saints Ambrose, Athanasius, John Chrysostom, and Augustine) delicately holding up the massive bronze throne, which contains an ivory and wooden chair dating to Carolingian times. It has been said that this baldachino is the first truly Baroque monument.

After the death of architect Carlo Maderno, the demand for Bernini increased and he became the architect of St. Peter's and of the Palazzo Barberini. To complete the many works assigned to him, he honed his organizational skills and managed to be the overseer of works carried out largely by helpers without any apparent loss of energy in the works themselves.

He was a devout Catholic (attending mass every day) and a staunch believer in what had been decided at the famous Council of Trent (1545–63)—

basically that the aim of religious art was to inspire the faithful and to help in recruiting new followers. Religious art had to be understandable and naturalistic but, equally important, it had to stimulate one's emotions.

For Urban VIII, Bernini created innovative monuments ranging from fountains to tombs. Urban's tomb in St. Peter's has the pontiff seated with his arm raised in an imperious gesture above representations of the Virtues. After Urban, Bernini's patrons were Popes Innocent X and Alexander VII. His most exceptional public monuments date from the mid-1640s to the 1660s and include the *Fountain of the Four Rivers* in Rome's Piazza Navona, dating to the years 1648–51. It was during this fully mature time that he created the superb *St. Theresa*.

In his later period, he concentrated upon architecture. After completing the Cornaro Chapel, his most memorable achievement was the church of Sant'Andrea al Quirinale in Rome, constructed between 1658 and 1670. But even more imposing is the grandiose colonnade enclosing the piazza in front of St. Peter's.

Bernini's late sculptures are sparse but highly powerful—this is an artist who seems never to have flagged in creative energy. In a tiny chapel in the Church of Santa Maria del Popolo in Rome, he carved two groups, *Daniel in the Lion's Den* and *Habakkuk and the Angel* between 1655 and 1661, which show off perfectly his unique combination of theatricality and humanity. Also from his late period are the unforgettable stone *Angels* for the Sant'Angelo Bridge in Rome, which he rebuilt between 1667 and 1671. Pope Clement IX was so taken by them that they were never set up on the bridge and now can be seen in the church of Sant'-Andrea delle Fratte in Rome. His most moving late sculpture is in a spartan chapel in the church of San Francesco a Ripa in Rome, dating around 1674. The statue commemorates the death of the holy woman Ludovica Albertoni, who is placed in an enormous volume of space and is highlighted so that the drapery surrounding her supine figure dances vivaciously. Her hands clutch her breast in a moving gesture of agony.

Bernini died at the age of 81 in 1680, after having pleased eight popes. He was considered to be one of Europe's greatest creative forces and principal inventor of one of the grandest and most enduring artistic styles in history—the Baroque.

# HÉLÈNE FOURMENT IN FURS

RUBENS STANDS out in the privileged circle of the five greatest painters in the long span of Western civilization. Astonishingly prolific, he produced hundreds of sleek, gracious, feathery, and absolutely stunning pictures. To me, the work that represents the pinnacle of his career is a life-size oil painting that he described in his will as *"Het Pelsken"* ("the little fur"). It was the only picture he specifically left to his widow, Hélène Fourment, and one of the few that she didn't destroy. It is not only one of the most universal images of womanhood ever made but one of the finest intimate portraits ever produced.

Some art historians believe that the subject is Hélène as Aphrodite, and that it is an outdoor scene because of a fountain in the far-left background. But that seems unlikely. Rubens has portrayed Hélène Fourment here as a woman about to jump into bed with her husband. There is no other way to explain the intensely private and deliciously inflammatory sensibility that the painting evokes. Nothing else in all of Western art compares with the turned head of this provocative woman, with her abundant golden hair reined in by a white hairband and her right arm raised to her left shoulder and pressed against

her breasts, which seem to spill over her forearm. Rubens keeps the whole surface alive by his exquisitely refined painting of her left hand and wrist, clutching at the fur robe and framed by the encircling white chemise just below her waist, and by his realistic treatment of her knees and feet, which seem to glow in the reflected light of the scarlet rug.

Rubens was born into a prominent Antwerp family who had moved to the German duchy of Westphalia to escape Spanish persecution during the war waged by the provinces of the Netherlands against Spanish control. The family moved back to Antwerp when he was ten, after his father died, and he was trained by local painters there. In May of 1600, at the age of twenty-three, Rubens went south to Italy and got a job with Vincenzo Gonzaga, the duke of Mantua. The young man absorbed everything he could learn from the many Renaissance paintings in the Gonzaga collection.

Rubens's first large painting, representing the gods of Olympus (today in the National Museum of Prague), is a huge and badly painted daub. But in a short time he emerged as one of the most graceful artists of history, a man who invented a new canon of human proportions and whose tal-

PETER PAUL RUBENS
b. June 28, 1577, Siegen, Westphalia
d. May 30, 1640, Antwerp

HÉLÈNE FOURMENT IN FURS
1630
Oil on wood
68⅔ x 32⅓ in. (176 x 83 cm)

Current Location: The Kunsthistorisches Museum, Vienna

ents as a colorist have perhaps never been equaled.

Rubens was not only a painter but a professional diplomat, and throughout his life he went on numerous diplomatic missions.

He eventually left the Gonzaga circle and returned to Antwerp in 1608, where he was enlisted into the service of the Spanish Hapsburgs, the regents of Flanders. He collected Old Master paintings and antiquities and painted up a storm. In October 1609 he married Isabella Brant and became a much-sought-after portrait painter and a major religious painter as well.

In 1622 Rubens was summoned to Paris by the widow of French king Henry IV, Marie de Médicis, who commissioned a large series of paintings for two long galleries in her newly constructed Luxembourg Palace. It's astonishing that he found time to paint, for between 1621 and 1630 he was pressed into almost full-time diplomacy by the Hapsburgs. He could use his profession as a painter to carry out numerous covert missions.

Isabella Brant died in 1626, and in 1630 Rubens married a gorgeous teenager, Hélène Fourment, the young woman commemorated for all time in this matchless painting.

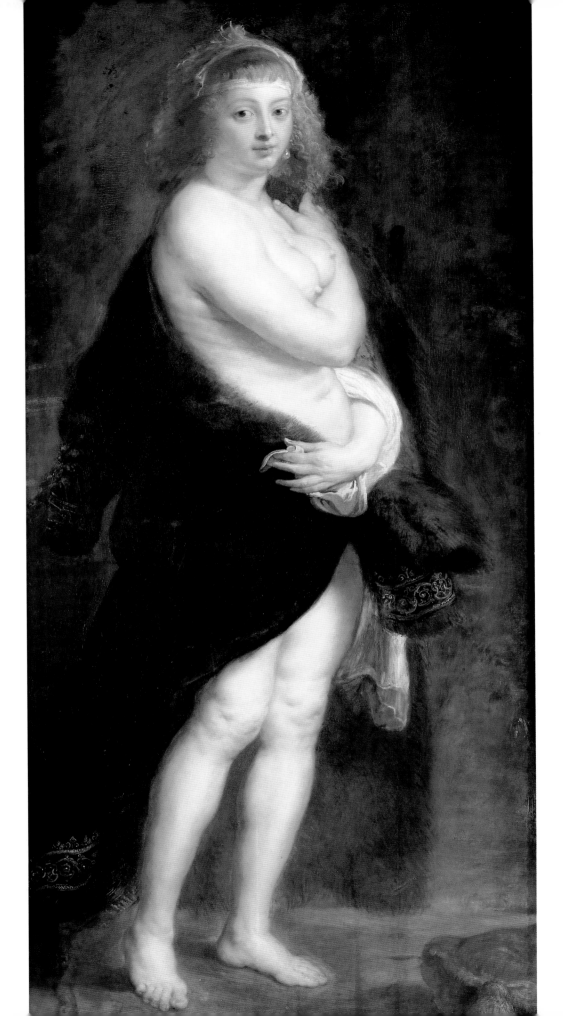

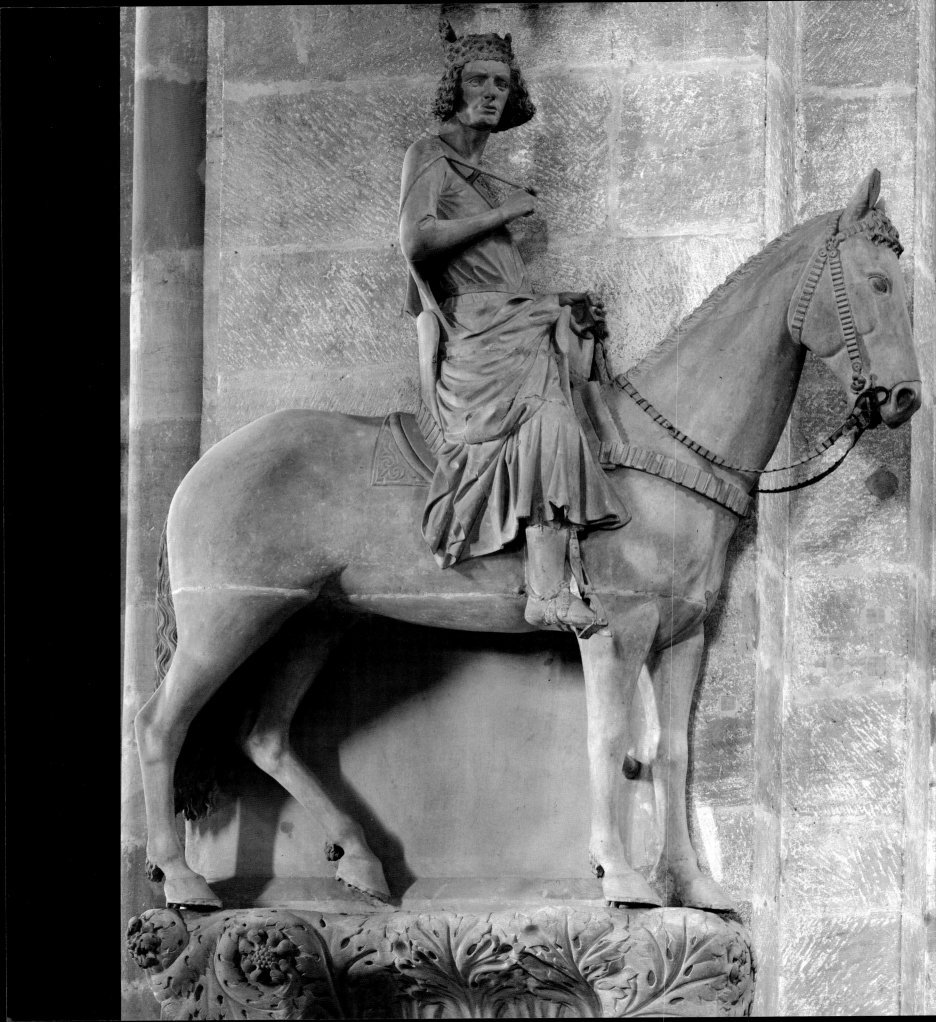

# THE BAMBERG RIDER

WESTERN ART is filled with equestrian portraits, and although several ancient Roman and Italian Renaissance artists are generally considered to have created the most vital of such images—such as the bronze equestrian statue of *Marcus Aurelius* (161–80 A.D.) on the Capitoline Hill in Rome and Donatello's *Gattamelata* (1445–50) in Padua—the best one, in my opinion, is a life-size thirteenth-century German sculpture in stone that was originally in the west façade of the Bamberg Cathedral and now can be found beside a pier in the eastern portion of the nave. It depicts a youthful royal knight on a majestic horse, suddenly stopped on his journey. The artist who created this arresting image remains unknown, but there is a theory that the sculptor can only be the same man who was the greatest master of cathedral building works, Master Bonensac. The statue dates most logically to the decade 1230–40.

This anonymous handsome young king—variously identified as St. George, the emperor Constantine, and Frederick II, among others—is shown looking out, urgently yet not anxiously, into the distance. His features are idealized, with clear eyes and a firm jaw, and his figure is lean. He is relaxed, even insouciant, for he casually holds the strap of his mantle over his right shoulder, as if it were some kind of a sling. But it isn't; indeed, one of the striking characteristics of this warrior is that he carries no weapon. This is no parade-ground celebrity or paid mercenary, but more a legend than a human being. He has the penetrating gaze of one who has never experienced fear or doubt—the perfect monarch. The horse is as spirited and heroic as his master. Combined, man and horse are as rock-hard and indomitable as a medieval castle. The *Bamberg Rider* is one of the most sensitively executed pieces of the entire Gothic period.

ARTIST UNKNOWN
Bamberg, Germany

BAMBERG RIDER
ca. 1230–40
Stone

Current Location: Bamberg Cathedral, Bamberg

# THE GOLDEN MASK OF KING TUTANKHAMUN

THE DISCOVERY of the tomb of King Tutankhamun in Egypt's romantic Valley of the Kings in the late evening of November 26, 1922, and the removal from it, over ten years, of nearly five thousand dazzling works of art caused a sensation throughout the world. It was, and remains, the richest discovery in the history of archaeology.

Tutankhamun, a shadowy pharaoh who lived more than three thousand years ago and died around 1350 B.C. under mysterious circumstances at the age of eighteen or nineteen, became an instant celebrity of the 1920s and remains one today. One suspects he always will be a star. The discoverers of the tomb—Howard Carter, a British Egyptologist, and his wealthy patron, George Edward Stanhope Molyneux Herbert, Lord Carnarvon—became unwilling celebrities at the same time.

After the shattering years of the Great War, the unearthing of the only pharaoh's tomb in the valley that had not been totally pillaged by ancient tomb robbers was extraordinarily appealing. The two excavators had been told by all the experts that the ancient City of the Dead had been completely excavated, yet they pressed on. For years they found nothing; but they assembled clues that led them to the inescapable conclusion that the valley held one more royal tomb, which other archaeologists had ignored.

Then, in the last season that Lord Carnarvon would support, in the last tiny area of the valley where they believed no earlier excavator had plumbed to the bedrock, they made their splendid discovery. Suddenly before them lay thousands of works of art of such serene beauty that certain visitors to the tomb literally felt faint when they looked at them.

I, too, felt I might faint when I first saw the mind-boggling display in the Cairo Museum when I first went there to start organizing the famous show. I have been there several dozen more times and have fallen in love with many of the works. Yet the one that has taken my breath and my heart away is the golden mask of the boy-king, and I will never forget the morning I lifted it off its perch and touched it.

This gold and lapis lazuli mask is the most beautiful and evocative work of decorative art to have survived early antiquity. It is perfect in execu-

tion and flawless in condition. Artistically, it ranks among the top portraits ever achieved—the gorgeous youth is portrayed as a king, a god, and a vulnerable child. No one who gazes at this magnificent piece will fail to be moved by the strength as well as the sensitiveness emanating from the visage. The uncanny thing about this huge piece of jewelry, this beautiful canister to contain mummified remains, is that it is almost more lively than life itself. With its incomparable artistry it has achieved the goal of the ancient Egyptians—eternal life.

We know almost nothing about Tut's accomplishments other than what is recorded on one stone stele (commemorative slab) that was overlooked by his brutal successor, who smashed every Tut monument he could find. The writings tell stirringly that the boy-king replaced existing chaos with order and restored the ancient gods to Egypt. Looking into that contemplative, confident, yet strangely anxious face, one feels it's not mere propaganda. Part of the phrase inscribed on a sheet of gold between the hands of the king's mummy says, "The king of Upper Egypt . . . deceased, given life like Ra." Indeed this radiant boy truly is the eternal sun god.

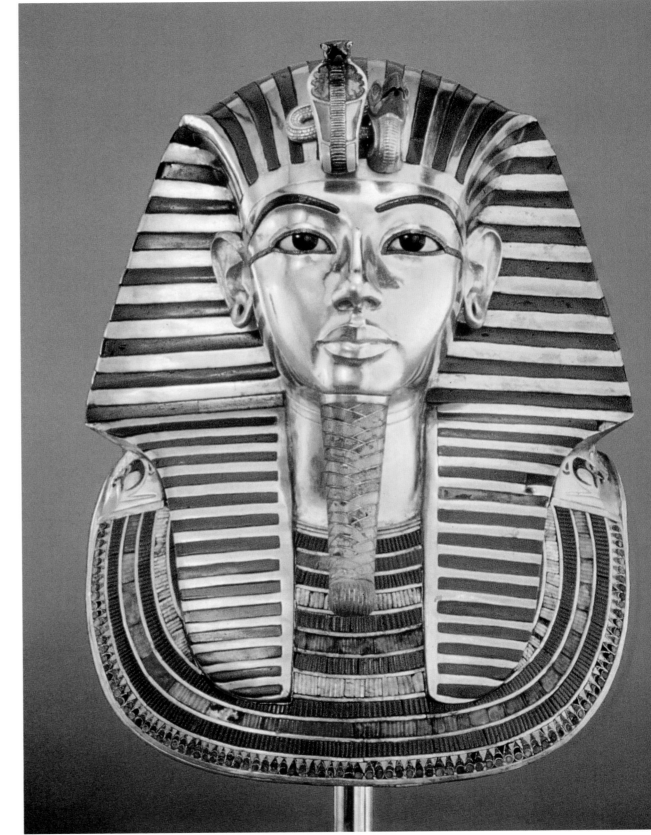

# JAN VERMEER

# THE VIEW OF DELFT

JAN VERMEER
b. Oct. 31, 1632, Delft, Netherlands
d. Dec. 15, 1675, Delft

THE VIEW OF DELFT
1660–61
Oil on canvas
38¾ x 46¼ in. (98.5 x 117.5 cm)

Current Location: Mauritshuis Museum, The Hague

THE GRANDEST cityscape ever painted, *The View of Delft* by Jan Vermeer, is a fanciful and imaginative portrait of the painter's beloved city, enraptured by his unique sparkling light. The time is precisely 7 A.M., but Vermeer has succeeded in capturing a variety of lighting effects from throughout a gorgeous sunlit day. The place from which he painted it has been precisely identified on a contemporary map—the upper story of a particular house—but the painting is by no means a slavish copy of what the artist's bright eyes showed him. Vermeer conflated part of the view and spread out other parts to achieve a beautifully balanced composition. The quality of the painting is remarkable for the deftness of Vermeer's handling of paint in every part of the picture—the brushstrokes evoking the billowing clouds, the glistening pearlettes of the sides of houses dappled by sun, the slate texture of those roofs in the distance, the calm waters, and the sky itself. The beacon of a church tower, almost in the center of the painting, may be a political statement (as, indeed, the whole picture may be), for it is the Nieuwe Kerk, and holds the tomb of William of Orange, a hero of the Netherlands for his role in the resistance to Spanish rule. However that may be, this magnificent picture transcends all politics.

Vermeer, whose oeuvre was overlooked for centuries, was "discovered" in modern times only around the mid-1930s, and scholars are still trying energetically to stitch together the documents, so far meager, that will tell us more about his life and career. He was born in his family's tavern in the marketplace of Delft, and he lived his entire life in that city. Delft's archives show that he married on April 5, 1653, and was enrolled in the artists' guild in December of that year. He served as chairman of the artists' guild twice: in 1662–63 and again in 1670–71.

The man seems to have suffered financial problems and there are records that indicate some rocky times. Surprisingly, he was more effective—or so it was thought—as an art dealer than as a painter. According to the sparse records, Vermeer lived modestly and without fanfare in a small world of tradespeople who took his works as currency for his debts. From time to time, it seems that he was able to gain commissions for portraits of upper middle-class gentry and their ladies—his refined ladies entertain placidly in their salons. The settings

are luxurious, filled with costly carpets, expensive spinets, and dresses laden with embroidery and fur such as ermine. He painted during the rich Golden Age of Dutch painting, a time in which the wealth was staggering—even in the middle classes—and his subjects mirror the general opulence. His works captured a life of ease and monetary tranquility, which he never, apparently, enjoyed.

The paucity of facts surrounding Vermeer's life has given birth to scores of interpretations, and most authorities choose to say that his life was exceedingly narrow. No matter how differing are the interpretations, he is generally pegged as a recluse, and as an artist of surpassing genius.

He died young, at the age of 43, and was buried in the Old Church of Delft. His wife, Catharina, frantically tried to save twenty-nine of his paintings from bankruptcy proceedings, but failed.

# WIVENHOE PARK, ESSEX

JOHN CONSTABLE
b. June 11, 1776, East Bergholt, England
d. Mar. 31, 1837, London

WIVENHOE PARK, ESSEX
1816
Oil on canvas
22⅛ x 39⅞ in. (56.1 x 101.2 cm)

Current Location: National Gallery of Art,
Washington, D.C.

TODAY WE WORSHIP the Impressionists, perhaps overly so and maybe for the wrong reasons, believing them to have been pioneers in the attempt to capture the true light of the outdoors. In their own time, though, they were described as being more interested in structure and form than in mere light—an insight that makes them more credible precursors to Modernist painting than is often acknowledged.

The amazing light and stunning atmosphere captured by landscape painters is not always achieved painting out-of-doors in front of the motif. We tend to ignore or not comprehend the incredibly acute visual memory of truly great artists and overlook their gifts in recalling what they saw weeks ago on a summer day, right down to specific glints on wet leaves or a momentary cloud formation. One of the most beautiful and moving outdoor landscapes ever produced is John Constable's view of Wivenhoe Park, a work of the first half of his splendid career and so full of joy that it seems to welcome one of his happiest moments— it was created around the time of his marriage to Maria Bicknell, a union that was refused for years by her stiff father, a rector who looked unkindly upon the idea of an artist as son-in-law.

This landscape is the ideal, sun-soaked image of a spectacular English country house and estate. The owners can be seen in a donkey cart in the middle-left distance, one of them wearing a red shawl as bright as a fire beacon blazing at midnight. They are some half a mile from the viewer, but everything about them seems clear. The servants—a pair of fishermen—are working away with their nets in the pond to the right, and one of them wears a startling crimson vest. The painting is nothing less than a portrait of a most glorious moment in mid-morning, with the enchanting tin-roofed mansion glistening in the bright sunlight, its walls bathed in a pinkish tinge. There are four cows, two swans, and nine ducks with a few babies. Forty-eight black birds careen in the sky, decorated with puffy cumulus clouds bearing the promise of an oncoming shower. The shimmering waters themselves are spectacular.

Constable was said to have slaved over his canvasses in the relative darkness of the studio, working away by oil lamp and candles, after having made some quick oil sketches to pin down cloud

formations and light. The more we learn about his life and working methods, the more we realize that he was very much a painter who relished working on the site, capturing the moment of real life.

Constable was born in a small village near the river Stour in Suffolk, an area of England renowned for its natural beauty. His father, a wealthy owner of wheat mills on both sides of the Stour—in both Suffolk and Essex—expected the boy to enter the family business. But Constable was fascinated with painting, and after a few months with a local gifted amateur and encouraged by the professional Sir George Beaumont, he achieved his unswerving desire by starting on the bottom rung of the ladder at the Royal Academy School in 1799—at age 23.

For almost eight years it appeared that this maladroit artist, who couldn't seem to be able to draw from life, would never make it. Yet Constable had a clear goal and marched toward it implacably. At the end of eight years he was creating landscapes that were far ahead of his predecessors. During these difficult, formative years, he started to go on outdoor sketching trips, which seemed to lift his spirits. He launched into portraits and even a religious picture—all of which were weak. He soon realized that he'd better stick to the landscape for all else was diluting his talents. From 1809 to 1816, he worked much of the time in London, escaping the city to sketch, when he could.

His goal was lofty—he wanted to commemorate the Stour valley in a series of monumental canvasses—and did. The most famous of the six is *The Hay Wain*, which greatly impressed Eugène Delacroix when it was exhibited at the Paris Salon of 1824. Then he created his famous view of Salisbury Cathedral, with its tumultuous rain-charged sky, which the Bishop who had commissioned the work didn't like, considering it too romantic.

In the 1820s Constable came under the spell of that magnificent colorist J. M. W. Turner, and his works became bolder, more assertive. In 1834 Constable virtually stopped oil painting owing to ill health and produced watercolors whose vitality belies his weakening physical condition. When he died, few people knew of his works, but around the middle of the nineteenth century, after his watercolors and free oil sketches began to be exhibited, his reputation grew rapidly.

# THE TEMPTATION OF SAINT ANTHONY

JACQUES CALLOT
b. 1592, Nancy, France
d. 1635, Nancy

THE TEMPTATION OF SAINT ANTHONY
ca. 1616
Engraving ink, with bistre sparked by occasional
gold hints, on paper mounted on canvas
366 x 299 in. (930 x 760 cm)

Current Location: Musée du Petit Palais, Paris
Note: To see it, contact the Prints and Drawings
curator of the Petit Palais, or ask your hotel concierge
to make the appointment.

THE GREATEST PROBLEM faced by artists who attempt to depict the horrors of Hell is how to produce a powerful and frightening scene populated by an army of devil's assistants and mercenaries. Even the great Michelangelo fell victim to this weakness in his somewhat boring *Last Judgment* in his Sistine Chapel fresco. Jacques Callot, one of the most brilliant French engravers of the sixteenth century, avoided this by envisioning Hell as a parable of temptation in which the one being tempted, St. Anthony, is made so tiny that he's all but invisible (thus turning him into a symbol of the insignificance of man). Where's Anthony? He's the monk in the tiny cave in the middle right. Surrounded, hounded, screamed at—the sounds implied in this print are loud and terrifying—he kneels and prays steadfastly. The horror of this image is that you're never sure whether Anthony will survive the divine test. At the top, there's an enormous flying demon surrounded by a horde of a dozen smaller, even more vicious looking demons that appear to have been spawned from his hideous body (with more on the way, every second). Dozens more of the disgusting creatures form dangerous ranks on the stony landscape of Hell—

on the barren ground and nestled in every cranny of the huge scarred rocks and cliffs. The only appealing figure is a naked and exceptionally beautiful young woman perched proudly on top of a sled made out of the rib cage of some monstrous dead dragon, like a beauty pageant winner on a parade float. But she may be the most deadly demon in sight. The whole atmosphere pulsates with heat and smoke and fire, and the distant sea seems to curdle and bubble in the tumult.

This unsigned drawing is the first of several bold renditions of the temptation of St. Anthony made by Callot, and the most vivid. It portrays the temptation of St. Anthony, but it is psychologically and visually also Hell and the Last Judgment. It's the single most frightening scene of the Inferno I've ever encountered—so orderly, like Fascism, and so full of menace, death, and unrelenting torture and pain. The drawing is sure, strong, and loaded with energy, and there is a startlingly pleasant contrast between the washed areas so redolent with atmosphere and the rapier-quick pen strokes that make up the myriad creatures. The armies of terror are drawn as a loathsome cloud of evil with the individual devils so small that one gets the impression that

the final day of judgment will come as some stupe-fying haze of frightening nature, filled with noxious bacteria and evil little creatures that slip into one's insides to devour one alive from the inside out.

Callot was born in Nancy in north-central France in 1592, and was raised there. He lived in Rome between 1608 and 1611, and in Florence in 1612, working for many important patrons. His fame expanded throughout Europe. He came back to Nancy in 1621 and had so many clients that he could barely keep up with the demands for his talents. Enormously famous in his own day, Callot's patrons included Cosimo II de Medici, Louis XIII, and the Spanish Infanta Isabella.

# CORREGGIO

## JUPITER AND IO

THE HIGH RENAISSANCE in Italy is one of the most puzzling and greatly misunderstood periods of Western art. It lasted for only a couple of decades, during which time many people were more interested in religious propriety than in resuscitating the antique Roman world or paying court to humanism. And because of that, it was, almost clandestinely, an exceptionally randy period of art in which certain artists experimented keenly in the graciously erotic.

One of the artists from the tail end of the rocket that was the High Renaissance is Correggio, whose extraordinary ceiling in the dome of the Cathedral of Parma is worth going out of your way to see. One sensual painting by this master of all moods and scintillating textures of paint that should not be missed is *Jupiter and Io*, from a series depicting the Loves of Jupiter executed for Federigo Gonzaga, duke of Mantua, in the last years of Correggio's creative life. It shows the mortal nymph Io willingly accepting the embrace of Jupiter, who has appeared to her in the form of a looming black-gray and purplish cloud—one of the many disguises that he adopts to evade detection by his jealous wife while he is chasing after the nearest female quarry. The

naked young woman straddles, cuddles, and squeezes that Jupiterean cloud, her head thrown back with the most satisfied look of orgasmic pleasure ever produced in the fine arts.

The softness of the subtly modeled body and its feminine appeal has rarely been surpassed. Io is sexy but dignified, eager and entranced, compliant and forgiving. She sits on a mossy ledge against which, in not-so-subtle juxtaposition, is a huge root that seems to be about to make its entrance into a nearby vase. The colors are sunny, despite the cloud, and it even looks as if the sun will burst through at the last moment of this tender embrace. Correggio—his real name was Antonio Allegri—studied with the great master Andrea Mantegna in Mantua. Although he picked up the flavor of Mantegna, he seems early on to have been more enamored by the softness and smoky subtlety of Leonardo and, in a real sense, he took what was superb from the delicate light and shadowing of that consummate genius and, lending it more glowing color, actually succeeded in bettering some of Leonardo's style.

The finest of the youthful works are religious paintings that grow increasingly more colorful and

CORREGGIO
(Antonio Allegri)
b. 1489?, Correggio, Italy
d. Mar. 5, 1534, Correggio

JUPITER AND IO
1532–33
Oil on canvas
64½ x 27¾ in. (163.8 x 70.5 cm)

Current Location: Kuntshistorisches Museum, Vienna

luminous. His fully formed work appears in Parma, first in a ceiling for the parlor of an Abbess in the convent of S. Paolo, done around 1518–19. Although there are lingering echoes of Mantegna, this is his own rich conception, full of optimism and daring. The Abbess was so delighted with him that she got him work painting the dome fresco of S. Giovanni Evangelista (1522–23), followed by the apse decorations. In the incredible cycle of paintings for the cathedral of Parma, Correggio manages to bring together into a sensible spatial harmony the entire huge ceiling, treating the grand space as if it were a single canvas and, in a sense, equating the dome of the structure with the vault of heaven itself.

Correggio's other works include his grand altarpieces, gemlike small works made for private devotion, and a handful of sexy mythological pictures—the *Jupiter and Io* and a splendid *Danae* (in the Borghese Gallery in Rome.) His altarpieces are so full of energy and light that some are known for their emotional content more than their titles—for example, the *Adoration of the Shepherds* of around 1530 in Dresden's Gallery is known as *The Night*, and the exceptional *Madonna of St. Jerome* in the National Gallery of Parma is usually called *Day*.

# PRIMAVERA

SANDRO BOTTICELLI
(Alessandro di Mariano Filipepi)
b. 1445, Florence, Italy
d. May 17, 1510, Florence

PRIMAVERA
ca. 1485
Oil on panel
6 ft. 8 in. x 10 ft. 4 in. (315 x 205 cm.)

Current Location: Galleria degli Uffizi, Florence

SANDRO BOTTICELLI'S *Primavera* (sometimes also called the "Allegory of Spring") is one of the most lyrical paintings in all of Western art, combining a pleasingly superficial tang of classical antiquity with a dreamy contemporary quality. And along with the soft harmony in this delicate pas-de-deux, there is a covert strength, even a sense of menace. The faces and figures are archetypically poetic Botticelli creations, drawn so masterfully that the obvious effort of fashioning them is completely hidden. Who are they other than the manifestations of celebration and the coming-to-life? Certainly the Three Graces can be identified and so can Cupid. But some of the other characters in this joyful play will perhaps always remain an enigma, which is usually the case in Botticelli's allegorical works. Among the thousands of works of Western art that depict floral motifs—the most popular of subjects—this triumphant burst of creative energy is by far the most subtle and luminous. It is as if every element in the image is made of or enveloped in flowers. *Primavera* is the best antidote I know of for the gloom of winter.

The name Botticelli, which in Florentine dialect means something like "little barrels," seems to have come from the nickname "Botticello" given to his older brother Giovanni, a pawnbroker. Botticelli, who studied in the 1460s with Fra Filippo Lippi and then with Andrea del Verrocchio, had his own workshop by 1470. He developed a distinctive style by the mid-1470s, turning away from the naturalism and exaggerated three-dimensionality then in vogue at the height of the Renaissance to a delicate, highly evocative, more linear style in the manner of low relief and embellished with soft pastel colors, as in the *Primavera*. Yet this low relief could be sharp, and often the edges of figures and architectural settings are metallic but satisfyingly crisp—a tendency that became predominant in his late work. In all of the works of his mature style there is an uncannily rhythmic continuity, and all his figures seem to be captured in a near-cinematic spotlight.

Botticelli painted the *Primavera* and the *Birth of Venus* around 1485 for Lorenzo di Pierfrancesco de' Medici (a second cousin of Lorenzo the Magnificent) to decorate his villa on the outskirts of Florence at Castello. (Both today are in the Uffizi.) In each, there is a hint of the so-called International Style (which we've seen in several wonderful

works from around the year 1400), together with the fresh new zephyr of classicism that had become a key element of his work.

By the late 1490s, Botticelli's style changed and became iron hard, as in the *Calumny of Apelles* (ca. 1495–97) and the striking *Mystic Nativity* (1500), which some historians believe must have been inspired by the fiery preachings of the fundamentalist Girolamo Savonarola. Yet the *Mystic Nativity*, and its archaic style, seems more in debt to Hugo van der Goes's *Portinari Altarpiece* (see page 30). These and other of his paintings from this period, though difficult to interpret, are indicative of the moralistic fervor that appears to stem from some sort of religious crisis.

During the last ten years of his life, the northern, backward-looking artistic style Botticelli had adopted was out of favor, and he received almost no commissions. He was buried in the church of the Ognissanti, Florence.

# CONSTANTINE THE GREAT

IF YOU GO to Rome, do not fail to see one of the most tremendous works of sculpture to have survived from the ancient Roman world, though only in fragmentary form: the colossal head, upper arm, knee, and hand of Emperor Constantine I (r. 306-37). These huge body parts were once a gigantic statue of the emperor that adorned the apse in a basilica begun by Maxentius but taken over by the emperor whose greatest achievement was a dictum that officially tolerated the worship of Christ. The structure is at the southern end of the Imperial Forums, quite close to the Colosseum. Why did only these pieces survive? It is probable that the immense statue was made of a wooden armature supporting gilded bronze or perhaps sheets of gold fashioned into the costume Constantine was wearing, and only those parts that were exposed were carved in marble. They are now on pedestals in the courtyard of one of the two museums on the Capitoline Hill, and even in their present state they impress the viewer as one of the most awesome portraits in Western art.

The emperor was said by one of his biographers to be able to sit for hours at a time to greet the hundreds of supplicants that were presented to him on public days without moving a muscle or twitching an eye. Maybe the statue's unknown sculptor captured him in this impressive mode, for there is an impassivity in the great face that is comparable to a natural rock formation. Some who look at this rather severe visage for the first time might think it is disturbingly primitive. Those huge eyes stare into one's soul with chilling power, like some sort of icon, and there is a sacrifice of finesse for brute force—a style that seems purposefully inhuman. Yet that sums up the essential character of art around the year 300, particularly in imperial portraits. Abstract power was preferred over realism or idealism, for the emperor had become an idea of godhead, not a man.

ARTIST UNKNOWN
Roman, early 4th century A.D.

HEAD OF CONSTANTINE THE GREAT
ca. 320
Marble
Height of head: 8 ft. 6 in. (2.6 m)

Current Location: Palazzo dei Conservatori, Musei Capitolini, Rome
Note: Because this work is displayed in the museum's courtyard, it can be viewed even when the galleries are not open.

# THE PERSISTENCE OF MEMORY

SALVADOR DALI
b. May 11, 1904, Figueras, Catalonia, Spain
d. Jan. 23, 1989, Port Lligat, Spain

THE PERSISTENCE OF MEMORY
1931
Oil on canvas
9½ x 13 in. (24.13 x 33.02 cm)

Current Location: Museum of Modern Art, New York

SALVADOR DALI IS perhaps the greatest wastrel of the fine arts—he threw his talent down the drains of flamboyant publicity and prostituted his gifts to the world of advertising and Hollywood. Yet in his earlier years, before he was swept up into the maelstrom of his own hype and became the pathetic celebrity he seemed to cherish, the Spaniard created some of the most indelible visual images of the twentieth century. A few of these will some day, I'm convinced, outshine and outlast even those of his far greater fellow artist Pablo Picasso.

*The Persistence of Memory*, the single most provocative, sensual painting produced by this hectic circus master of painting, is so small that it could be a miniature. It is renowned for its three "limp" watch faces, which appear to be melting, and a smaller timepiece covered with ants, set in a weird, barren landscape with a truncated dead tree, from which one of the limp watches is suspended. The "hyper-realist" technique applied to the surreal images of this small, powerful painting is startling and accounts for some of its exceptional magnetism. Dali himself mused that the work was nothing more complicated than the tender, extrav-

agant, and arbitrary Camembert of time and space.

Dali linked himself to Freud, and so did the fashionable magazine writers who idolized Dali, but there is little real connection between Freud or psychoanalysis and Dali's fecund visual imagination. Yet *The Persistence of Memory* monumentalizes a dream that many people have experienced—the oddly pleasurable and disturbing slowing down of time, together with the feeling that one's senses have atrophied, and with the hint of a threat that perhaps at the end of this dream we might not wake up.

Dali's early obsession for drawing and painting was molded into a fierce discipline by a local Spanish Impressionist in his home town of Figueras. In 1921 he enrolled in Madrid's Academy of Fine Arts but was expelled in 1923 for insubordination, an act that thrilled him, for Dali was a life-long "insubordinator." He was even jailed for a month for anarchy during the restless political tumult of the early twentieth century. In 1924 he went back to the Academy and turned away from the classical painting he loved and experimented with Cubism and Futurism. His first show, in 1925, attracted rave reviews, although there were some who chastised him for his glibness, a charge that would continue

throughout his roller-coaster career. In 1926 he was thrown out of the academy a second time because in his oral exams he kept telling his examiners that he was a far better and more intelligent painter than any of them.

In 1928 he traveled to Paris and met Picasso and Miró, who were only briefly an influence on his artistic activities. He also went to Holland and fell in love with Vermeer, adapting the Dutch master's punctilious technique. In 1928 he returned home to Spain—Catalonia—and ventured into radicalism. The following year, Dali returned to Paris to work with filmmaker Luis Buñuel, and the pair made the flamboyantly grisly avant-garde film *Un Chien Andalou*, a savage shocker even today (still famous for the scene in which an eyeball is sliced by a razor blade). On its first showing in 1929 there was a riot. It was at this time that Dali met the Surrealists—René Magritte, Paul Eluard, and his wife-to-be Gala—and became a convert to the movement. Fleur Cowles, the best Dali biographer, tells how the painter, fascinated yet terrified by the beautiful Gala, took her to a cliff and was tempted to throw her off. It was thought that Dali had fallen into dementia owing to his overheated passion for

the beauty. According to Cowles, Dali commanded her to tell him what she wanted him to do to her— the most ferociously erotic act she could imagine. Gala reportedly answered calmly that she wanted him to kill her. After that she became Dali's Muse, model, manager, and wife. He had a genius for publicity, as did Gala, and they became enormously wealthy, catering to the rich and trendy members of Café Society, as the celebrity scene was then known, and painting their portraits.

In 1941, Dali had his first American triumph with a solo exhibition at the Museum of Modern Art. From that time on, he couldn't paint portraits of reigning celebrities fast enough, and the money rolled in. After World War II, Dali went back to Spain and settled in Port Lligat.

By the time he died, Dali had become a mental and physical wreck, preyed on by con men who had him sign thousands of sheets of lithography paper, which were then used to make cheap prints sold as Dali "originals." The critics and art historians spurned and mocked him. But these days, Dali's reputation is being somewhat rehabilitated. The Metropolitan Museum of Art in New York even held a show of his works in the late 1990s.

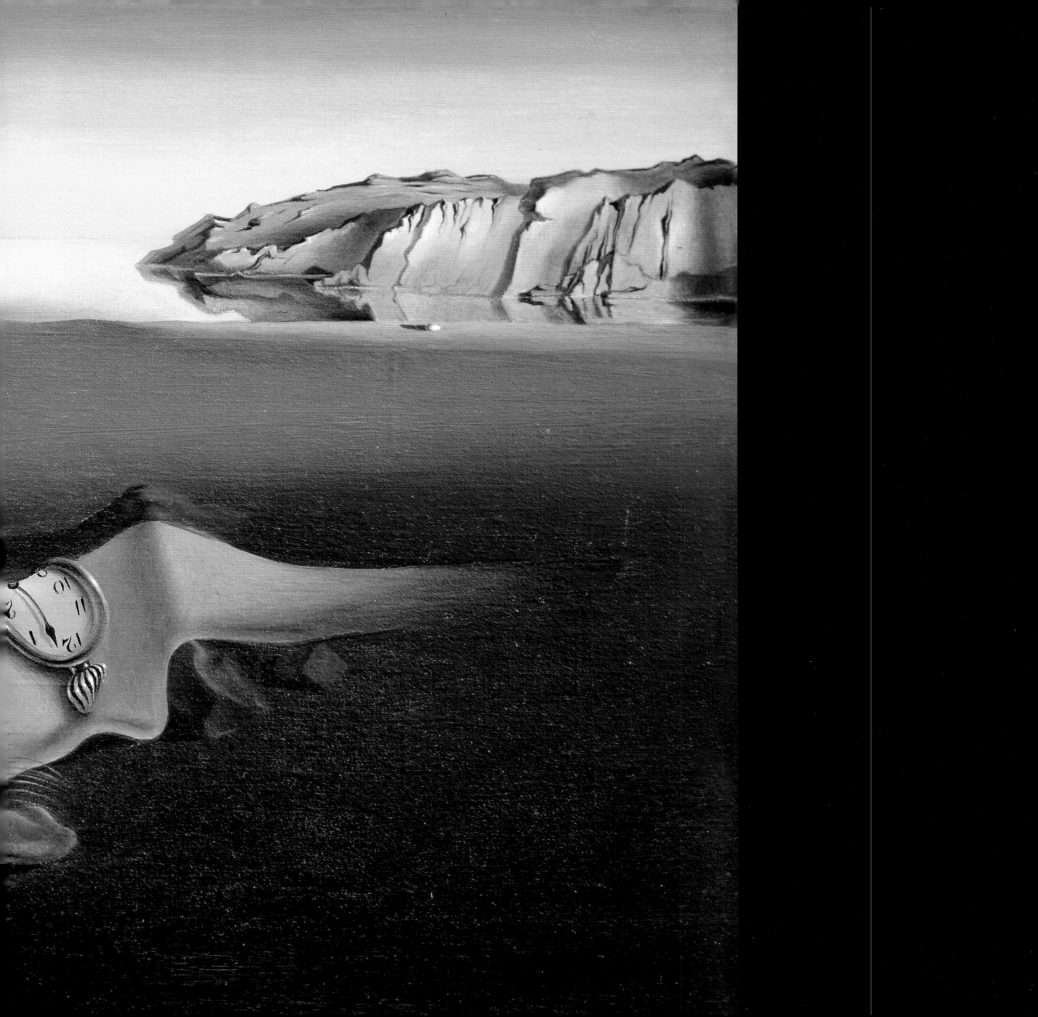

# EVE

GISLEBERTUS OF AUTUN

AS A SUBJECT IN Christian art, the Last Judgment acquired its complex iconography around the year 1000, and became one of the most popular themes in art during the twelfth and thirteenth centuries. From that period, there are dozens and dozens of representations of the dramatic story of Christ risen, sitting upon his throne of glory, condemning the damned to Hell and allowing the righteous to be lifted from limbo to be with him in Paradise. One of the most captivating is carved in stone in the tympanum over the main entrance (the west portal) of the Cathedral of S. Lazarus in Autun in Burgundy. It was designed or carved by a sculptor named Gislebertus, as indicated by a Latin inscription in gold beneath the feet of the figure of Christ: *Gislebertus hoc fecit* (Gislebertus made this). The figures are large and carved in typical twelfth-century unnaturalistic, almost abstract style. Most of the cathedral's other carved sculptures are also his, including those for the north portal and for approximately sixty capitals (including a series representing the *Infancy of Christ*), which for that period are unique in their sensitivity and strength.

The most striking figure in the extensive series of carved scenes is a large stone statue of *Eve*, now in the nearby Musée Rolin, which once adorned the lintel of the north portal. She is the only Romanesque nude that is both sexy and profoundly penitent. She is depicted sprawling erotically on her elbow as she snatches the forbidden fruit. A handy bough hides—just barely—her pubic hair, but the sensual quality of this earth mother and strumpet is heightened by her large and voluptuous breasts. Particularly compelling is the sure modeling of the face, which at first glance appears to be nothing more than a mask with a tiny nose, a slash for a mouth, and deeply undercut eyes, but soon reveals itself as a face of uncanny humanity. Another scene that is highly entertaining, and must have been originally intended to be witty, shows the three Magi sleeping on their way to Bethlehem, all three in one bed under a single coverlet, protected by an angel. In the seventeenth century, when Romanesque art was dismissed as "primitive" and "crude," this facade was going to be replaced by a porch. But one man on the town council pleaded that Gislebertus's work not be demolished but covered over, because someone, someday, might find the amusing crudities of some value. It was done, and one of the glories of Western art was saved.

GISLEBERTUS OF AUTUN
active ca. 1100-ca. 1135, Burgundy, France

EVE
from north portal of Cathedral of
S. Lazarus, Autun
ca. 1125-35
Stone

Current Location: Musée Rolin, Autun, France

# THE GHENT ALTARPIECE

HUBERT VAN EYCK
b. ca. 1366, Maaseyck, Flanders
d. May 6, 1426, Ghent

JAN VAN EYCK
b. ca. 1390, Maaseyck
d. July 9, 1441, Ghent

THE GHENT ALTARPIECE
1425–32
Oil on panel
11 ft. 5¾ in. x 15 ft. 1½ in. (3.5 x 4.6 m)

Current Location: Cathedral of Saint-Bavo, Ghent, Flanders (Belgium)
Note: Although the altarpiece has recently been installed in a new, larger space in the cathedral of Saint-Bavo, be advised that the place can be very crowded.

THROUGHOUT THE Middle Ages, one of the standard ways of accounting for the creation of masterworks such as the *Book of Kells* (see page 102), for example, was to say that they had been made by angels. If we didn't have documents that firmly establish that *The Ghent Altarpiece* in the Cathedral of Saint-Bavo was created between 1425 and 1432 by the mortals Hubert and Jan van Eyck, we might believe that this radiant series of images had been painted by a heavenly host.

The conception of the altarpiece is unique. It consists of twenty panels of different shapes and sizes, in two rows. Of the twelve interior panels, the largest is *The Adoration of the Lamb* (the central panel of the lower row), which shows the Lamb of God on an altar in a meadow, several yards behind a Fountain of Life, surrounded by angels, apostles, prophets, bishops, popes, and virgin saints, with a Flemish town in the distance. In the five panels above it, one sees a very naked Adam and Eve on the extreme left and right, next to scenes showing angels singing and playing music, framing a triptych of the Virgin depicted as a queen, God the Father portrayed as a relatively young man (his chiseled features make him seem very athletic,

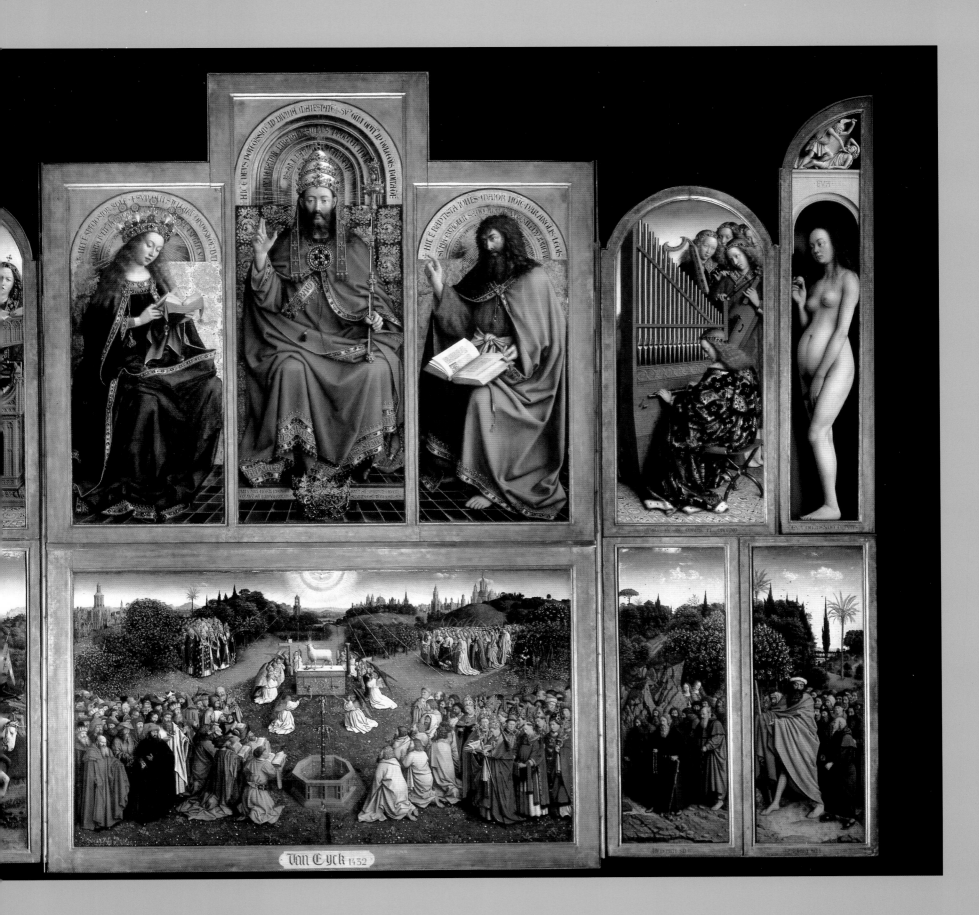

a surprisingly human characteristic for the Almighty), and John the Baptist. All the biblical personages look like Flemings of the early fifteenth century. In the bottom row, *The Adoration of the Lamb* is flanked by pairs of panels depicting the Just Judges and the Warriors of Christ, and the Holy Hermits and the Holy Pilgrims.

When the imposing altar is closed there are several more vignettes and personalities, many of them painted as if they were carved alabaster sculptures; the trickery is captivating. There are three rows on the exterior. On top, two Old Testament prophets and two classical sibyls proclaim the inevitability of the Annunciation, which dominates the center of the closed altarpiece and offers a stunningly pure landscape in the distance. On the bottom are two donors (whose identity has always been a subject of intense speculation) who kneel adoringly and flank two spectacular "alabaster statuettes" depicting, on the left, John the Baptist and, on the right, St. John the Evangelist.

The painting is renowned for how every detail is brilliantly rendered. The realism of this work is literally breathtaking and there is simply no other work in existence that can come near to the intense concentration of the utter reality of everything in the picture, but especially of the details. Everything, from the hundreds of jewels and pearls in the massive bejeweled crown worn by God the Father to the fleece of the lamb, seems to have been (and perhaps was) painted with a single-hair brush. A visitor could spend a week viewing just the amazing crown. The transformation of base materials to the divine, the sheen of gold on embroidered garments, in no way takes away from the overall impression of devotion and piety. For reverence, the Ghent altarpiece wins out even over Michelangelo's Sistine ceiling frescoes.

There is a painted inscription on the Ghent Altarpiece that states, "The painter Hubert van Eyck, greater than whom no one was found, began [this work]; and Jan, his brother, second in art [carried] through the task . . ." Because of this, generations of art historians have argued over which part of the masterpiece is Hubert's—if any, for the inscription is a transcription from the sixteenth century and earlier references do not mention Hubert at all. In the attempt to discover

Hubert, historians have tried to attribute to him the harder, less lyrical "Eyckian" works such as *The Three Maries at the Tomb* in the Boymans Museum in Rotterdam, but perhaps we'll never know securely which are signature works by the—presumably elder—brother.

Most experts these days believe that Hubert designed and partly completed his original version before his death in 1426, and that between 1430 and 1432 Jan repainted much of it and created completely new sections, including the Adam and Eve and the upper landscape of the central lower panel. It is almost universally acknowledged that Jan was one of the greatest innovators and stylists in all art history. He perfected painting with oils and is the greatest practitioner of the technique. He signed his paintings—perhaps the first Flemish artist to do so—with the inscription "IOHANNES DE EYCK," adding to some of them the seemingly humble motto *"Als ich chan"* ("As best I can"). The documents of his life are scanty. The first known record has him working in The Hague as "honorary equerry and painter" to John of Bavaria, Count of Holland, in October 1422, a position he apparently held until the count died in 1425. Van Eyck then went for a short time to Bruges before he was enlisted by another grand patron, Philip the Good, Duke of Burgundy. On Philip's behalf, Jan van Eyck not only painted but acted as the Duke's confidential agent abroad. One of his missions was to travel to Spain in 1427 to set up a marriage between the Duke and Isabella of Spain—which didn't work out—and, following that, another matchmaking mission in 1428, through which he succeeded in arranging for Philip to marry Isabella of Portugal in 1429; as part of the deal, he painted a portrait of Philip's intended. He worked in Lille and in Bruges as well as in Ghent; toward the end of his life, he stayed for the most part in Bruges.

Jan van Eyck signed nine paintings and dated ten, yet it is exceptionally difficult to formulate a chronology of his works that satisfies a majority of the experts. Other triumphant works include *The Marriage of Giovanni Arnolfini and His Wife, Giovanna Cenami* of 1434, in the National Gallery in London, and the *Madonna with Canon van der Paele* of 1434–36, which is in Bruges.

# LES DEMOISELLES D'AVIGNON

PABLO PICASSO

PABLO PICASSO
b. Oct. 25, 1881, Málaga, Spain
d. Apr. 8, 1973, Mougins, France

LES DEMOISELLES D'AVIGNON
1907
Oil on canvas
96 x 92 in. (243.9 x 233.7 cm.)

Current Location: Museum of Modern Art, New York

IN 1907, Pablo Picasso exploded into a fury of creativity that produced a nerve-shattering, grim, thoroughly unpleasant—yet spectacularly beautiful—image of humanity that would change the course of art forever. This world-shaking event was, of course, his ragged, chaotic, inchoate, even possibly evil, study of a number of women, a picture the surrealist Max Jacob dubbed *Les Demoiselles d'Avignon* after the brothels along Barcelona's Avignon Street.

The faces are African masks, the bodies are flat slatherings of strange colors, the still life elements are abstracted—every aspect of the work seems under attack and at war with every other work of art. A more complete denunciation of humanity and all artistic styles that had preceded the work cannot be imagined. The large painting is disturbing, loathsome in some respects, abhorrent, repellent, and at the same time magnetic, unforgettable, and lyrical. One can see it hundreds of times and still be struck dumb by its audacity, its freshness, and its courage—and, especially, by the way it seems to be the summation of the organized, state-sanctioned cruelty, the angst and schizophrenia of the modern age. I hate it and love it and defy anyone to feel differently about this hideously magnificent creation.

Picasso kept the painting rolled up and out of sight for several years, but when it was finally shown to his friends, Georges Braque is said to have exclaimed, "After this, we'll all have to drink gasoline!"

Picasso was, I suppose, *the* indelible artistic personality of the twentieth century. No other period of art has seen the likes of him. He was a genius of the fine arts, including sculpture, which he kept partially hidden for many years, and pottery. But Picasso was also a talented poet and a playwright. He is said to have believed that as long as he worked he'd stay alive, but the truth is probably that his personal energy didn't allow him to cease working. His artistic output is vast—understandable when one considers that he worked ceaselessly for 80 years.

Picasso's father, José Ruiz, was an academic drawing teacher who recognized that he had a child prodigy when his son was 10. The youngster was encouraged to draw from casts and live models. Picasso tended to joust with the official art schools he attended when a youth and in time ceased going to school at all.

In 1895, the family moved from Malaga to Barcelona, at the time a hotbed of Secessionism.

Barcelona was very avant garde, with Paris as its intellectual model. There the youthful Picasso soaked up not only the raging political fires of the day but also the excitement of an intellectual life that was distinctly pro-proletarian.

Picasso studied briefly in Madrid but left art school to wander the streets and sketch real life. He fell in love with the Prado and Spanish masters such as Velázquez and Goya. When he returned to Barcelona a little less than a year later, he'd become independent, refusing to continue going to art school of any kind, and more and more taking his mother's surname, Picasso. In 1900 he had his first Barcelona show, which was an instant success. He went to Paris shortly thereafter, where his dark colors were transformed into the brilliant palette of Van Gogh.

From 1901 to 1904, Picasso moved back and forth from Barcelona to Paris painting castoffs, the wretched, the ill, and even women in the prison at Saint-Lazare. He moved to Paris in 1904 and, along with his new friend Guillaume Apollinaire, became entranced with the traveling circus and *saltimbanques*. These wandering performers on the fringes became his symbols of the position of the artist in contemporary society.

Then, in 1907, suddenly bursts forth the irritating *Les Demoiselles d'Avignon*, where his fascination with African masks, striated as are some of the faces in the painting, replaced his interest in ancient Iberian sculpture. From 1908 on, Picasso —inspired by Cézanne's semi-abstract paintings— started to work with Georges Braque. Cubism gradually emerged; its beginnings can be seen faintly *in Les Demoiselles d'Avignon*. He worked with Braque on this dynamic new way of depicting the objects in still lifes from 1900 to 1912. Cubism was never simple geometry but a more exciting— and confusing—manner of representing objects from differing points of view simultaneously. All of the traditions of illusion and perspective were cast aside in the successful attempt to show multiple views of a vase or a guitar on the same canvas.

# ISENHEIM ALTARPIECE

THE MOST EMOTIONAL religious painting ever created is the altarpiece that Matthias Grünewald painted in the early sixteenth century for the monastery church of the Order of St. Anthony at Isenheim, in Alsace. The great work, more than twenty feet in length when its wings are open, dominates a gallery in the nearby museum in Colmar to which it has since been moved. It was commissioned by the head of the order to enlarge a 1505 wooden altarpiece that consists of carved figures of St. Anthony, St. Augustine, and St. Jerome. Grünewald added his painted scenes on three sets of wings, two of them movable, to make a polyptych viewable in three stages. The first stage, with the movable wings closed, shows the *Crucifixion* flanked by fixed wings depicting St. Anthony and St. Sebastian, with a *Lamentation* on the predella below. Once standing before the *Crucifixion*, you will be transfixed and horrified, for the crucified figure of Christ is covered with the most horrible series of lacerations, which you slowly realize cannot be the marks of his beatings, but must be the marks of some kind of terrible disease. That is in fact what they are: they are intended to resemble the sores of the sick people who were cared for by the Antonite monks. The monastery served as a hospice for those who were afflicted by syphilis (which was then incurable) and thus fated to suffer and die horribly.

The second stage of the altarpiece, with the outer set of movable wings open, consists of the *Angel Concert of the Madonna and Child*, in which an angel in pink plays the cello in front of an elaborate baldachino in which, on the far left, a feathered creature—perhaps the devil—is joining in, all in honor of the Virgin and Child. This is flanked by the *Annunciation* and the *Resurrection*. In the *Resurrection* panel, a lily-white figure of Christ, almost totally cleansed of the signs of disease and surrounded by an enormous golden halo and swathed in multicolored drapery, hovers above the tomb. At his feet are the sleeping soldiers of the Gospels. But there are other creatures, hideously wounded by the disease, who look upon the Savior and are about to rise and be cleansed like him. The colors, which at first seem jarringly pastel or moodily murky, in time become soothing. When the inner wings are opened, the carved figures of the original altarpiece are revealed, flanked by Grünewald's painted panels *The Hermit Saints*

MATTHIAS GRÜNEWALD
(Matthias Gothardt Neithardt)
b. ca. 1470, near Würzburg, Germany
d. August 1528, Halle, Germany

ISENHEIM ALTARPIECE
ca. 1509/10–15
Oil on panel
Main body: 9 ft. 9½ in. x 10 ft. 9 in.
(2.97 x 3.28 m)
Predella: 2 ft. 5½ in. x 11 ft. 2 in.
(0.75 x 3.4 m)

Current Location: Musée d'Unterlinden, Colmar

*Anthony and Paul in the Desert* and *The Temptation of St. Anthony*. The details of the ravages of syphilis are rendered with medical exactitude, yet they in time become painterly harmonies. The message of the work—that salvation will be delivered to believers no matter what are the sins of their flesh—is profoundly moving. After seeing the *Isenheim Altarpiece*, one cannot help but leave shaken, uplifted, and enlightened.

One of the greatest of the Northern Renaissance masters, Grünewald produced some of the major emotional and spiritual visions of all Christendom. Yet, his works are such that even the person relatively uninterested in Christian themes can gaze upon his stupendous works and be astonished.

Grünewald's real name was Matthias Gothardt—Grünewald being a name manufactured in the seventeenth century; Niethardt was his wife's family name, so he sometimes is known by that—and was born in Würzburg, but no one seems to know when. By about 1509, he is chronicled as being the court painter to the elector of Mainz, the archbishop Uriel von Gemmingen. Around 1510 he received a commission from a Frankfurt merchant to add two wings to the altarpiece *Assumption of the Virgin*, recently completed by Albrecht Dürer, for which he created four delightful saints in grisaille, which are stunning in their liveliness and in the unique handling of the crinkling, pleated draperies. About 1515 he was named the artist for the extraordinary panels of the *Isenheim Altarpiece*, which appear to have been strongly influenced by the text of the popular *Revelations of St. Bridget of Sweden*, written around 1370. Another of his great pieces is the *Meeting of Saints Erasmus and Maurice* (now in the Alte Pinakothek in Munich). It seems that he was sympathetic to the Peasants' Revolt of 1525 and spent the last two years of his life visiting in Frankfurt and Halle, cities that followed the emerging Protestant persuasion. At his death, a number of Lutheran texts were discovered in his effects.

# HIS MODELS

IN PARIS, THE Petit Palais has a small collection of medieval works of art and a few paintings that are almost completely overlooked because of the convenience and the popularity of the Musée d'Orsay. But one of them is worth a special visit, and one doesn't have to waste one's time looking at anything else. This is a large painting of two life-size naked women in bed together by Gustave Courbet, painted at the height of his prodigious powers with paint that has not (as is too often the case with this artist) turned sour and darkened. The two voluptuous beauties are artist's models. One is certainly Flo, Whistler's mistress, and the other, whose identity is not known for sure, was one of Courbet's models. They are both terrific-looking and would be considered immensely appealing at any moment in history. The painting was a shocker when it was exhibited at the gallery Courbet himself established to show off his works since the Academy rejected them one hundred percent, and it remains so now, for the women are locked in a tight embrace and are obviously enjoying highly satisfactory foreplay. Despite the sexy nature of the image, the painting is in no way pornographic or even smutty, because Courbet

has rendered his models as professionals in their line of work who have placed their gorgeous bodies in poses that show off their humanity like some magnificent still life.

Courbet was a political radical who was arrested for having participated in the destruction of the Vendôme column and fled to Switzerland in 1873: there he died unlamented and in great poverty. During the burgeoning years of his career his ultra-realist works were so detested by the critics that no one would show them; he started his own gallery, which was mobbed by the curious. He stands as one of the most puzzling French painters in history. The reason for that may be that he is a true revolutionary, a shabby, impertinent, noisome presence whose works still rankle—especially in the cleaned-up aura of the contemporary United States. What else to think of a painter who created bloody hunting scenes and portraits of nude women that are almost terrifyingly naked? Yet his works are as subtle as they are strong, and the only downside is that the paint of many of the pictures has darkened, imparting a gloominess to them that he never intended. Look longer at any Courbet, though, and they start to shine.

GUSTAVE COURBET
b. June 10, 1819, Ornans, France
d. Dec. 31, 1877, La Tour de Peílz, Switzerland

HIS MODELS
1862
Oil on canvas
29½ x 37⅖ in. (75 x 95 cm)

Current Location: Musée du Petit Palais, Paris

# CAMEO OF EMPEROR AUGUSTUS

THIS FIRST-CENTURY Roman cameo by an unknown artist surpasses all other cameos in existence in intricacy, power, and aesthetic appeal. Often called the *Gemma Augustea*, it is a perfect example of the high art that Augustus, the first Roman emperor (r. 27 B.C.-14 A.D.), brought to Rome—an idealized, sophisticated style antithetical to the more prosaic realism that preceded it during the Roman Republic. The cameo, crisp snow white against deep black, is carved in subtle low relief out of a large piece of onyx. It was made in the year 10 A.D. and probably commemorates the victory of Augustus's Roman army over the Pannonians the preceding year. The allegorical depiction of Augustus's triumph is divided into two registers. In the top register, the emperor sits on his throne, naked from the waist up, being crowned with a wreath by Oecumene ("the inhabited world"). Father Tiber looks on warmly at the emperor. Roma is seated beside him and looks adoringly at the all-powerful ruler of the world. Just above his head—like a sort of moon—hovers the sign of Capricorn, indicating that Augustus was born in January. Tiberius, the general in the campaign against the Pannonians, is seen on the left side alighting from his chariot driven by a winged Victory. The frieze in the lower register shows the prisoners brought back as slaves and the Roman legionnaires erecting a monument to the event.

The style is sleek, flawless, and regal. The breathtaking perfection of the details—even the pupils of the eyes are rendered—never impinges on the overall artistic harmony of this gorgeous sculpted semi-precious stone. Looking at the awesome figure of the emperor and his exceptional body and profile, one can see why Augustus was considered to be a god in his lifetime, or at least was represented as one.

ARTIST UNKNOWN
Roman, early 1st century A.D.

CAMEO OF EMPEROR AUGUSTUS
(*Gemma Augustea*)
10 A.D.
Onyx
7½ x 9 in. (19 x 23 cm)

Current Location: Kunsthistorisches Museum, Vienna

# RAIN, STEAM, AND SPEED

JOSEPH MALLORD WILLIAM TURNER
b. April 23, 1775, London
d. Dec. 19, 1851, London

RAIN, STEAM, AND SPEED—
THE GREAT NORTHERN
WESTERN RAILWAY
1844
Oil on canvas
35½ x 47½ in. (90.8 x 122 cm)

Current Location: National Gallery, London

EVERY TIME I VIEW a painting by Joseph Mallord William Turner—*any* painting—I am tempted to place him among the top three Western painters who ever lived, along with Diego Velázquez and Leonardo da Vinci. He is visionary, painterly, provocative, and intense, producing in nearly every instance a memorable image. Indeed, many art historians admit to remembering more pictures by Turner than by almost any other artist.

I have dozens of favorites when it comes to this awe-inspiring genius, but I've always considered the best of the best of his work to be *Rain, Steam, and Speed—The Great Northern Western Railway*. It possesses all the elevated artistic characteristics of the man, plus what is arguably his most uncanny vision. I adore it because I find it the most golden, dreamlike, and perceptive prefiguration of the change of the world from simplicity to modern times—our times, good and bad. Here there are no gods and goddesses or angels, demiurges or divine manifestations swooping down and changing mankind, no separation of the air and earth, no miracles. There is just a primitive, belching, clanking, and smelly locomotive pulling its open-air railroad cars, which cascade toward us,

smoking and screeching with the dimly perceived passengers—who are dressed in Sunday best—laughing with joy. The action takes place along a narrow bridge from which there is no escape. No one can get out of the way—even the frightened and, one suspects, soon-to-be-done-away-with rabbit desperately running ahead of the juggernaut. But *Rain, Steam, and Speed* is more than a prediction of the power of the industrial revolution; it is a work-of-genius painting, in colors that are a unique but typically Turner alchemy of rust, gold, blues, and whites of the fog approaching. In the dragon's maw of the locomotive, the fiery hues seem to threaten all of the natural world.

Joseph Mallord William Turner's career took off when he exhibited a pair of watercolors at the Royal Academy in 1791. In the next decade he was exhibited regularly, becoming a professor in 1807. Later, the brisk sales of his works, especially his luminous landscapes, freed him from teaching. As his fame grew he opened a gallery of his own in London, where crowds came to view such masterpieces as *The Fighting Téméraire* and *Rain, Steam, and Speed*. Later in his career, he began to pick up unrelenting flak from certain

critics because of the increasing freedom of his style, but he was defended admirably by the youthful John Ruskin. He died in London in 1851 and in his will gave more than 19,000 oils, watercolors, and drawings to the nation (which, alas, destroyed a brilliant series of sexually explicit drawings).

Turner is one of the great geniuses; an innovator of staggering talent and verve who still today shocks one with the audacity of his achievements. The place to see paintings by Turner—other than London's National Gallery, the home of *Rain, Steam, and Speed*—is the Tate Gallery, where his speedy sketches of the atmosphere look like contemporary abstractions, though far more profound.

# GOLD PECTORAL

UNKNOWN ARTIST
Greek, 4th century B.C.

GOLD PECTORAL
4th century B.C.
Gold
12 in. (39.6 cm)

Current Location: Historical Museum, Kiev
Note: The pectoral is in the vault of the
Historical Museum; what's on display is a
brilliant reproduction. So, if you visit, you should
ask the museum people to drag out the original
for you to see, which they will do for a modest
(and appropriate) donation.

ACCORDING TO THE ancient Greek historian Herodotus, the Scythians who roamed the Russian steppes from the ninth to the third centuries B.C. were monsters who occasionally drank toasts of victory from the skulls of their victims, although the Romans regarded them more as innocent "noble savages." They were also cultivated enough to hire as their artists the greatest Greek goldsmiths of the time, artists during the period when the Parthenon and the Pergamon altar were being created (see pages 260 and 55). Many Scythian treasures have been discovered in kurgans—round, beehive-like graves found in the Ukraine since the seventeenth century. Some of the objects buried with anonymous Scythian princes and chieftains are stellar works of art, equal in quality to the monumental sculptures of Greek temples. There are dozens of spectacular Scythian gold works of art displayed in the cramped, dusty vitrines of the Gold Room in the Hermitage in St. Petersburg, some of which are amazing, but the best Scythian gold work discovered so far is this piece in Kiev.

This enormous pectoral (chest piece) from the high Hellenistic period of the 4th century B.C. was made to be draped over the chest of a nomadic Scythian chief. Alexander the Great would have been so lucky to have worn this at the moment he conquered the world. It consists of three bands of delicately wrought figures and ornamental motifs, including a troupe of Scythians tending their livestock, some animals struggling against an attack by other animals or mythological creatures, and an abundance of floral ornament the likes of which have rarely been equaled in intricacy or spirit. The forty-eight minuscule figures are individually cast and soldered to the frame.

The unknown artist has contrasted scenes from the home life of the Scythians with wild, symbolic struggles of beast against beast. In the upper register, calves and foals are suckling, while two Scythians sit on the ground and sew a sheepskin shirt, with fleece so thick you can feel the lanolin oozing out of it. At the right, a third man milks a ewe, and, at the left, a fourth man (depicted in an unusual three-quarters frontal view) puts the lid back on an amphora. These scenes are framed by a kid, a goat, and a bird at each end. The middle zone is decorated with floral ornaments, on which four birds perch. At the center of the lower band, three pairs of griffins are attacking horses, proba-

bly symbols of evil assaulting good. These groups are flanked by lions and panthers attacking a deer on the left and a boar on the right, while at the tapering end of this band, a hound chases a rabbit and a pair of grasshoppers confront each other.

This triumphant work was found in a dig in the Dnepropetrovsk district, near the town of Ordzhonikidze, in an underground place called the Tolstaya Mogila kurgan near Kiev. It is one of the three most majestic gold works of art ever to have survived, and, most likely, one of the three best ever made in Western civilization.

# LAS MENINAS

DIEGO VELÁZQUEZ
b. ca June 6, 1599, Seville
d. Aug. 6, 1660, Madrid

LAS MENINAS
1656
Oil on canvas
125¼ x 108⅝ in. (318 x 276 cm)

Current Location: Museo del Prado, Madrid

DIEGO VELÁZQUEZ was not only a genius of a painter—perhaps one of the top five who ever lived—but he was also one of the most accomplished curators and connoisseurs in history. Many of the finest Italian paintings in the Prado were acquired by Velázquez in 1649 and 1650 on a trip to Italy, where the Spanish king Philip IV sent him to buy art for the royal collection. He almost didn't return, or at least that's what Philip began to think after Velázquez kept delaying his homecoming.

Thank goodness he did return, for had he not, the world would not possess what well may be the most thrilling portrayal of humanity ever created, a combination of portrait, self-portrait, illusion, reality, dream, and romance, likeness, and propaganda ever painted: *Las Meninas* ("the Maids of Honor"), now housed in the Prado.

This is an uncanny picture, in tight restraint at times and at others almost recklessly undisciplined. It is like an enchanted fragment of a living environment that has been mysteriously transported intact through the ages. The picture shows the Infanta—the child princess Margarita—surrounded by her ladies-in-waiting, her dog, and a friendly "house" dwarf, with Velázquez putting the finishing touches onto a huge canvas and the king and queen reflected in a mirror at the long end of the chamber, which seems to be—appropriately—a picture gallery. In the mirror placed just off center, the adoring monarch and his queen can be seen, probably posing for another one of the countless portraits painted by Velázquez.

What is so gripping about this huge painting is the way it captures an instant and makes it infinite. The king and queen have come for their sitting, opening the door into the gallery, and have surprised the Infanta and the painter, who is wearing a costume that appears to be one of high honor.

The way the canvas has been painted is breathtaking—the effect is ethereal, atmospheric, full of natural light, a monument to the heady and terribly difficult act of painting. The details are splendid—whether of the clothing, the distended face of the dwarf, the fur on the great dog, Velázquez's amused and surprised expression, the minute touches of color on his palette, or the murky paintings hanging everywhere.

The picture has it all—the dignity of officialdom, the tenderness of humanity, the laughter of a child, and a sense of joy and celebration unmatched

in all of art. It has always been the most startling lifelike image, but since its recent cleaning by John Brealey, the former conservator of paintings at the Metropolitan, it has become twice as radiant.

As a painter, Velázquez is unmatched in the portrayals of humanity, the creation of drama, in his elegance, his softness of touch, his power of execution, and his depth of understanding. After *Las Meninas*, among the other masterpieces by Velázquez, I'd have to select his sparkling *Juan de Pareja*, if for no other reason than that I bought this gem for the Metropolitan Museum of Art when I was the director. The portrait is of his go-fer and traveling companion, a hot-blooded black *bravo*. Velázquez painted it to show up his Italian colleagues, who readily admitted to having been bested, and to convince flinty Pope Innocent X to commission a portrait from him, which he did.

The number of personal documents is very small, and documentation of his paintings is rare. Velázquez almost never bothered to either sign or date his works. Though many copies of his portraits were evidently made in his studio by assistants, his own production was not large and his surviving works number fewer than 150. He is said to have worked slowly, and during his later years much of his time was occupied by his duties as a court official in Madrid.

Born in Seville, he was baptized on June 6, 1599, as Diego Rodríguez de Silva y Velázquez. In 1611 he was formally apprenticed to Francisco Pacheco, whose daughter he married in 1618. Although Pacheco was himself a not-so-exciting Mannerist, it was through his teaching that Velázquez developed his early naturalistic style. He was not more than nineteen or twenty when he completed the ultra-realistic *Water Seller of Seville*, today in the Wellington Museum in London. The naturalness of the figures and the still-life details reveal his phenomenal eye.

In 1622, a year after Philip IV came to the Spanish throne, Velázquez arrived in Madrid for the first time, eager to obtain royal patronage. He gained fame by painting a memorable portrait of the poet Luis de Góngora, but had no opportunity of portraying the king or queen. In the following year he was recalled to Madrid by the prime minister, Count Olivares, a fellow Sevillian and a future patron. Soon after his second arrival he painted a portrait of Philip IV that made his name. He was

appointed court painter and became a royal fixture and, for all intents, a member of the family—being given the luxury of a workshop in his gallery to which the king had a key so that his patron could walk in and watch.

Velázquez had complete access to the royal collection with its rich hoard of masterpieces, especially by the Italians. He became enamored with the works of Titian and that great Venetian was to influence him more than any other painter. He also admired Rubens, whom he met when the Flemish artist came to the Spanish court in 1628.

Velázquez visited Italy twice, first in 1629 and a second, lengthy sojourn in 1649–1650. After his return from the first Italian trip, Velázquez entered upon the most productive period of his career, creating splendid royal equestrian portraits such as *The Surrender of Breda*, his great contribution to the series of military triumphs painted for the king's throne room, as well as the poignant portraits of court dwarfs displayed in the Prado.

The chief purpose of Velázquez's second visit to Italy was to buy paintings and antiques for the king to decorate new apartments in the royal palace and to review the talents of fresco painters to decorate the ceilings. His first stop was Venice, where he acquired works by his beloved Titian as well as Tintoretto and Veronese. In Rome he was warmly greeted by prelates and artists, especially the French painter Nicolas Poussin and Gianlorenzo Bernini. It was in Rome that he created those two fabulous single portraits, the *Juan de Pareja* and pope *Innocent I*, now in the Metropolitan and the Doria Pamphili, respectively.

He returned to Madrid in the summer of 1651 with some of his purchases and was welcomed by the somewhat impatient King, who soon appointed his friend chamberlain of the palace, a job that had Velázquez arranging the royal apartments and the king's trips as well—an odd combination. During Velázquez's Italian absence Philip had remarried, and the young queen, Mariana of Austria, and her charming children provided new subjects for him to portray. This was the spur to the creation of the grand *Las Meninas*.

Velázquez's last royal activity, in the spring of 1660, was to arrange the decoration of the Spanish pavilion for the marriage of the Infanta María Theresa with Louis XIV. Shortly after his return to Madrid, he fell ill and died on August 6, 1660.

# THE WELL OF MOSES

CLAUS SLUTER
b. ca. 1340–50, probably in Haarlem,
Netherlands
d. ca. Jan. 30, 1406, Dijon, France

THE WELL OF MOSES
1395–1406
Limestone
Height of figures: 68 in. (173 cm.)

Current Location: Chartreuse de Champmol,
Dijon, France

THE ART PRODUCED for the court of Burgundy around the year 1400 rivals in excellence that of any other period in history. Painter Jean Malouel, the superb illuminators the Limbourg brothers, and master sculptor Claus Sluter were the most gifted among a great many artistic geniuses who worked for the dukes of Burgundy during this period. Sluter's prime achievement was a great stone Calvary conceived as a "Fountain of Life in Christ," erected for the Carthusian monastery (the Charterhouse of Champmol) starting in 1395, in the body of a well that serviced the institution's sophisticated irrigation systems. On that site today, all that remains of the monumental fountain—which must have reached a height of twenty-five or thirty feet—is the huge hexagonal curved stone base. The base originally supported the giant crucifix and its figure of Christ flanked by Mary and John; fragments of the poignant statue of Christ, which was almost totally destroyed during the French Revolution, are preserved in the local archaeological museum. Every figure in this monument was painted with lifelike color by Jean Malouel, uncle of the Limbourg brothers.

The spectacular hexagonal base is decorated with six over-life-size Old Testament prophets and, above them—lamenting the torturing and death of Christ—six sublime angels, whose outstretched wings support the cornice below the now-absent Calvary. In the center is David, from whom Christ descended; on the left is Moses, and on the right is Jeremiah; in the back are Zachariah, Daniel, and Isaiah. These massive, august figures, with their strikingly realistic faces, have an incomparable spiritual power. Daniel and Isaiah are depicted talking vociferously to each other and are agreeing on the inevitability of the coming of Christ and his Passion. Moses is an unforgettable image, with his thick, two-tailed ocean of a beard and his bulky nubs of horns, and a face that is one of the most expressive in all Western art. The angels weep and moan, one with a hand to his eyes to wipe away the tears, another covering his right eye with a hand in a gesture of great sadness. The patterns of glacier-like drapery transform these awesome figures into expressions of elemental force as well as men and prophets who foretold the coming of Christ.

Sluter is, simply put, a miracle. The profound realism of his work was completely out of sync with the International Gothic Style of other artists

of his day. His earthbound naturalism is wedded to an ethereal and harmonious spirituality to such an extent that stone prophets seem to live and angels to sing. These, combined with his dramatic flair, suggest a kinship with the flamboyant sculpture of the French Baroque, nearly two hundred years later—enough to conclude that Sluter's works influenced the entire movement. He stands as one of the top ten artists in history.

Sluter is thought to be the Dutch stonemason mentioned in records in Brussels around 1379 as Claes de Slutere van Herlam, who entered the service of Philip II the Bold, duke of Burgundy, in 1385. Other than the spectacular *Well*, Sluter also created the stone figures of the duke and duchess represented by their patron saints, John the Baptist and Catherine flanking the Virgin and Child. The other work by Sluter is the duke's tomb, which today may be seen in the Museum of Fine Arts of Dijon.

The tomb of Philip the Bold is especially noteworthy for the astonishingly beautiful mourners, of which there were forty, only about sixteen feet high but full of energy and emotion. Three of the mourners are missing, three are in the Cleveland Museum, and one is in a private collection in France.

# THE TRÈS RICHES HEURES

POL, JEHANQUIN, AND
HERMAN DE LIMBOURG
b. Nijmegen, Gelders (now Netherlands),
active ca. 1399–1416
d. 1416

TRÈS RICHES HEURES
DU DUC DE BERRY
ca. 1413–16
Illumination on vellum
8 x 5 in. (20.3 x 12.7 cm)

Current Location: Musée Condé, Chantilly
Note: The manuscript was recently removed
from public view for fear that its delicate painted
and gilded pages would deteriorate further.

THERE ARE MANY luminaries of art in that superb period of visual creativity that swept through the important courts of Europe around 1400—jewelers, furniture-makers, tapestry designers, sculptors, painters, and manuscript illuminators—but none have the spark and the elegance of the brothers Limbourg—Pol, Herman, and Jehanquin—French illuminators of several masterful Books of Hours. And no work equals the fabulously daring, sweet (in the best sense), and awe-inspiring Book of Hours commissioned by the greatest French patron of the arts during this period, Jean, the duke of Berry.

The king of illuminated manuscripts, which is what it was called repeatedly in its time, consists of 206 bound sheets of fine vellum painted with scenes representing the twelve months of the year, the Life of the Virgin, and the Passion of Christ. Because it was left only half-finished when the three artists and their patron died in 1416 from the plague, it was completed in 1485 by a French illuminator, Jean Colombe, in a crude style. The Limbourgs' contributions are nothing less than the best of the best.

The calendar cycle consists of full-page illustrations of courtly scenes such as hawking and peasant activities such as plowing and sheepshearing, each one surmounted by an arch containing the zodiac sign, days of the week, phases of the moon, and an iconic representation of the sun transported by Apollo in his chariot. They are all marvelous (except perhaps November, which is largely by Colombe), but to me, several stand out.

August is especially radiant. This is an idyllic portrait of the hot, sultry month when the harvest began in old France. In this lustrous illumination, we see a castle in white stone dominating the top—one of the duke's possessions, but one that has not been identified securely. Just outside the gleaming city walls, the golden wheat is being harvested and stacked into sheaves. A ponderous cart dragged by oxen is taking the harvest away. There's a small lake on the middle right; on the banks two people can be seen taking off their clothes to join a pair of agile and obviously joyful swimmers who are paddling along in an amazing realistic way.

In the foreground one finds the main scene, a retinue of starchy nobles. Unlike the lucky swimmers, the swells are dressed to the nines. A gorgeous lady sits on a brown horse with a handsome courtier who holds a hawk; in front is a solitary lady on a

Aries

Taurus

Gemini

Cancer

Taurus

Gemini

Cancer

Leo

Julius.

Augustus.

September

Libra

Scorpius

white steed, and, at the head of the procession, a lady and male courtier on a magnificent slate-gray stallion. In front and looking back solicitously there's an agile master of hawks. Two leaping dogs accompany the animated procession.

Another fabulous illustration is the *Zodiac Man*, sometimes called the "Anatomical Man," although he's not anatomically correct. One sees two male nude figures, one facing front, the other behind him facing in the opposite direction, within a sharply oval framing device. The oval frame consists of three bands: the outer, thin one is covered with digits; then there's a wider band illuminated with superb little symbols of the zodiac, then another thin band. The figures seem suspended in a delicate blue sky—heaven, one presumes—dotted with a variety of rain-swollen, wind-blown gray-brown clouds. The diminutive figures of Adam and Eve hang on to the upper arms of the slender, androgynous figure facing us. Signs of the zodiac float over his body; his vitals are covered by the scorpion of Scorpio. Above the heads of the pair are two zodiacal signs—on the left Aries, a gorgeous blue-silver goat, and on the right the crossed fishes of Pisces. These must be of special significance, perhaps something to do with the duke's signs, for in the head of the figure facing us appears Aries and the man is standing on the two fishes of Pisces. The drawing of the creatures and symbols are breathtaking, as are the nudes.

The three brothers were the sons of a sculptor and nephews of a great painter of the early fifteenth century, Jean Malouel. They always worked together, although Pol seems to have been the leader of the team. Around 1400 they were apprenticed to a Paris goldsmith and for two years beginning in 1402 Pol and Jehanquin worked in Paris for the duke of Burgundy. After the duke's death in 1404, they served the duke of Berry. For him they created their most splendid illuminated books, among which is the rich and radiant *Très Belles Heures* (also known as *Les Heures d'Ailly*), today in the Cloisters in New York. The *Riches Heures* is the blockbuster of their career, despite the fact that it was left unfinished in 1416; it was completed around 1485 by Jean Colombe in a heavy style.

# MILO OF CROTONA

PIERRE PUGET, ONE OF the most accomplished sculptors in history, is today all but unknown (especially in the United States, no doubt because there are few, if any, of his works to be seen there). Were it not for Puget's work, the French Baroque style would possibly have been febrile. His sculptures have a ferocious energy and éclat combined with a mountainous solidity that is unique in art. If one were to characterize Puget's style succinctly, one might say that he brought the sinuousness and sensuality of silk together with the satisfying harshness of boiled leather and tempered steel.

Puget was at his best when depicting scenes of violence and passion, and no work is a more fitting example than his monumental *Milo of Crotona*, almost nine feet tall in glistening, beautifully finished white marble. The form of the sculpture creates an enormous figure eight of power and agony, and has the integrity of Greek tragedy. In fact, the story on which it is based is Greek, and it's about hubris. Milo, renowned for his strength, was overly proud of his physical attributes. One day he spotted a tree stump and started to rip it apart with his bare hands. But his left hand became caught in the cleft, which held him fast with a force that was too much for even his strength. Trapped and in pain, desperately trying to free himself, and growing weaker at each attempt, Milo was suddenly attacked and killed by a lion.

For years Puget was shrugged at in France, but the excellence of his work will gain him admirers now that the renovation of the Louvre is complete, with its beautiful courtyards, one of which is dominated by this, his greatest sculpture.

Puget was arrogant and tough, and prone to temper tantrums; Jean-Baptiste Colbert, Louis XIV's culture minister (a.k.a. propaganda minister), could not stand him. So Puget got some of his best commissions only late in life, after Colbert died in 1683.

PIERRE PUGET
b. Oct. 16, 1620, nr. Marseilles
d. Dec. 2, 1694, Marseilles

MILO OF CROTONA
1670–83
Marble
Height: 8 ft. 10½ in. (275.5 cm)

Current Location: Musée du Louvre, Paris

# THE BATTLE OF SAN ROMANO

ONE OF THE genuine creations of Italian Renaissance art was an illusion of space and perspective that was far more clever than anything produced in classical times. The artist who doted most upon perspective—sometimes to the point of obsession—was the Florentine painter Paolo Uccello. But in a series of three paintings that once decorated a wall of the bedchamber of Lorenzo de' Medici, he created a grand vision that is not diminished by theory or technique or preoccupation with vanishing points. These pictures are furious, magnetic images of whirling struggle, grit, sweat, blood, pain, and triumph. Completed around 1445, they are thought to be an idealistic representation of the battle of San Romano fought between the Florentines and the Sienese in 1432.

Particularly attractive is the panel now in London, portraying Niccolò da Tolentino leading the Florentines, with its pink ground and strange tilted landscape, the incredible feel of the tarnished silver armor, the lances and waving standards, the frantic re-arming of crossbows. There's an impressive clang and clash of battle evoked by these images, accompanied by a sense of fear.

By ten years of age Uccello was an apprentice in the workshop of Lorenzo Ghiberti. In 1415 Uccello joined the Florentine painters' guild, yet nothing of his work from that time has survived. His earliest frescoes—sadly much damaged—are in the so-called Green Cloister of Sta. Maria Novella in Florence, representing scenes from the creation, dating around 1424–25.

From 1425 until 1431 he worked in Venice as a master mosaic maker, but again nothing remains that we are sure is by him. Returning to Florence he made some frescoes for the church of S. Miniato al Monte—also mere ghosts—and then obtained the commission to create a fresco equestrian portrait of Sir John Hawkwood, the mercenary who successfully commanded Florentine troops at the end of the fourteenth century. After a brief sojourn in Padua, Uccello returned to Florence and went back to the Chiostro Verde of Sta. Maria Novella and there painted two separate scenes surrounding the biblical story of the flood, this time using a far more complicated formula for perspective.

Following this, Uccello painted his famous scenes of the rout at San Romano. All the fruits of his intense study of perspective come into play in these truly magnificent depictions of battle.

PAOLO UCCELLO
(Paolo di Dono)
b. 1397, Prato, Italy
d. Dec. 10, 1475, Florence

THE BATTLE OF SAN ROMANO
ca. 1445
Tempera on panel
6 ft. x 10 ft. 6 in. (1.8 x 3.2 m)

Current Location: National Gallery, London.
Note: This is one panel of a triptych; the other two panels are in the Musée du Louvre, Paris, and the Galleria degli Uffizi, Florence.

# LAMENTATION

GIOTTO HAS BEEN described as the creator of modern painting—with good reason, too. He managed to instill life and substance into flat, painted forms in the first few decades after the year 1300, a century before the full flowering of the Renaissance style, and he broke free of the stiff, hieratic formula that had been the convention in religious painting since the first Byzantine icon paintings. Equally important is his achievement of creating some of the most unforgettable images of humanity within vividly presented dramatic scenes. He was also a spectacular colorist.

Giotto's greatest surviving work—and the one in the best physical condition—is the series of frescoes in a chapel in Padua erected by a wealthy merchant, Enrico Scrovegni, over the remains of a Roman arena. The chapel is thus usually referred to as either the Arena Chapel or the Scrovegni Chapel. Covering the walls of the nave in three tiers, Giotto's frescoes present scenes from the lives of Joachim and Anna, the life of the Virgin, and the life and passion of Christ as a continuous narrative, with the *Last Judgment* as its climax, filling the entire entrance wall. Below the three bands are charming monochrome personifications of the Vices and Virtues.

These paintings comprise what I believe to be the single greatest work of art in Western civilization—alone worth a trip to Italy. Their emotional content is such that the story seems fresh, laden with tension and a sorrow so profound that tears come to the eyes of many viewers. Every one of the scenes in this exceptional cycle is gripping, but two stand out as being universal in quality. One is the *Kiss of Judas* in which Judas, whose face is twisted and full of rage, engulfs a particularly sweet Christ in a dramatically treacherous embrace. It is so moving that looking at it makes one's heart skip a beat. The other scene, the *Lamentation*, is the most familiar painting of the series. Here, a strip of barren rock stretches diagonally across the painting, passing behind the grieving John the Evangelist—an image of universal human despair—and directing one's attention to the lower left corner, where Mary cradles her dead son on her lap in a manner that sums up infinite human grief.

Giotto di Bondone is something of an enigma even though we are told that he was a shepherd lad who was discovered making perfect sketches of sheep on flat rocks (one wonders about that story), and was said to be an extremely successful busi-

GIOTTO
(Giotto di Bondone)
b. ca. 1266/67-76, Vespignano
(near Florence), Italy
d. Jan. 8, 1337, Florence

LAMENTATION, ARENA CHAPEL
1305-06
Fresco

Current Location: Capella del'Arena
(Capella Scrovegni), Padua, Italy

nessman with a flourishing factory that made pigs' bristle brushes of all sorts.

His date of birth is a puzzle—either 1266–67 or 1276, depending on the source. It's fairly certain that he studied early on with the great Italian Cimabue and was heavily influenced by the monumental works of Nicola Pisano (see page 162).

He is known to have worked in Assisi, Rome, Florence, and Naples, but the works that have survived were extensively damaged and have been grotesquely restored in many instances. Thankfully, the great frescoes in Padua have not suffered too greatly and the incredible nature of this towering genius can be fully enjoyed there.

# THE HARVESTER VASE

ARTIST UNKNOWN
Minoan

THE HARVESTER VASE
ca. 1550 B.C.
Steatite
Width: 4½ in (11.3 cm)

Current Location: Archaeological Museum,
Herakleion, Crete

MINOAN ART is rightly considered by art historians to be among the most expressive and lyrical ever created. Those who have had the opportunity to see the fragmentary frescoes in Athens of elegant ladies and astonishing sea life realize that some of them rival in quality and accomplishment even those of the Renaissance. Minoan pottery and goldwork are exceptional, too, but the work I find to be the high point of this artistic civilization is somewhat unheralded and, even in its own museum, the Archaeological in Herakleion, Crete, it is hard to find. Unless one pressures one of the guides, it's easy to speed by the glass case on the second floor in which it stands.

The object is only a fragment of the center section of a round black stone vase, found in an excavation at Hagia Triada in Crete, which is carved with some of the most dynamic and startlingly expressive reliefs that have so far been found from Cretan civilization. Some unknown grand master of antiquity has portrayed, in an explosively powerful style, a bunch of harvesters coming home from the fields after a long, blisteringly hot day. They are being led by an ecstatic foreman (or perhaps a priest) who is swinging some kind of musical instrument. The field hands are singing so boisterously that one suspects the exuberance and joy come not only from the knowledge that the day's work is over but also from some potent wine. The small reliefs are so vivid that one can hear the voices and the heavy tramp of the feet of the muscular and lithe men. Looking at it, contemplating its ancient date, it's hard not to think that in the thousands of years that have passed since this masterpiece was created, when it comes to depicting human experience art has not progressed very much.

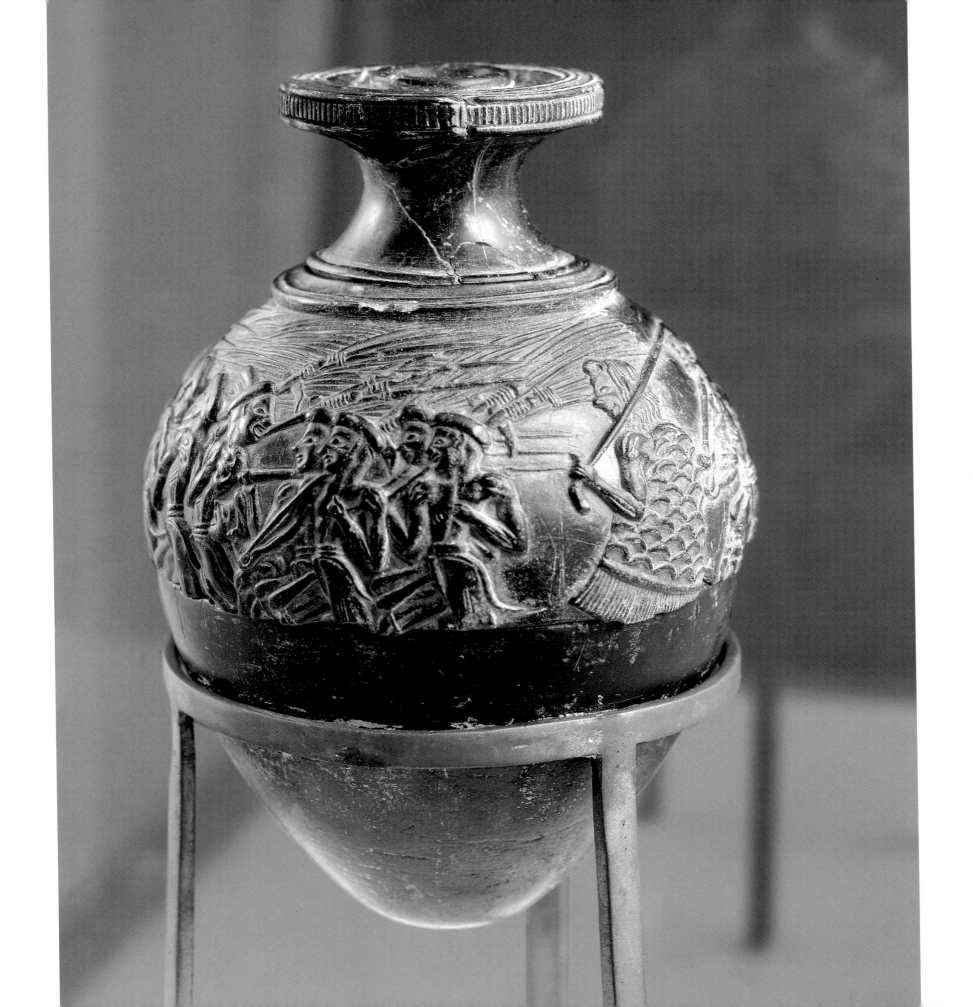

# BLUE POLES

JACKSON POLLOCK

JACKSON POLLOCK
b. Jan 28, 1912, Cody, Wyoming
d. Aug. 10, 1956, The Springs, New York

BLUE POLES
1952
Oil, enamel, and aluminum paint on canvas
82⁷⁄₁₀ x 191³⁄₅ in. (210 x 486.8 cm)

Current Location: National Gallery of Australia, Canberra

ONE OF THE most vilified artists in history is Jackson Pollock—the American painter cruelly dubbed "Jack the Dripper" and the one many philistines dismiss with the complaint, "My kid can paint better than that!" But Pollock's huge drip paintings are emotionally rewarding and skillfully conceived and executed, and are gaining in esteem all the time. The verve and explosive energy, the never-ending swirl of seemingly haphazard forms seem stronger than when they first shocked the world in the late 1940s and early 1950s.

Pollock never randomly "dripped and splashed." He planned his abstract works meticulously in advance and carried them off precisely according to his preconceived scheme, while allowing some random journeys and gestural explosions for extra power. He inserted a welter of bits and pieces of sliced marbles and glass chunks to enhance the overall effect. The works are far different from the parodies made by imitators dashing buckets of paint across a canvas on a studio floor. It may be significant that invariably fakes of his canvasses are quickly detected.

Pollock's paintings are grand and energetic landmarks of their time, especially his great *Blue Poles* (No. 11, 1952), in which eight enormous poles bend and sway in a tumultuous landscape of greens, reds, yellows, pinks, and blues. A vast post-nuclear forest of energy seems to have been created. The world is limitless, seeming to work its way in and out of the ordinary consciousness of mankind. I believe that it is Pollock's finest creation, combining the dynamism of all his periods, from the highly structured to the most elusive.

Pollock was born on a sheep ranch in Wyoming, and his family moved around several times between California and Arizona. Although interested in his art classes, he was a poor student and was expelled from two high schools. At the age of sixteen, he joined a brother in New York City to study at the Art Students League under the feisty Missourian Thomas Hart Benton. He liked Benton's independent streak and teaching philosophy, as well as his machismo and his delight in hard drinking. Pollock's big break came in 1940, when John Graham included several of his works in the show "French and American Painting" at the design firm McMillen Inc. in New York. In 1943, after patroness Peggy Guggenheim included him in two group shows at her Art of This Century gallery, she

gave him a one-year contract to produce a body of abstract works and mounted his first solo exhibition. His signature style began to emerge, featuring dynamic drips and splashes, scribbled lines, and poured skeins of paint—a style that coalesced in 1947 with a radical breakthrough in technique that led to an explosion of creative energy. Contemporaries, dubbed by art writers as the New York School, sometimes called Action Painting because of its supposed undisciplined energy, included Barnett Newman, Willem de Kooning, and Franz Kline. Today, with the benefit of time's perspective, the stylistic cohesiveness of the New York School seems vague. Its impact, however, was profound and especially de Kooning and Pollock created what was truly a new mode of abstract art that owed virtually nothing to Europe.

Pollock, an uncontrollable alcoholic, somehow managed to create extraordinary works. There's a haunting tale of his visiting the Cedar Tavern, the Manhattan hangout of the Abstract Expressionists, described by art historian Edward Lucie-Smith: "The habitués . . . made it almost a point of honor to get him drunk. 'For them,' one eye-witness wrote, 'Jackson was a freak, part of the entertainment, a notorious figure . . . who had somehow succeeded in spite of himself.'" He died in 1956 in an auto accident near East Hampton.

# LADY WITH THE UNICORN TAPESTRIES

ARTIST UNKNOWN

LADY WITH THE UNICORN
TAPESTRIES
Late 15th century
Tapestry

Current Location: Musée de Cluny, Paris

THERE ARE FEW works of art as gracious as the *Lady with the Unicorn* tapestries in the Musée de Cluny in Paris. This series of six late medieval tapestries depicts a beautiful woman in company with a docile lion and a once-wild and unconquerable unicorn, now tamed, in scenes that presumably represent the five senses. There is one inscription, *A mon seul désir* ("To my only desire"). The woman appears in every tapestry; we have no idea of her identity. Whoever she is, she's the universal personification of the best of civilization—someone charming, intelligent, sympathetic, and sensitive. And without question, this gorgeous woman—all of whose senses were the most accomplished—was beloved.

The colors, predominantly a blue of the most electric and deep hue and a red or scarlet that has the intensity of the most brilliant translucent enamel, are stunning. The backgrounds consist of magical forests—called *millefleur* in art history—in which grow countless varieties of flowers and herbs. They are also populated with magnificent creatures: rabbits, foxes, goats, birds, dogs, a monkey or two—one equipped with a roller with a chain that slows the creature down from its wild leaps—an ocelot, a diminutive leopard, and, of course, the stars of the show, a gleaming white unicorn and a tawny lion.

Each tapestry is a masterpiece. One of the most satisfying and luxurious, a thrilling riot of colors and forms, is the one showing the anonymous lady playing a small pipe organ. Her charming maidservant is pumping the bellows. The beige-yellow lion is depicted seated heraldically, looking back and holding a lapis-colored lance carrying a rectangular banner with a red ground and a diagonal azure field decorated with three crescent moons. The unicorn holds a lance supporting a banner with two flapping tails, which has the same crescent moons. The unicorn seems to be prancing or galloping in joy. Another tapestry shows the lady standing on a blue island amid a sea of red, between four abundant fruit trees, holding the lance with its distinctive banner flanked by a seated lion and a standing unicorn. She gently—and very provocatively it seems to me—holds the unicorn's horn. In medieval literature, the unicorn was both the symbol of Christ and of a male lover, but this scene appears to speak of love rather than spirituality.

We have no idea of the identity of the artist who designed these tapestries, or where they were woven (one source identifies the location as somewhere in Flanders, and another believes it is France's Loire Valley). Whoever the creator of these splendid images was, he has left the world one of its finest works. How do the Cluny's *Unicorn* tapestries compare to the *Hunt of the Unicorn* tapestries in The Cloisters in New York? Might they have been designed by the same artist and made in the same place? Sadly, no. When the two sets were exhibited in adjoining chambers at New York's Metropolitan Museum of Art in 1974, the Cluny's humbled those belonging to The Cloisters.

# THE WILTON DIPTYCH

THROUGHOUT EUROPE, the period from 1380 until about 1430 saw the creation of some of the most gracious art of all time. This soft style was Pan-European in nature and for that reason is sometimes referred to by art historians as the International Style of Gothic art. It is marked by its sinuousity and sweetness. One of the most intriguing works from this period consists of two exquisitely painted wooden panels and is called the *Wilton Diptych*. Although we know the approximate dates for when it was made, and the personages portrayed in it, we have no idea who painted the work or even where the artist came from. Art historians have debated the national identity of its creator, with most agreeing (though with no clear-cut proof) that he was English—an assessment with which I concur.

In the left panel, the young English king Richard II (r. 1377-99), crowned and garbed in a magnificent red-and-gold damask robe, kneels on the rocky ground and looks toward the image of the Virgin Mary holding the Christ Child and surrounded by a host of angels in the right panel. The Virgin is wearing a stunning blue garment, and the angels who attend her are dressed similarly. The backgrounds of both panels are gilded, and the gold is stippled with a variety of designs. The king wears his personal emblem of a white hart—one of the most beautiful animals in art—and a collar made of broompods. Richard is being presented to the Virgin by John the Baptist, while behind the young king stand Edward the Confessor (in the center) and Saint Edmund, the last king of the Angels, holding the large arrow with which he was martyred.

The *Wilton Diptych* is a work that combines a sense of peace, majesty, awesome power, purity, poignancy, and elegance. It is unmatched in the world. Especially exciting are the subtle differences between the faces of the angels. At first glance, they look the same, but each possesses its own distinct character. If you look closely into the orb on top of the staff held by an angel in the right panel, you will perhaps be able to see a tiny green island with a single castle and a boat on a silver sea—the symbols of England under the protection of the Virgin and King Richard. The back of the diptych is also painted.

ARTIST UNKNOWN

THE WILTON DIPTYCH
1395-99
Oil on panel
Each panel: 19 x 12 in. (48.3 x 30.5 cm)

Current Location: National Gallery, London

# GUDEA, KING OF LAGASH

ARTIST UNKNOWN
Sumer

GUDEA, KING OF LAGASH
ca. 2120 B.C.
Diorite
Height: 17¼ in. (43.8 cm)

Current Location: Metropolitan Museum of Art,
New York

THE FRENCH archaeologist Ernest Sarzec is little known today, but he is responsible for one of the major finds of the ancient Mesopotamian world. Around 1875, while serving as vice consul in Basra of the Ottoman Empire, he was given blanket permission to excavate the mound of Tello and thus discovered the ancient Sumerian capital of Lagash. Sarzec unearthed one of the truly exceptional finds in all archaeology, spectacular sculptures of the seventh ruler of Lagash, a genius by the name of Gudea. He also dug up approximately 30,000 clay tablets that provided a penetrating insight to the history of this legendary kingdom, which flourished around 2150 B.C. Gudea composed a beautiful hymn in which he describes in detail the reconstruction of Eninnu, the temple of the god Ningirsu. Sarzec found many small sculptures of the gifted ruler in diorite; most have made their way to the Louvre, where they have been reinstalled brilliantly in the new Assyrian section.

But one Gudea portrait came to the Metropolitan Museum of Art in the early 1960s—and it is arguably the best of the striking images and one of the premier works of all antiquity. Black as deep space, carved in diorite so hard that diamond drills were unable to penetrate the stone's surface, the statue shows Gudea seated with his delicate long-fingered hands clasped benignly at his chest. His naked shoulders are broad and muscular; his face—carved superbly, with its great, lively eyes offset by the perfectly round ceremonial hairdo with tiny, tight curls—is the epitome of intelligence. One can readily believe that this man was the accomplished poet of his day as well as a capable administrator and calm judge—all of which he was lauded as being. He was also a warrior and, in this cubic image, seems like an armed mega-bomb ready to vanquish every enemy in his path. The host of writings inscribed into the hard stone tell of his accomplishments.

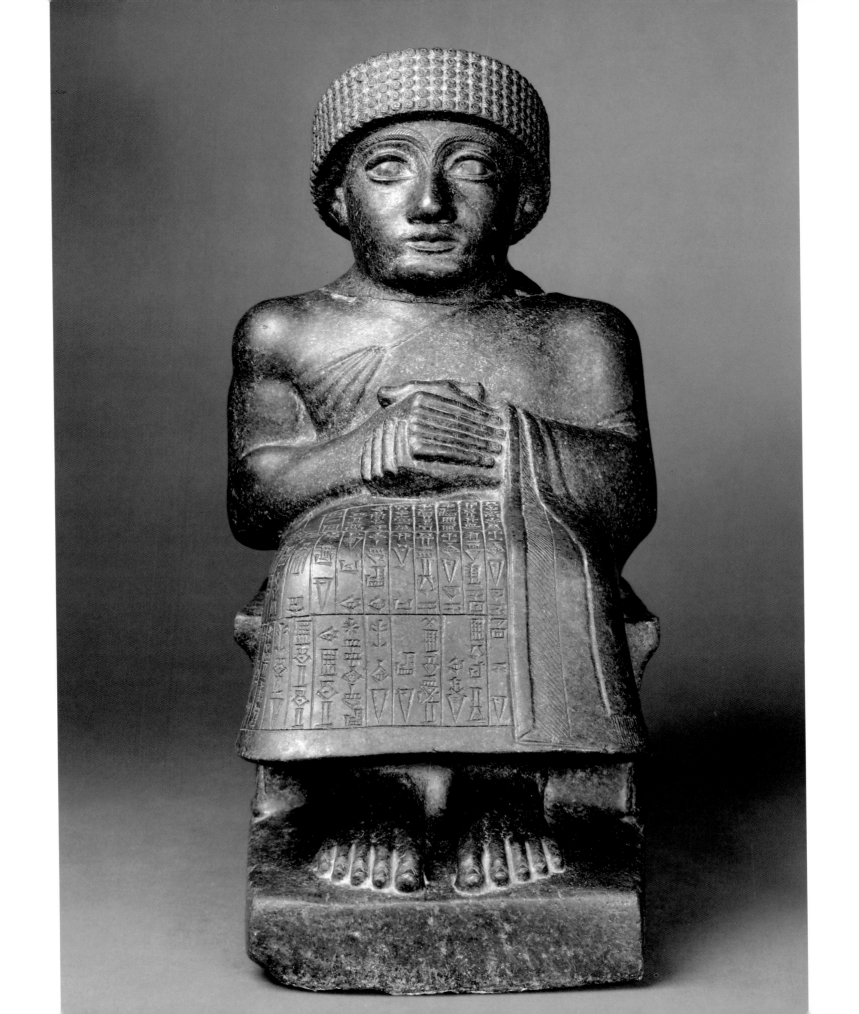

# SELF-PORTRAIT

ALBRECHT DÜRER

b. May 21, 1471, Nuremberg, Germany
d. April 6, 1528, Nuremberg

SELF-PORTRAIT

1500
Oil on panel
26¼ x 19¼ in. (67 x 49 cm)

Current Location: Pinakothek, Munich

THE SINGLE MOST arrogant, annoy-ing, and gorgeous portrait ever created is Albrecht Dürer's painting of himself from the year 1500, in which he has boldly advertised who he is and what the viewer should think of his work. On the left side is his monogram and the date, and on the right side is the Latin inscription *"Albertus Durerus Noricus/ipsum me propriis sic effin/gebam coloribus aetatis/anno XXVIII"* (Albrecht Dürer from Nuremberg, painted this myself with incredi-ble colors at the age of twenty-eight years"). What is striking is that there are almost no colors at all— the palette is limited to browns, black, and flesh tones, with two accents of white. Yet the result is without question "incredible." One of the areas of white is the vented right shoulder of his fur-trimmed garment, and the other a glimpse of his shirt in the form of a small triangular shape at his breast just below the center of this magnificent image, perhaps to indicate his purity of heart.

This is the artist as Christ and God. The reli-giosity of the portrait is emphasized by the uncompromising frontality, similar to the Byzan-tine mosaics showing the domineering face of the Savior. Other references to Christ are the crooked open fingers of Dürer's right hands, as if in a ges-ture of blessing, and his long, greasy, curly locks of hair. The modeling is subtle and sublime, mak-ing the artist look alive yet living in another world. He appears a bit harsh, yet intriguingly sensual. In the limpid, serene and gentle eyes, one can see the reflections of the artist's studio as well as the cosmic beyond. One is left with the impression that although this genius may not have created the cosmos, he believes he controls it.

There have been few artists with the prodigious natural talent of Dürer, and there has probably been no artist as popular from his own time to the present. His engravings—especially of religious subjects—were so adored that the emperor passed a law at one time especially to protect Dürer against forgers and copyists.

Dürer first studied with his goldsmith father, from whom he learned to draw, and was quickly recognized to be a prodigy. Between 1490 and 1494 he traveled through Germany and surround-ing areas to gain a broader artistic education and worked as a book illustrator in Basel and Strasbourg before settling in Nuremberg.

His early style is confident and dramatic, but

it was not until he traveled to northern Italy and came across the Renaissance masters, including Leonardo (who seems to have admired Dürer's works—the jet black background in Leonardo's *Woman with an Ermine* (see page 267) may have been inspired by Dürer)—that his art took off. After his first trip to Italy in 1495, Dürer set up a workshop in Nuremberg and began receiving commissions for portraits and religious paintings from German patrons, including Frederick the Wise, Elector of Saxony. But his primary interest continued to be the creation of engravings and woodcuts. Among his best works are his series of engravings, especially the *Apocalypse*, 1497–99, the *Great Passion*, of 1510, and crisp and haunting apparitions such as the *Knight, Death and the Devil, St. Jerome in His Study*, and *Melancholia I*, all from 1514.

In the summer of 1518 he met Martin Luther and became a convert to his anti-Papist ideas. In his final years, Dürer devoted himself primarily to theoretical and scientific writings and illustrations, although he continued to paint, creating one of his most striking works, the *Four Apostles*, in 1526. It is clear that right up until his death, his extraordinary painterly powers never diminished.

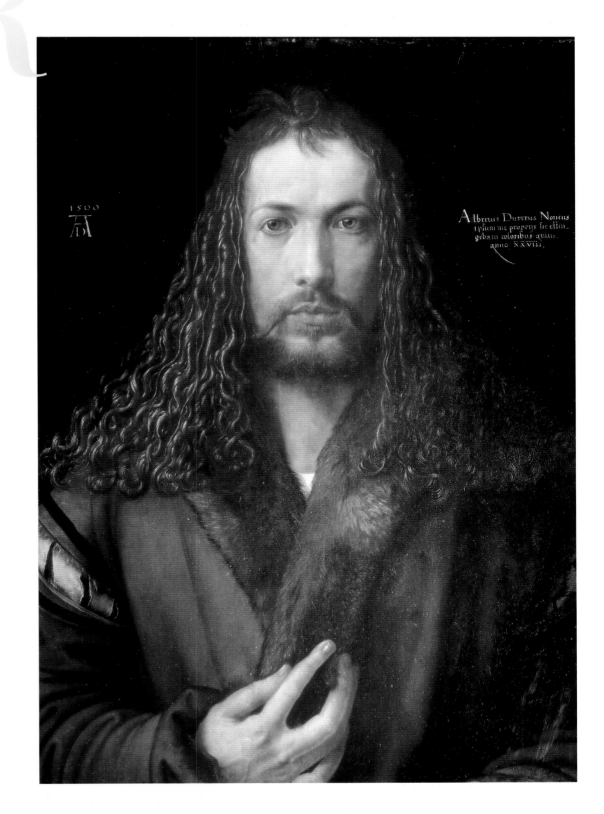

# THE SHE-WOLF OF ROME

MANY ART historians believe that the Etruscan artists, especially of the early 7th century B.C., had the Greeks beat hands down. In many of the bronzes, paintings, terracottas, and black bucchero pottery there's a taut and earnest directness, combined with a pleasing lack of idealism. These days, after our discovery that the art of so-called "primitive" civilizations, like the Olmec or Benin, is equally valid as classical Greek art, the early Etruscan achievements are correctly looked upon as formidable. Their terracotta statues of loving couples wining and dining on the tops of sarcophagi are penetrating glimpses of humanity and are perhaps the most optimistic portrayals of dead souls ever made.

For me the most enthralling work of art to have survived from Etruscan times is a huge bronze wolf bitch, now in a special gallery among the Capitoline Museum's sculpture gardens, which are on the left side of the plaza. *La Lupa Romana*, dating from the 7th century B.C., is a symbol of several aspects of Etruscan theology and legend. She's thought to be the image of the she-wolf who adopted the infant founders of Rome, Romulus and Remus, and suckled them into adolescence. (Beneath her enormous teats are two small 17th-century bronzes representing the youths.) Her other manifestation was the beast of death.

This powerful representation is unique in art and may be one of the finest animals to have survived through time, for the artist has imbued the creature with a fearsome urgency—a killing feeling—combined with a memorable tenderness. It is the combination of exceptionally well-crafted detail with a timeless overall form that makes this beautiful work of art so stunning.

ARTIST UNKNOWN

THE SHE-WOLF OF ROME
(La Lupa Romana)
7th century B.C.
Bronze
Height: 33½ in. (85 cm)

Current Location: Museo Capitolino, Rome

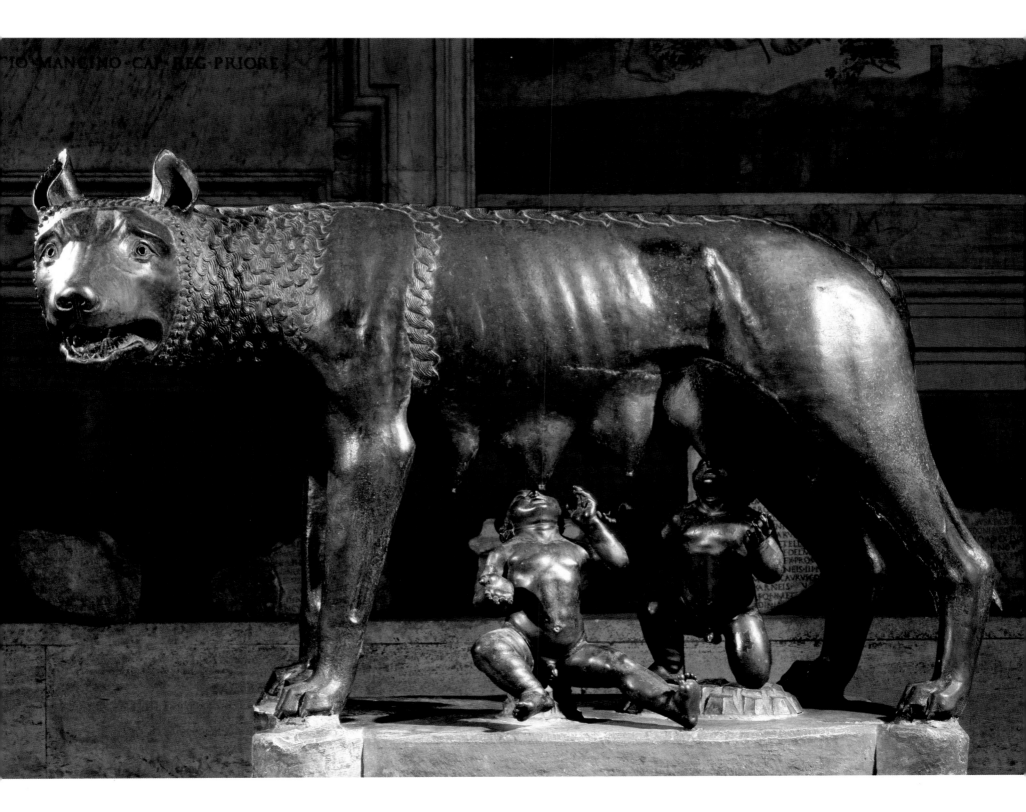

# THE STARRY NIGHT

VINCENT VAN GOGH

VINCENT VAN GOGH
b. Mar. 30, 1853, Zundert, Netherlands
d. July 29, 1890, Auvers-sur-Oise, France

THE STARRY NIGHT
1889
Oil on canvas
28¾ x 36½ in. (73 x 92 cm)

Current Location: Museum of Modern Art,
New York

THE MOST EXALTED works of art since the end of the eighteenth century seem to have sneaked up on mankind. Almost invariably, artistic genius and truly significant statements were mostly reviled in their own time and only gained widespread appreciation much later, if at all. Artists were usually spurned as "anti-social misfits," or even "riff-raff." The quintessentially misunderstood painter of modern times is Vincent van Gogh, although we exaggerate the extent of his alienation during his life. Why this artist has today been chosen by an overwhelming segment of the public to sum up the turmoil, inconstancy, and wretchedness of mankind as well as humanity's most sublime aspirations is a mystery. But there's no arguing it.

Standing at the pinnacle of his incomparable body of work is *The Starry Night*, a strange, disturbing, yet satisfying late painting that he created in St. Rémy in southern France a year before his death. It's as if he depicted the account in Genesis of the creation of the universe and included the birth of the Christian church as well. This sky seems to me to be what it might have looked like after the creation of the cosmos, when the storm of creation had passed, the stars had cooled, the moon had been formed, and the heavenly bodies glowed more brilliantly than at any time since.

Van Gogh had been obsessed with a night landscape for many years, and while he was doing realistic works found himself incapable of allowing himself to explode into the fantasy. He tried to make such a dreamlike image from reality and painted at night under a gas jet, but that failed. In 1889, confident that his imagination possessed the right creative forces, he gave up the idea of an open-air night landscape and invented this majestic creation. Here we have serenity and chaos, peace and cosmic disturbance all at once, symbolized in the serene village and peaceful church and the twisted cypress tree, the incandescent crescent moon, the blinking stars whirling like adolescent Novas. The Milky Way roils across the blue-black sky of night like an ocean wave whipped by the hurricane inflicted by the explosive birth of the galaxy.

Van Gogh is perhaps the single most enthralling "modern" painter of all. His works combine a tangible amount of realism (not being burdened with the frustrating abstract "inconsistencies" of Cézanne or Picasso) with the correct measure of disturbing reality, so that he has become the virtual symbol of

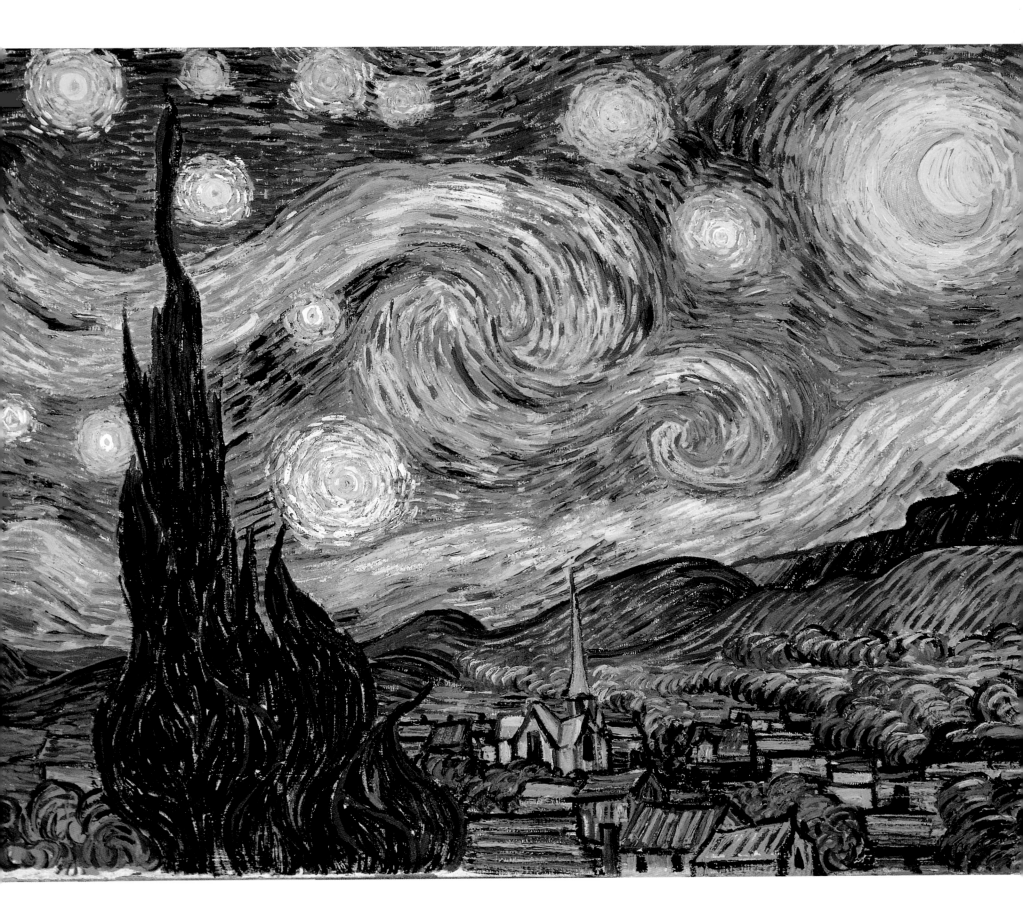

universal expressionism, the spirit of the anguished artistic soul that, some feel, exists in all humanity. He was a patient, awkward, exceptionally gifted draftsman, and his drawings may be his best achievement. No other artist, with Rembrandt the possible exception, has managed to create such bold, unerring, strong lines that turn an image on paper into a real landscape or human being.

As is well known, he led a troubled and, to him, a highly unsuccessful life—although he did sell occasional paintings and had several students who followed his style (and some of whose works have been falsely labeled his). He was born in a small village in the Brabant, the oldest of six children of a Protestant pastor. He started off in life as an art dealer in the Hague, and for a while, in London, before giving it up for painting. Although he had some formal art instruction, he was largely self-taught and in the beginning was slow and awkward.

Van Gogh's career falls roughly into two periods. From 1873 until 1885, he struggled to express himself throughout several apprenticeships and abrupt changes in artistic direction. From 1886 to his death in 1890, his second period was an extraordinary time of dedication and startling success, until van Gogh was shattered by a series of mental breakdowns.

Early on in his life he was rejected by a young woman in London, and after that he became increasingly solitary. He tried becoming a preacher but was dismissed; his attempt to throw away all his possessions and join the truly poverty-stricken as an aid to his evangelism was looked upon by the church as unseemly.

In 1880 he discovered drawing and decided his mission in life was to use art to bring consolation to humanity. He studied drawing at the Brussels Academy and in 1881 moved to his father's parsonage in Holland and began to work from nature. Discouraged by the burdens of learning on his own, he studied briefly at The Hague and haunted the excellent museum there. He returned to the study of nature, first at Drenth, an isolated part of northern Holland, and then to Nuenen in the Brabrant, where he created his famous dark and powerful scenes of peasants.

Finding Nuenen too provincial, he moved to Antwerp and there discovered Hals, Rubens, Veronese, Japanese prints, and Delacroix. He refused

to follow the principles of academic training and left the Antwerp academy in 1866, traveling to Paris to be with his brother Theo. There he met the "moderns," Toulouse-Lautrec, Gauguin, Pissarro, and Seurat. Under their influence, he rapidly developed a radiant palette and by 1887 van Gogh was producing exciting Impressionistic works. Two years later, tired of city life, he decided to seek out true nature and in February 1888 left for Arles in the south of France.

In the works of the following year—his first splendid period—his landscapes and portraits fairly burst open with bright colors and he developed a technique in which he worked at great speed and high emotional intensity. He invited Gauguin to come to what he hoped might be a new academy of Impressionism, but the two were incompatible in almost every way and on Christmas Eve 1888, van Gogh, cracking under the strain, sliced off his left ear. Gauguin fled and van Gogh was sent to the local hospital for several weeks. When he was discharged he created such masterpieces as *Self-Portrait with Pipe and Bandaged Ear*. But he was forced to return to the hospital, because his mental illness kept threatening his health.

At the end of April 1889, afraid of not being able to paint—and he equated painting with the possession of his sanity—he voluntarily entered the asylum at Saint-Rémy-de-Provence. He remained for a year and his works during this time are among the most energetic of his short career—*The Starry Night* was painted there. Yet he suffered continual attacks and, stricken with homesickness, left the asylum for Paris, arriving in May 1890. A few days later he settled in with doctor-artist Paul-Ferdinand Gachet at Auvers-sur-Oise in the north. This arrangement, sadly, didn't last long, for he argued with the doctor and worried deeply about his over-dependence on his brother Theo, who had married and had a son. He shot himself accidentally at the end of July 1890, and died two days later of blood poisoning.

There is more bunk written and believed about van Gogh than any other painter of recent times. His life is still more or less disastrously defined by the fanciful Hollywood movie *Lust for Life*. In fact, he did sell pictures during his lifetime; his works were even forged while he was alive; he had students; and it seems convincing that he did not commit suicide.

# PHIDIAS
# THE PARTHENON SCULPTURES

**PHIDIAS**
b. ca. 500 B.C., Athens, Greece
d. ca. 432, Athens, Greece

**SEATED GODS**
Poseidon, Apollo, and Artemis,
from the east frieze of the Parthenon
(in background)
5th century, B.C.
Marble
Height: 43 in.

**THREE GODDESSES**
from the east pediment of the Parthenon
5th century, B.C.
Marble

Current Location: British Museum, London

WHY ARE THESE sculptures from the fifth century B.C. so dazzling? Why do they seem to go to the heart of our civilization? These surviving fragments, long removed from the Parthenon (the principal Temple of Athena on the Acropolis, in Athens), resonate with what is most noble and most civilized in human nature. As works of sculpture, they are matchless. Not only are they carved with a perfection that has never been equaled, but they possess an astonishing sense of life and movement—from the Athenian citizens or gods and goddesses with their rippling and flurrying draperies to the horses that seem to gallop along the frieze. Even the figures shown sitting still appear to convey some gentle movement. The sculptures are also inventive and daring. The reliefs from the frieze—such as the Horsemen or Poseidon, Apollo, and Artemis—are only several inches deep, but their sense of depth and rounded form seems greater. The more-than-lifesize sculptures from the pediments—such as the Three Goddesses from the east pediment—are carved fully in the round, even though no one in antiquity would have been able to climb up there and see their backs. These and certain other figures

remain etched forever in one's mind—including the fragmentary so-called *Amphitrite* from the west pediment, the lolling naked *Dionysus* from the east pediment, and the striking image of the single horse's head (also from the east pediment) that symbolizes the eternal power of the sun. Taken all together, they are a staggering achievement, and seeing them is equal to any of the greatest artistic experiences.

Phidias, a greek sculptor of the high Classical period from Athens, was considered by the Greeks of that period to be the greatest of all sculptors. Under the sponsorship of the Athenian Statesman Pericles, he was appointed supervisor of the sculptoral decoration of the Parthenon and probably created the overall scheme for the sculptures. The son of Charmides, he studied with Ageladas and was a contemporary of the sculptor Polycleitos, who perfected the technique of bronze casting. In addition to his supervision of the Parthenon sculpture, Phidias created two colossal statues of Athena (the bronze Athena Promachos on the Acropolis and the gold-and-ivory statue of Athena Parthenos in the Parthenon, surpassed those by creating a huge seated gold-and-ivory

statue of Zeus for the temple at Olympia (which made it to the end of the fourth century A.D. before being burned in a riot in Constantinople), and is said to have invented a miraculous method of softening ivory and molding it into the various parts of human beings. Shortly after the dedication of the Athena Parthenos, Phidias was indicted for stealing part of the statue's gold sheathing, but records of the subsequent trial and sentencing are too obscure to be accurate.

One of the legends has it that Phidias was such a great sculptor because he alone had seen the exact image of the gods and that he revealed it to man. When one sees his works, especially for the first time, it seems very likely to be true. Although a few sections of the frieze exist in the tiny Acropolis Museum in Athens, the bulk of the works are in the British Museum, London, obtained in the early nineteenth century by Lord Elgin in a deal with the Turks who were then the masters of Greece (and under whom the marbles probably would have been burned into lime). The controversy over whether these magnificent stones should remain in London or be returned to the Acropolis burns as consistently as any political issue of modern times.

# THE EXPULSION

MASACCIO
Tommaso di Ser Giovanni di Simone
b. Dec. 21, 1401, San Giovanni Valdarno, Italy
d. Nov. 1428, Rome

THE EXPULSION FROM THE
GARDEN OF EDEN
from the Brancacci Chapel Frescoes
ca. 1427
Fresco
83½ x 35 in. (214 x 90 cm)

Current Location: Church of S. Maria del Carmine,
Florence

FOR ALMOST three years, until shortly before he died at the age of twenty-seven, Masaccio painted about half of the twelve great wall frescoes in the Brancacci Chapel of the church of S. Maria del Carmine in Florence and left for eternity some of the most powerful pictures ever created. They are all head and shoulders above anything created in their day and may possibly rank with the top dozen works of art of civilization. One is sublime: *The Expulsion from the Garden of Eden*. The subject was always a favorite in Christian art for the church was eager to show what happens when the holy rules are broken and, no doubt, also didn't mind the titillation that the scene produced. The number of times the Expulsion was depicted in art is beyond tallying, but Masaccio's version is the very best. We see a sword-wielding angel, who is both benign and an authoritarian monster at the same time, hovering right above the panic-stricken figures of Adam and Eve, who have just been impelled through the narrow arch of the Gates of Eden after receiving the sentence to move out and join the cruel world. One has the feeling that they recognize only partly what has happened. They feel guilt but are not crushed by it. Both are naked, and Masaccio has depicted their bodies as being anatomically real and at the same time almost abstract, with a strange emphasis on the legs, which seem to be almost incapable of moving despite their obvious strength. The gestures and emotions of the condemned pair are vivid. Adam, supposedly the stronger of the two, has completely broken down and covers his face with quivering hands. Eve cries out in anguish and covers herself with her hands to hide her nakedness. The genius of this image is that it evokes so plainly the tragedy of the two sinners who will somehow survive—and perhaps also conveys the Renaissance view of man as beholden to God but independent as well.

Masaccio is known in art history for being one of the earliest artists of the Renaissance, a man who created human figures who possess anatomical reality, acting in spaces that give the impression of a natural environment. He is also renowned for the beauty of his style and his penetrating observations of humanity. Masaccio painted the Brancacci Chapel frescoes in collaboration with another artist, Tommaso di Christoforo Fini di Panicale, known

as Masolino ("little Thomas"), sometime between the end of 1424 and 1427–28, when Masaccio left Florence for Rome. He and Masolino divided the work, and some of the pictures left undone or incomplete by Masaccio were finished by Filippino Lippi in the 1480s. Masaccio's real name is Tommaso di Ser Giovanni di Simone and, according to sixteenth-century biographer Giorgio Vasari, was known by the nickname Masaccio (which means "big, clumsy Thomas") because of his lack of sophistication about worldly affairs and his apparently careless manner of dress. Among the most profound influences on Masaccio were the dynamic sculptures of Donatello, who was in Florence at the same time. Masaccio was impressed by the mixture of anatomical presence and a heightened emotionalism. After joining the painters' guild in Florence in January 1422, Masaccio worked there for most of his brief life, leaving only to work in Pisa in 1426, and to go to Rome in 1428, dying there that autumn (or in 1429) of malaria. The startling thing about Masaccio is that all his known works—all fully mature achievements—were painted in the blinding flash of only eight years.

# THE GATES OF HELL

ALTHOUGH MANY connoisseurs look down on Auguste Rodin as overly romantic, he is still one of the most influential image-makers of modern times. His *Gates of Hell* deserves to be on the list of the most accomplished works of art because of the sheer bravado of the ensemble—loosely inspired by Dante's *Divine Comedy*—and because of his invention of one of the most unforgettable images, *The Thinker*, which Rodin conceived as a sculptural relief on the lintel of *The Gates*. What more vivid single act of sculpture in the nineteenth and twentieth centuries is there?

Today this brooding male nude is parodied, plagiarized for second-rate cartoons, dismissed as a cliché by many art historians, and ignored by most teachers of art history. Nonetheless, the awkwardly powerful figure of *The Thinker* has an astonishing sense of the infinite. It may owe a passing debt to the Hellenistic *Belvedere Torso* in the Vatican Museum, but it is richer than its model, and in terms of the human figure it stands as a remarkable achievement, one of the most original and expressive sculptures of mankind since ancient times. *The Belvedere Torso* is specific; *The Thinker* could be any race, any time.

*The Gates of Hell* overall is something of a muddled, waxy mess and gives the impression that its surface was softened at some time and then chilled to its present look. The truth is that it was never finished. *The Gates* was commissioned in 1880 for a planned decorative-arts museum in Paris, but the sculptor was unable to bring the work to fruition. What he left at his death was cast in bronze in 1917. It's fascinating that this incomplete portal is a work of such power and monumentality.

The primary model for Rodin's portal was Lorenzo Ghiberti's *Gates of Paradise*, an awe-inspiring series of bronze relief panels that adorn the doors of the Baptistery in Florence (see p. 44). But Rodin's fervent imagination energized this highly ordered group of religious scenes into a sweeping maelstrom of forms. Capped by the memorable *Three Shades* at the top of the lintel, we see a continuous sequence of rising and falling figures condemned to hell. There are—and for some of the individual figures we have to peer hard because the sculptures are deliberately generalized and obscured—the images of Sorrow; the famous falling man, with his anguished hand held over his terrified face; Adam and Eve; the personification

AUGUSTE RODIN
b. Nov. 12, 1840, Paris
d. Nov. 17, 1917, Meudon, France

THE GATES OF HELL
1880–1917
Plaster model
18 x 12 ft. (5.5 x 3.6 m)

Current Location: Musée d'Orsay, Paris

of avarice and death; vignettes of a family gone stark, raving mad; blind lust in the images of Ugolino devouring his children; and the copulation (almost) of Paolo and Francesca.

The most magnificent characteristics of *The Gates of Hell* are its explosive passion and lack of discipline. It is a captivating statement of chaos, which may be why it appeals to us today and will seize viewers, I am convinced, in a thousand years.

Like many artists of the nineteenth and twentieth centuries, Rodin had to struggle to emerge. Born poor, he went to drawing school at the age of thirteen but by seventeen, when he was eligible to take the exam for entry to the École des Beaux-Arts, he failed three times running. In 1858 he turned to cutting decorative stonework—which probably seasoned him more effectively than any course at the École would have done. He studied at the lesser Petite École and in time worked as an assistant in the studio of the journeyman decorative sculptor Albert-Ernest Carrier-Belleuse.

It is significant that Rodin's first serious attempt to make it—a bronze entitled *The Man with the Broken Nose*—was rejected because it seemed to be merely an unfinished fragment. When he was dismissed by Carrier-Belleuse in 1871, he went to Belgium where he worked on bits and pieces for banal memorials created by established academic sculptors until 1877.

His artistic life exploded when, at age thirty-five, he traveled to Italy for the winter of 1875–76 and soaked up the glories of Donatello and Michelangelo. The style that he molded was eventually that which guaranteed his place in history. One of his first efforts, *The Age of Bronze*, caused a sensation in Paris in the Salon of 1877 because its hyper-reality convinced some that Rodin had cast it from a living model.

Among his other memorable images are *The Kiss, St. John the Baptist Preaching,* and *The Burghers of Calais*—a monument for the French city to commemorate the six burghers who had sacrificed themselves as hostages to England's King Edward III in 1347 to lift the English army's siege of the city.

# WOMAN WITH AN ERMINE

IN A ROOM IN a museum in Kraków hangs the best painting Leonardo da Vinci ever made, *Woman with an Ermine*. Of all his magical works, this is the most compelling and seems the embodiment of artistic perfection, partly because the picture is in better condition than many of his other paintings. The strikingly beautiful young woman is painted on a severe jet black background that is unique in Leonardo's oeuvre. At first glance, this young woman holding the usually unpleasant animal in her arms seems the epitome of beauty, chastity, and modesty. But the more one looks, other attributes begin to emerge—cunning, a latent feral quality, dissolution, even evil. She's hardly an innocent; indeed, her smile is almost reptilian. Neither woman nor ermine is a sweet, cuddly creature. They both give the impression that they have turned to look toward some object of prey.

Who is she? Her identity has been a subject of continual speculation over the centuries. One theory holds that the ermine is a clue to her name, since "ermine" in ancient Greek is *gale*, a possible reference to the name Gallerani—in particular, Cecilia Gallerani, the mistress of Lodovico Sforza, the Milanese duke who was Leonardo's patron between 1482 and 1497. She was considered to be one of the most enchanting women of the court of Milan. Her affair with the all-powerful Lodovico began when she was sixteen, and she gave birth to his child soon after. For that, the duke gave her a present of the rich little town of Saronno. After Lodovico married Beatrice d'Este, he handed Cecilia over to Count Carminati-Gergamini.

Other than this obscure reference to an ermine there's no other clue as to who the subject of the painting may be. Perhaps she is someone who lived before Leonardo's time. He has painted her with her brown hair parted in the center and covered with a diaphanous veil. This kind of veil appears in a small group of sixteenth-century paintings depicting an exceptionally evil first-century Roman woman—Poppaea Sabina, Nero's brutal wife, who was slaughtered by him. Perhaps this image of a beautiful young woman is meant to be a portrait of both Cecilia and Poppaea.

Leonardo was born in 1452, the illegitimate son of Ser Piero, a Florentine notary who enjoyed a fine reputation in the city of Vinci near Empoli. His mother was a young peasant who subsequently married an artisan. Leonardo grew up peacefully in

LEONARDO DA VINCI
b. April 15, 1452, Vinci, Italy
d. May 2, 1519, Amboise, France

WOMAN WITH AN ERMINE
1483-90
Oil on wood
21 x 15½ in. (53.4 x 39.3 cm)

Current Location: Czartoryski Museum, Kraków
Note: *Woman with an Ermine* is just a stone's throw from the church containing Veit Stoss's superb altarpiece (see page 119).

his father's house and received a normal education. But his artistic talent was recognized early on and he was apprenticed to the painter and sculptor Andrea del Verrocchio in Florence at age 15. He also worked in the shop of Antonio Pollaiuolo, another painter and sculptor of distinction. In 1472 Leonardo was accepted into the painters' guild of Florence but worked for nearly five more years with Verrocchio. His early works are tight, impeccably drawn, and possess a spirit that can only be described as magnetic and slightly unworldly. The spectacular *Ginevra dei Benci* in Washington's National Gallery of Art is one of these marvelous works. In addition to the paintings, Leonardo completed a series of superb drawings in both pen and pencil. The range of their subject matter is almost limitless—one finds studies for pumps as well as people, military weapons and installments, and mechanical equipment of an almost infinite variety.

In 1482 Leonardo entered the service of Ludovico Sforza, the duke of Milan, leaving Florence where he had gained a number of commissions that he failed to carry out, the beginning of Leonardo's annoying tendency to avoid finishing some of his best—and faithfully promised—works. He spent seventeen years in Milan and was listed in Sforza's register of the household as a painter and engineer; he was consulted regularly on matters pertaining to architecture, fortifications, hydraulics, and military tactics. His reputation soared, yet his production of works of art became more and more limited. In Milan he completed only six works— the grand *Woman with an Ermine* among them. The intriguing *Last Supper* in Santa Maria delle Grazie must be considered a failed work. Leonardo used an experimental method involving some kind of paint mixed with soap—encaustic—plus oil tempera applied directly to the dry plaster surface, which resulted in a large-scale deterioration of the painting beginning during his lifetime. (Visit the almost pristine *Room of the Ash Trees*—the *Sala delle Asse*—in the Castello Sforzesco of Milan instead.) Another unfinished work was a gigantic bronze equestrian statue of the duke, which was ready to be cast when the outbreak of a war forced the use of the bronze for cannons. In Milan,

Leonardo organized a large shop with many aides and followers—all of whom could paint exceedingly well—with the result that paintings by his followers have consistently been attributed to him.

Leonardo was perhaps the most versatile and accomplished artist of the Italian Renaissance, a brilliant but erratic genius of the visual arts and architecture, and arguably the most gifted draftsman of all time, who left all too many works unfinished or unresolved. One can only imagine the oeuvre he might have left us had he only finished half of what he promised. Then we would have shining altarpieces, fresco cycles, at least one huge bronze equestrian statue, and countless incomparable buildings—plus maybe even the first glider that worked. But the incredible diversity of what he did manage to achieve, in art and in science, gives us cause to admire what might be called a total career. The genuine Leonardo pickings are slim in the United States, but do not miss the fine drawing of a bear in New York's Metropolitan Museum of Art, or the wondrous small portrait of a young woman, *Ginevra del Benci* in the National Gallery of Art, Washington, D.C.

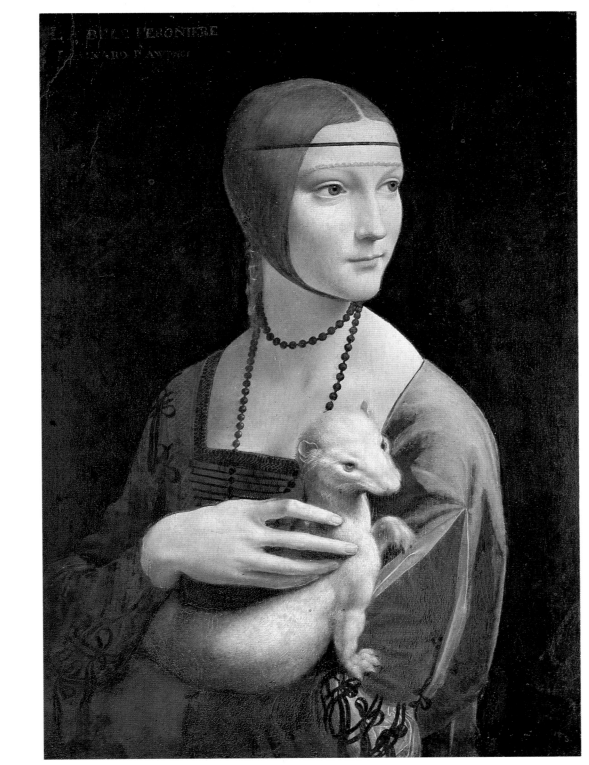

# INDEX

CREDITS

# LIST OF PLATES